Colin Rhodes
studied Fine Art and Art History at
Goldsmiths' College, London, before completing his PhD on
Primitivism at the University of Essex. He has written and
lectured widely on Primitivism and German Expressionism
and is currently Head of Contextual Studies at
Loughborough College of Art and Design.

WORLD OF ART

This famous series
provides the widest available
range of illustrated books on art in all its aspects.
If you would like to receive a complete list
of titles in print please write to:
THAMES AND HUDSON
30 Bloomsbury Street, London WC1B 3QP
In the United States please write to:
THAMES AND HUDSON INC.
500 Fifth Avenue, New York, New York 10110

Printed in Singapore

COLIN RHODES

PRIMITIVISM AND MODERN ART

179 illustrations, 28 in color

THAMES AND HUDSON

For Nicky, Tom and Anna

ACKNOWLEDGMENTS

Many people deserve thanks for their help and advice during the writing of this book. I would like to thank in particular Professor Peter Vergo, Neil Cox and others at the University of Essex for their friendship and long-standing contributions to my study of Primitivism. I am grateful also to Gill Perry who has repeatedly confirmed and enriched my ideas. I owe a considerable debt to Dr A. K. Wiedmann, whose seminars at Goldsmiths' College, London, first opened my eyes to the subject of Primitivism. His interest in modern artists' use of myth informs parts of Chapter 5, and the important term 'perceptual primitivism' is his.

© 1994 Thames and Hudson Ltd, London

First published in the United States of America in 1994
by Thames and Hudson Inc.,
500 Fifth Avenue, New York, New York 10110

Library of Congress Catalog Card Number 94-60286
ISBN 0-500-20276-1

Printed and bound in Singapore

Contents

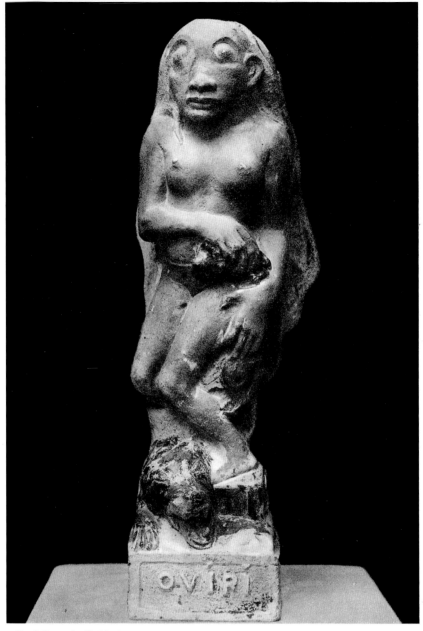

1 Paul Gauguin *Oviri* 1894–95

Introduction

Primitivism is nowadays seen as a relatively recent set of ideas, arising in Western Europe in the eighteenth century at the time of the Enlightenment, which coincided with the beginning of an unprecedented period of European colonial expansion. Colonialism, in fact, lies at the heart of theories about Primitivism. The colonial enterprise in the eighteenth and nineteenth centuries provided a wealth of examples of cultures new to the West, set within a system of unequal power relations which determined that the primitive, or more often in contemporary writings, 'the savage', was invariably the dominated partner. Geographically, European beliefs placed the savage in Central and Southern Africa, the Americas and Oceania. However, the West itself has long believed that it contains its own primitives – peasant populations, children and the insane.

The term Primitivism is used in relation to modern art to describe tendencies that can be found throughout most of its developments, from Symbolism and Art Nouveau in the 1890s through to American Abstract Expressionism in the 1940s. Unlike these art movements, however, Primitivism does not designate an organized group of artists, or even an identifiable style arising at a particular historical moment, but rather brings together artists' various reactions to ideas of the primitive in the course of this period. Primitivism in modern art has traditionally been seen in the context of artists' use of nominally primitive artefacts as models for developments in their own work; beginning in the first decade of the twentieth century in France and Germany, and spreading quickly throughout Europe and to the United States. However, Primitivism encompasses much more than simple formal borrowings from non-European art; this 'Stylistic Primitivism' can just as easily be related to the influence of primitive art as symbolic of particular artistic processes. Similarly, as we shall see, there is a large body of Primitivist art, particularly among Dadaists and Surrealists, which bears no direct relationship to primitive art – its Primitivism lies in the artists' interest in the primitive mind and it is usually marked by attempts to gain access to

7

what are considered to be more fundamental modes of thinking and seeing.

When artists looked to primitive objects, whether from outside the Western world or from the West's own 'primitives', as possible source material, they inevitably brought their own preconceived idea of 'primitive culture'. In the case of tribal art, for example, objects from the European colonies had been available, though virtually ignored by artists, since the beginning of the eighteenth century, if not before. It has been argued that early twentieth-century European artists, such as Picasso and Matisse, became interested in primitive art around 1906 simply because it reflected recent formal developments in their own work. This explains nothing about the ways in which tribal objects were understood by European culture in general at this time, nor does it indicate the meanings that progressive artists sought to reveal in laying claim to the primitive. The significant questions that must be asked surely concern the meanings that modern artists read into primitive artefacts, the perceived relationship of the objects to their work, and the ways, if any, in which their interest in, and understanding of, the primitive works (and their creators) differed from prevailing views.

Primitivism describes a Western event and does not imply any direct dialogue between the West and its 'Others'. In the context of modern art, it refers to the attraction to groups of people who were outside Western society, as seen through the distorting lens of Western constructions of 'the primitive' which were generated in the later part of the nineteenth century.

Primitivism should not be confused with the primitive. The American art historian Robert Goldwater, in his seminal book *Primitivism in Modern Painting* (1938), introduced his readers to the subject by challenging what is still one of the most common, though nowadays very tired, attacks on modern art:

> The most contemptuous criticism of recent painting comes from those who say: 'any child of eight could have done that'. It is also the most difficult of all judgements to answer, since it involves the recognition, but not the admiration, of an apparent spontaneity of inspiration and simplicity of technique whose excellence we have come to take for granted.

In this passage Goldwater alerts us to the important precedent set for much modern European art not only by the forms of children's drawings and other kinds of so-called primitive art, but also by artists'

ideas about the nature of the creative processes which lay behind those forms. The primitive was regarded, on the whole, as always more instinctive, less bound by artistic convention and history, and as somehow closer to fundamental aspects of human existence. Many modern artists sought to capture some of this freedom, as they perceived it, in their own methods, but it would be incorrect to identify Primitivist art unequivocally with its primitive precedents. The Swiss artist Paul Klee is one who was clearly aware of the problem. He wrote:

> If my works sometimes produce a primitive impression, this 'primitiveness' is explained by my discipline, which consists of reducing everything to a few steps. It is no more than economy; that is the ultimate professional awareness, which is to say the opposite of real primitiveness.

Primitivism is marked by subtle layers of difference in the ideas of modern artists about the primitive and the uses to which these thoughts were put. Indeed, if we are to discover the ways in which images as visually distinct as Constantin Brancusi's *Little French Girl* (1914–18), the Surrealist André Masson's *Metamorphoses* (1939) and the American Abstract Expressionist Adolph Gottlieb's *The Oracle* (*c.* 1947) can all be considered Primitivist, it is essential that we explore the ways in which modern artists themselves perceived and used the primitive. (These are discussed further on pp. 117 and 165–6.)

In the pages that follow my aim is to give an overview of, and to highlight and clarify, the often confused major issues and values at stake in the Primitivist world-view through a discussion that focuses on the modern artists most closely associated with it. This has meant that France, Germany and, to some extent, Russia are the most frequently referred to, not least because it was there that the earliest and arguably most important manifestations of Primitivism were apparent – although this is not to say that the Primitivism of artists working in other areas such as Eastern Europe, Scandinavia and North America do not have their own intrinsic interest.

Primitivism is informed by a multiple, complex and often chronologically overlapping set of ideas which means that it is neither possible nor indeed desirable to discuss its manifestations in modern art in terms of a conventional chronologically progressive order. The diverse issues raised by Primitivism extend far beyond the use in modern European art of images and styles appropriated from Africa, Oceania or other remote and exotic cultures that have, at times, been

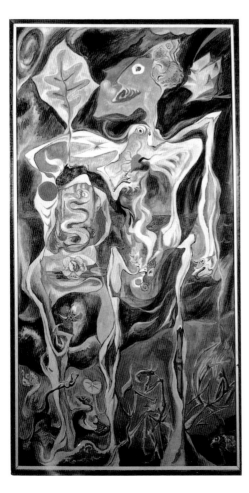

2 *(above)* André Masson *Metamorphoses* 1939

3 *(right)* Constantin Brancusi *Little French Girl* 1914–18

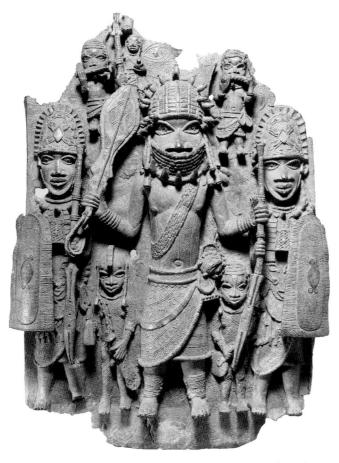

4 Benin bronze plaque with three chiefs in ceremonial dress from
Nigeria. Seventeenth century

designated as 'primitive'. The 'primitive' can also be found in the
Western world (peasants, children, the insane and even women!).
There is a fascination with 'exotic' subjects, as in Orientalist painting,
from the nineteenth century to Matisse and after. The yearning for the
mystical and the mythic is apparent in contemporary art. All of these
elements have been called 'primitive'. What this book aims to do is to
identify and to clarify the different ways in which the 'primitive' has
been understood, sometimes simultaneously, by artists who, for
many reasons, felt impelled to look outside the conventions set by
their own culture. The thematic framework I have devised here,

therefore, causes artists and movements to reappear at different points. Broadly speaking, however, the period covered ranges from the art of Gauguin in the 1890s to that of the American Abstract Expressionists in the 1940s.

Much of this book attempts to explore the assumptions made about peoples and cultures both within and without the Western world perceived as different in some significant way, or 'Other', by modern artists working in Europe and the United States. I have already indicated something of the wide range of artists' ideas about the primitive, yet I also maintain that there is a common thread running through all these attitudes: it emerges in their shared Western identity and the perceived European tradition reaching back to Classical Antiquity, if not further, which clings to the West's ideas about itself even today. Despite the apparent cultural and historical differences between modern European and American artists between around 1890 and 1950, for convenience's sake I have left intact an implicit assumption that the West is a coherent cultural unit, although I realize that this is, in itself, open to critical scrutiny and debate.

The Primitive and Primitivism

PERCEPTIONS OF THE PRIMITIVE

The word 'primitive' generally refers to someone or something less complex, or less advanced, than the person or thing to which it is being compared. It is conventionally defined in negative terms, as lacking in elements such as organization, refinement and technological accomplishment. In cultural terms this means a deficiency in those qualities that have been used historically in the West as indications of civilization. The fact that the primitive state of being is comparative is enormously important in gaining an understanding of the concept, but equally so is the recognition that it is no mere fact of nature. It is a *theory* that enables differences to be described in qualitative terms. Whereas the conventional Western viewpoint at the turn of the century imposed itself as superior to the primitive, the Primitivist questioned the validity of that assumption, and used those same ideas as a means of challenging or subverting his or her own culture, or aspects of it.

However, the very act of appealing to the primitive involves for the artist an implicit acceptance of conventional beliefs, albeit voiced in positive terms, as something to be envied or respected. This emphasizes the profoundly equivocal issue that lies at the heart of Primitivism, namely that, although artists might entreat the primitive as support and justification for projected cultural or social change, this alteration is always expected to come from within the West – there is never any question of the wholesale replacement of the aspects of culture to which the Primitivist is objecting with the primitive itself. For example, when the artist Marius de Zayas staged an exhibition in 1914 of 'African Negro Art' in New York it was in a gallery that usually showed modern Western art which he had no intention of displacing. Rather, he claimed, his exhibition bore witness to the new art of Europe, embodied in the work of Picasso and through whose insight, 'Negro art has reawakened in us a sensibility obliterated by an education which makes us always connect what we see with what we

13

know.' Typically, for De Zayas the African works functioned not as a new form of sensation, but as a kind of psycho-cultural *aide-mémoire*.

Charles Darwin's theory of evolution lies behind many early anthropological and sociological definitions of the primitive. It is significant, however, that what were originally essentially mechanistic principles of biological transformations were quickly translated into a philosophical proof for new versions of the medieval idea of a vertically oriented 'Great Chain of Being'. In the case of humanity, this meant a 'ladder' on which men were arranged in ascending order of importance according to 'race' (and often class). Darwin's most important notion – the theory of natural selection – was a convincing model with which to describe the evolutionary *process*. In short, Darwin held that evolution was dependent on genetic variation and that it proceeded through a process of divergence from simplicity to complexity. Thus, for taxonomic purposes, he suggested in his *On the Origin of Species* (1859) that the best way to establish the line of descent of a given animal was through studying the development of the embryo: 'In two groups of animal, however much they may differ from each other in structure and habits, if they pass through the same or similar embryonic stages, we may feel that they have both descended from the same or nearly similar parents.'

In this schema the embryonic (that is, relatively simple) stage of a living thing corresponds to the more ancient stage. The theory leads quite logically to the assumption that the development of individual members of a given species from embryonic form to maturity is a reflection of the evolution of the whole species; or, in the words of the influential Jena biologist Ernst Haeckel (1834–1919): 'ontogenesis is a brief and rapid recapitulation of phylogenesis'. In the various forms of Social Darwinism, perhaps best exemplified in the writings of Herbert Spencer (1820–1903) in Britain and Haeckel in Germany, this was applied to theories of social evolution. They claimed that the same relationship existed between the psychological and social development of the civilized individual from infanthood to maturity and that of civilized societies as a whole. In these cases, so-called primitive (or savage) 'races' were highlighted as examples of rudimentary types, as evidence of Europe's own past. It was, of course, only a short step for European science to arrive at the racist assumption that different human groups progress at different speeds,

that the West had produced the highest example of mankind and had proved its intrinsic superiority by gradually gaining control of the earth through the colonial enterprise.

Darwin himself made the perceived low evolutionary status of the savage abundantly clear throughout his *The Descent of Man* (1871), placing him at the beginning of the social, cultural and psychological development of mankind: a reminder of Europe's past that he found far from comfortable. Thus, although Darwin believed that 'there can hardly be any doubt that we are descended from barbarians', in his view the savage is, as in the thought of the seventeenth-century British philosopher Thomas Hobbes, an ignoble being, rather than someone to envy, as is more often the case in the idea of the Noble Savage which emerged from the writings of the philosopher Jean-Jacques Rousseau in the eighteenth century. Darwin's views on this particular subject are clearly stated in the following passage from *The Descent of Man*:

> The astonishment which I felt on first seeing a party of Fuegians on a wild and broken shore will never be forgotten by me ... such were our ancestors. These men were absolutely naked and bedaubed with paint, their long hair was tangled, their mouths frothed with excitement, and their expression was wild, startled, and distrustful. They possessed hardly any arts, and like wild animals lived on what they could catch; they had no government, and were merciless to everyone not of their own small tribe. . . . For my own part I would as soon be descended from that heroic little monkey, who braved his dreaded enemy to save the life of his keeper, or from that old baboon, who descending from the mountains, carried away in triumph his young comrade from a crowd of astonished dogs.

This kind of evaluation of savage cultures was entirely consistent with the theories of 'primitive society' adopted by the emerging discipline of anthropology in the second half of the nineteenth century. Negatively, however, primitive society was inevitably defined in terms of qualities that were opposite and hostile to Western society as anthropologists understood it.

Nineteenth-century theories of cultural evolution usually enabled the temporary coexistence of dynamic, competing groups and earlier divergences whose developmental potential had become frozen. This was an important means by which European thinkers such as Spencer were able to make claims about the relative primitiveness of tribal

cultures. In addition, through interpretations of the archaeological evidence of ancient cultures, analogies were often made between these supposed contemporary primitives and prehistoric ones. By insidious reasoning, tribal societies were often not even credited as emerging civilizations, but as evolutionary culs-de-sac, arrested in their development at some nebulous point in the past, at once contemporary and ancient. As such, they could be viewed as the sociological 'missing link', preserved, living examples of the 'childhood of humanity'.

In Germany in the second half of the nineteenth century Haeckel enthusiastically adopted Darwin's theories. He converted Darwinism into an all-pervasive philosophy which he called Monism. His theory was popularized through his internationally read book, *The Riddle of the Universe* (1899). Haeckel's description of the evolution of the human mind illustrates perfectly the prevailing view of cultural evolution in Europe at the turn of the century:

> For the profitable construction of comparative psychology it is extremely important not to confine the critical comparison to man and the brute in general, but to put side by side the innumerable gradations of their mental activity. Only thus can we attain a clear knowledge of the long scale of psychic development which runs unbroken from the lowest, unicellular forms of life up to mammals, and to man at their head. But even within the limits of our own race such gradations are very noticeable, and the ramifications of the 'psychic ancestral tree' are very numerous. The psychic difference between the crudest savage of the lowest grade and the most perfect specimen of the highest civilization is colossal – much greater than is commonly supposed. By due appreciation of this fact, especially in the latter half of the [nineteenth] century, the 'anthropology of the uncivilized races' has received a strong support, and comparative ethnography has come to be considered extremely important for psychological purposes.

Haeckel describes the savage intellect as fundamentally primitive, placing the possible achievements of tribal peoples far below those of modern Europeans, and closer to animals in a state of nature. Yet, it is possible to see Haeckel's fixing of the savage in 'nature' as a gesture of envy as much as of racist arrogance. It may be hard to believe that the man who wrote the previous words could also dream of discarding 'the conventionalities and unnaturalness of the civilized ... [and] surrounded by a simple uncultured people, I might hope to form an

idea of the imaginary paradisal civilization of our primitive ancestors' (*India and Ceylon*, 1883).

THE SAVAGE MIND

By the turn of the century the belief that the vision of the savage was somehow *pre-rational* or childlike had passed into popular thought. This is particularly clear in the once influential idea of the French ethnologist Lucien Lévy-Bruhl (1857–1939) that tribal peoples live in a state of 'primitivity'. They are distinguished, he argued, by a psychology (*mentalité primitive*) that is different in kind – and inferior – to that of civilized people, and which is determined by confusion and participation. The French Structural Anthropologist Claude Lévi-Strauss, for his part, later rejected the value judgment inherent in this characterization and placed primitive thought alongside that of the civilized in qualitative terms, but thereby reaffirmed the idea of a distinct and different 'savage mind' (*la pensée sauvage*).

Beliefs about 'primitivity' that are consonant with, though usually more sympathetic than those of Lévy-Bruhl, can be readily found in writing on primitive art throughout the first half of the twentieth century when artistic Primitivism was at its most pronounced (as well as, sadly, sometimes even today). Much writing on artistic Primitivism deals exclusively with Western responses to tribal cultures and specifically with artistic insights gained through the experience of primitive art. This position already contains, however unwitting it may be, a significant assumption – that the primitive is a recognizable category containing a large number of extra-European cultural groups united by a shared social organization and/or psychological state. This argument does not, however, bear close scrutiny.

In the first half of the twentieth century parallels were often drawn uncritically between the world-view of the savage and that of the child, and contemporary primitive society was compared to that of Europe's Stone Age ancestry. But, as the writer and ethnologist Leonhard Adam, who is representative of popular opinion during this period, put it:

> Here we come to an important distinction between European children's art and the art of primitive adults. The primitiveness of children's art is a transitory phenomenon in the life of the individual, a mere stage in his development, and in complete contrast to the primitiveness conditioned by an entire culture of which it forms a part.

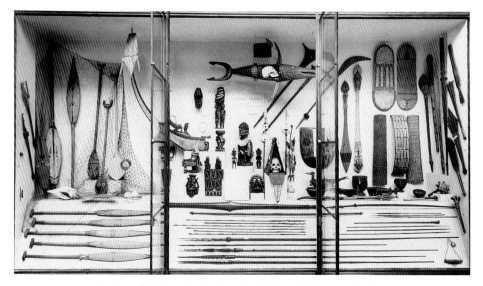

5 Section of Melanesian displays in the British Museum, London *c.* 1952

The continued comparisons made between the art of children and 'tribal' peoples would seem to suggest that the yardstick against which levels of primitiveness were measured at the beginning of the twentieth century in anthropological thought (and until after the Second World War in more popular writing on primitive art) was not so much prehistoric man or the living savage, but the European child. Not surprisingly, the Primitivist attraction to childhood (of the individual or of humanity) is an important factor in much modern painting and sculpture, perhaps most famously in the work of Klee, and after the Second World War, the French artist Jean Dubuffet and some members of the largely Expressionist CoBrA group (Copenhagen, Brussels and Amsterdam), such as the Dutch painter Karel Appel and the Danish painter Asger Jorn.

The tendency to type the savage or tribal as eternally childlike lies behind the fact that attempts have until very recently rarely been made to establish or to provide dates of production – or even acquisition – for primitive art. Implicit here is a belief that objects 6 made relatively recently, such as the Brighton Ibo mask (collected between 1905 and 1910, but probably dating from the late nineteenth

century) are probably little different to lost objects of greater antiquity. Viewed as the material culture of long-standing traditions, primitive art is thus cast as static and isolated from history. Intimate contact with the West is a relatively recent phenomenon for most so-called primitive societies, making it hard to imagine how such an opinion could be supported other than through the theoretical models of Social Darwinism. The effect of eradicating history is further emphasized when writers identify the primitive exclusively with tribal cultures, rejecting even the so-called Court Civilizations of Egypt, Mesoamerica and Benin (Nigeria), which are seen as historically remote and therefore extinct.

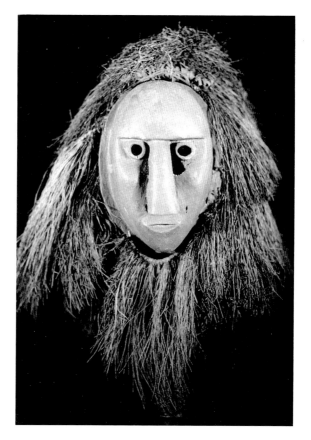

6 Ibo mask from Nigeria.
Collected 1905–10

From at least the sixteenth century contact with other cultures and greater knowledge about Europe's own past increasingly provided an outlet for discontent with contemporary society among many European artists. This is what the American writers Arthur Lovejoy and George Boas called 'Cultural Primitivism' in their book *Primitivism and Related Ideas in Antiquity* (1935) which broke new ground. They defined it as, 'the discontent of the civilized with civilization, or with some conspicuous and characteristic feature of it. It is the belief of men living in a highly evolved and complex cultural condition that a life far simpler and less sophisticated in some or all respects is a more desirable life.'

For the French artist Jacques-Louis David at the end of the eighteenth century this idea meant rejecting what he saw as the insipid and over-refined qualities of recent French painting and attempting to return to the 'purity' of Greek art. However, throughout the following century this feeling of discontent meant that interest in more exotic cultures grew and with it the tendency to make use of objects produced by them; at first making itself felt in a fascination with the civilizations of the Far East – as can be seen, for example, in the influence of Japanese prints in much Impressionist painting and Art Nouveau design – and subsequently in the so-called tribal cultures of Africa, Oceania and North America.

The discontent of the Primitivist is characterized to varying degrees by nostalgia. The Primitivist will not judge the ideal state of the world to be in the present (for in this case there can only be cultural contentment) – it will either be located in the past, or in the future, where it takes the form of a Utopian dream of a 'return' to some previous state of grace. In other words, for the Primitivist the primitive state itself has to be valued as a regrettable loss, rather than as a mere starting-point.

Cultural primitivism should, therefore, be regarded as the category under which all other primitivist manifestations are gathered. Given its importance, it is worth remembering that the civilized standard to which Lovejoy and Boas refer is itself relative and prone to shifting definitions. The cultural discontent that characterizes Primitivism in modern art must be positioned specifically in relation to the dominant ideas operating in the West in the first half of the twentieth century, represented by materialism in politics and science, and positivism in philosophy.

Artists and critics alike used the word primitive in their writings during the period from around 1900 to the First World War, but it is unlikely that it referred to tribal cultures at this time, for whom the term savage was more usual. The issue is clouded by the fact that the word primitive commonly refers in art history to artists who have been traditionally regarded as the harbingers of a new art – providing both a break with past tradition and the foundations on which a new one might develop. The term is general in its reference, but has often been used to describe the progressive early Italian masters, such as Cimabue, Giotto and Masaccio in the fourteenth and fifteenth centuries – artists who have traditionally been seen as the originators of an artistic development that reached a state of perfection in the High Renaissance styles of Raphael and Michelangelo at the beginning of the sixteenth century.

The common tendency to see the history of art in terms of a series of organic developments from birth through maturity to decay is particularly evident in the ideas of artists such as the Expressionist Blue Rider group in Munich around 1911. They considered themselves to be primitives of a new art and to be part of a loosely defined, radical European Post-Impressionist tradition that rejected nineteenth-century Realism and also included such artists as Cézanne, Gauguin, the Fauves and Picasso. The interest shown by these and other artists in various aspects of the primitive, both within and without the West, are not to be confused with this specifically art-historical definition of the word.

However, it is no coincidence that an interest in alternative traditions and cultures often went hand in hand with artists' Messianic desire to deliver a new beginning to a Europe they perceived as old and spent. One of the Blue Rider artists, Franz Marc, writing with reference to the Byzantine era, set the tone for the Primitivism of the first half of the twentieth century when he declared:

> We are standing today at the turning point of two long epochs, similar to the state of the world fifteen hundred years ago, when there was also a transitional period without art and religion. . . . The first works of a new era are tremendously difficult to define. . . . But just the fact that they *do exist* and appear in many places today . . . makes us certain that they are the first signs of the coming new epoch – they are the signal fires for the pathfinders.

As we shall see in the next chapter, following the lead of such artists as Gauguin in the last decade of the nineteenth century, modern artists often looked first to Europe for 'primitive' sources to provide lessons that promised the possibility of revitalizing Western art and culture. Sometimes they looked back to the apparently less complex culture of the European Middle Ages. At other times they sought the primitive in contemporary groups of people, especially peasants and children, who seemed to them to represent, in their customs and attitude to life, a 'survival' of this more primitive historical past.

Primitives Within

In the previous chapter we saw how nineteenth-century models of human biology were brought to bear on a wide variety of cultures that were subsequently characterized under the all-embracing term, primitive. At the heart of these theories was the child, whose observed stages of physical and psychological development were used as a gauge to measure comparative levels of cultural complexity in groups ranging from the presumed savages of Africa, America and Oceania to Europe's peasant population. When the same argument was extended to early twentieth-century models of disease the concept of the primitive came to include neurotics, schizophrenics, criminals and sexual deviants, whose 'conditions' were commonly understood as degenerative – a sort of twisted return to primitive states.

Moreover, at a time when women were discovering a voice in society – for example, in the suffragette movement – they were subjected more furiously than ever before to scientific scrutiny by their male contemporaries. It was usual to conceive of the entire female population in terms of its differences to the male and to address 'the woman problem' in a language which often echoed that employed when speaking of the savage.

The second half of the nineteenth century in Europe witnessed a tendency among progressive artists and writers to turn the focus of their attention away from academic 'high' art to the folk production of rural populations. Whereas the former was now regarded, in the Expressionist painter, Emil Nolde's words, as 'over-bred, pale, and decadent', the latter came to represent all that was simple, pure and without pretension or artifice. Thus, the arts and crafts of European peasants took their place beside other primitive forms, such as the art of Japan, ancient Egypt, Indonesia and fifteenth-century Europe.

In 1891 the French writer Octave Mirbeau evoked the 'splendour of barbarism, of the catholic liturgy, of Hindu dreams, [and] Gothic imagery' in an article on Gauguin, so producing an image of artistic eclecticism which represents the styles and practices of a Symbolist generation who are now collected under the umbrella of Art

23

Nouveau. The strand that, it was argued, drew these disparate elements together was the search for clarity and simplicity in art and life.

Maurice Denis, the French artist and critic, claimed in 1909 that artists of his and Gauguin's generation turned to the primitives of Europe and Africa precisely because they found Japanese prints (which had been so important to the Impressionists) too complex and knowing. Naive simplicity was sought instead in 'oriental idols, Breton calvaries, *images d'Epinal*, figures from tapestry and stained glass'. The distinct medievalism of the pan-European interest in tapestry, stained glass and cheap wood engravings indicates a common belief among artists that Western culture before the sixteenth century had been essentially popular. It was thought that during the Middle Ages in northern Europe the arts had not yet oriented themselves into categories of 'high' and 'low'. Many writers have claimed that the aesthetic that occurred throughout Europe at the end of the nineteenth century was one of the major enabling factors in the discovery of African and Oceanic art at the beginning of the twentieth.

For many progressive artists folk arts and crafts assumed importance both as art and, perhaps more disturbingly in the light of events in Europe with the rise of Fascism throughout the 1930s, as a symbol of the distinct racial character of a region's past. Thus, on the one hand artists such as Denis, and the German artists Fritz Mackensen and Nolde emphasized the physical, moral and religious superiority of the indigenous peasant populations of their respective homelands, and on the other they raised images of the strong peasant against stereotypes of the weak and effete urban dweller. To be sure this has much to do with a romantic primitivism that claims ascendancy for the countryside – symbolic of nature – over a demonized, unnatural city, exemplified in Nolde's landscapes and in Expressionist poetry such as Georg Heym's *Der Gott der Stadt* (1912). However, it must also be seen in terms of a deep-seated reactionary distaste for cosmopolitanism among many avant-garde artists throughout Europe and the United States, which was fuelled by Social-Darwinian beliefs in the catastrophic results of miscegenation on the 'national stock'.

THE NOBLE PEASANT

The French painter Gauguin is the most famous example of the modern artist who sought out what he believed to be 'primitive'

places and peoples outside Europe, not as a tourist, but by attempting to become involved in the 'primitive' way of life, at first in the Caribbean and later in the South Seas – in Tahiti and the Marquesas Islands. Even at the end of his life, when he was in a state of profound disillusionment, Gauguin continued to argue for the superiority of 'primitive' peoples and to proclaim: 'I am a savage'. However, his search for the primordial did not begin in the South Seas, but in France itself – in the areas around Pont-Aven and Le Pouldu in Brittany. Artists had been drawn to this region during the summer months since the mid-nineteenth century from as far afield as Finland, Switzerland and the United States, often in search of a more primitive landscape and people than those of the increasingly industrialized suburbs of Paris. The experience of foreign painters in Pont-Aven had, in fact, been a direct factor in the establishment of artists' colonies in coastal towns and villages in such places as Newlyn and St Ives in England, and Magnolia and Provincetown in Massachusetts in the late nineteenth century.

The work of French academic artists working in Pont-Aven, such as Pascal Dagnan-Bouveret, contains earlier images of the noble peasant by the Barbizon painter Jean-François Millet and the French Realist painter Gustave Courbet which have been transported to Brittany and recast as relics of a past lost to much of the rest of France. It is commonplace today, though, to emphasize that the elements of Brittany represented by progressive artists and by their academic counterparts was essentially a fiction. By the time Gauguin travelled to Pont-Aven in the mid-1880s, for example, it had become a thriving tourist resort within easy reach of Paris. In addition, the economy of this part of Brittany was not based as in myth on peasant farming, but was a successful and highly developed agricultural economy. Even this would have been considered relatively primitive in comparison with the industrialization sweeping across most of Europe at the time.

The 'traditional' local dress and customs that are prominent in late nineteenth-century representations of Brittany remain even today part of the tourist's experience. Yet, it has now been established by Fred Orton and Griselda Pollock in 'Les Données Bretonnantes' (1980) that the variations on Breton costume depicted in paintings by Gauguin and the Pont-Aven school postdated the French Revolution. This was not a reminder of the region's Celtic past, but a nineteenth-century development; the costume was – and still is – worn on public occasions and 'came to signify region, locality, class, wealth and marital status within a nouveau-riche peasantry'. Similarly, although

25

many old Breton customs and festivals survived the Revolution, they came increasingly to be regarded as part of the tourist spectacle.

The myth of a primitive Brittany remains, despite revelations of a more complex actuality. There is a tendency within us all to frame the unknown in terms of our own experiences and beliefs, and both artists and tourists were more likely to 'discover' the Brittany of their expectations than to see the region in its own terms. Thus, in 1888 Gauguin was able to write: 'I love Brittany; here I find a savage, primitive quality. When my clogs echo on this granite ground, I hear the dull, muted, powerful sound I am looking for in painting.' It was, however, not just the surroundings that impressed him – Gauguin felt at times that he had found a model for living in the perceived simple lifestyle of the Breton peasants: 'I am at the seaside in a fisherman's inn near a village [Le Pouldu] that has a hundred and fifty inhabitants; there I live like a peasant, and am known as a savage.'

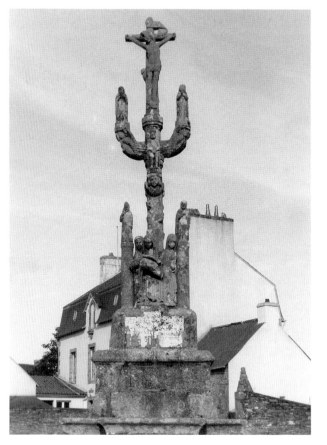

7 Calvary from Nizon, Brittany. Sixteenth century

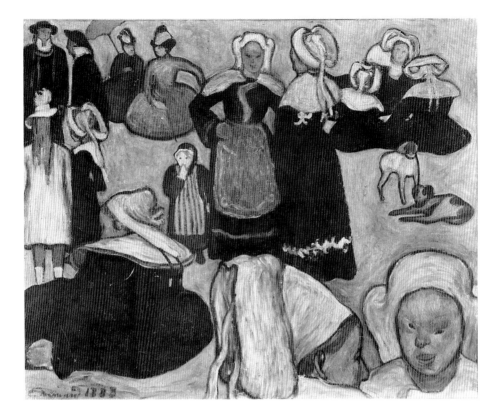

8 Emile Bernard *Breton Women at a Pardon* 1888

The tendency to see Brittany in terms of one's expectations is evident through comparisons made between the practice of contemporary academic and progressive artists. The illusionism both of Dagnan-Bouveret's picture of Breton peasants in traditional costume, *Breton Pardon* (1886) and of Lucien Lévy-Dhurmer's *Our Lady of Penmarc'h* (1896), for example, is brought to bear on the same kind of Primitivist subject matter as is the decorative symbolism of Emile Bernard's *Breton Women at a Pardon* (1888) and Armand Séguin's 8 zincograph, *Toads* (1895). The striking difference, though, lies in the fact that whereas the Bretonism of the former complies with Parisian academic standards of technique and style, in the work of such artists as Bernard, Denis, Gauguin, Séguin and Paul Sérusier style is partly determined by the formal characteristics of the 'primitive' arts and crafts of the subjects of their pictures. It is the works' pronounced

primitive appearance, effected through the synthesis of subject matter and style, that contemporary critics saw as evidence of the progressive nature of the art of these men.

10 Gauguin's Primitivism in his Breton work made around 1888–89 testifies to the complexity of his response to his surroundings. In *Breton Calvary – Green Christ* (1889), for example, the pietà from the base of the calvary at Nizon, near Pont-Aven, is transported to the coast at Le Pouldu – the whole composition is touched by the simplicity of the naive carving (as well as Bernard's 'cloisonnist' style). The scale of the calvary is enlarged and it is brought into contact with the Breton soil, implicating the peasant woman and her goat in the Holy group, and thereby extending the sense of religiosity to the landscape and its inhabitants.

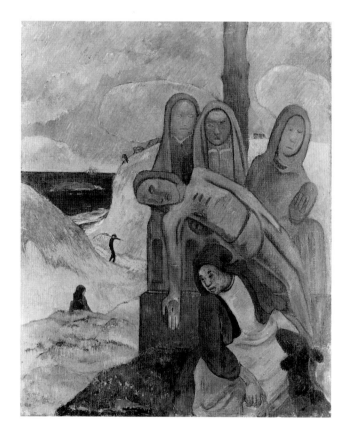

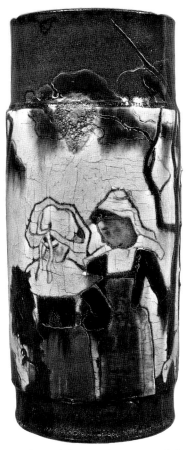

9 *(opposite)* Paul Gauguin *Breton Calvary – Green Christ* 1889

10 *(right)* Paul Gauguin *Vase with Breton Girls* 1886–87

Western artistic interest in peasant crafts and decoration around the turn of the century is related to the Art Nouveau quest for unity of style in everything from the fine arts to all aspects of design and architecture. Pioneers of Art Nouveau such as William Morris and Henry van de Velde placed tremendous importance on the harmonization of art and design practice. They believed that a universal art meant universal prosperity and that this was to be achieved through a desire to synthesize art and life in ways that utilized modern techniques, while emulating the culture of the peasantry and the medieval guild system. For Morris, in particular, this meant rejecting the luxury and ostentation that was characteristic of the environments of the rich and returning to what he regarded as democratic simplicity and functionality in all areas of design. However, like others,

especially in Munich and Vienna, Morris's new Utopia was to be furnished not by harnessing the machine through mass production but by reforming handicrafts.

Art Nouveau styles are characterized by the integration of various artistic disciplines – for instance, furniture and utensils assume something of the form of sculpture and painting, while the autonomy of painting and sculpture is rejected in favour of their decorative functions in an architectural context. This accords perfectly with artists' experience of peasant dwellings in Brittany and throughout Europe, in which every object seemed worthy of decoration, and so the whole was unified – from cupboards and benches to door panels, crockery and plant pots. Many of the painters of the school of Pont-Aven were inspired to try their hands at such work, often creating objects that were a strange synthesis of the rustic and the cosmopolitan.

From around 1910, in addition to the straightforward treatment of architectural commissions as opportunities to create total works of art, a new generation of artists in Germany, Britain, Russia and the United States created decorative environments in which to live and work. We shall address what is probably the most extreme manifestation of this tendency in Chapter three when we see how the German Expressionist Brücke group decorated their studios in Dresden and Berlin in a way that owed much more to the decorative styles of certain non-European 'primitives' than to indigenous peasant practices. Even in Munich, among the rather less ostentatiously Bohemian artists associated with the Blue Rider group, attempts were made to 'go native'. For example, during his extended stays in the Bavarian town of Murnau the Russian painter Wassily Kandinsky copied the clothing and customs of the peasantry, extending these images to the home he shared with the German artist Gabriele Münter. This is recorded in paintings such as Münter's *Kandinsky and Erma Bossi at the Table* (1912). The couple filled the rooms with folk crafts executed in naive styles, including Russian ceramics, *lubok* prints (popular woodcuts), and Bavarian glass paintings. Kandinsky decorated the furniture and staircase in a folk-art style.

In self-imposed exile in Switzerland after the First World War the former Brücke artist Ernst Ludwig Kirchner chose to make his permanent home among the peasants of Frauenkirch rather than with the professional people and tourists in the nearby resort of Davos. He continued to pursue his cosmopolitan existence vicariously through voracious reading and visits from friends. From the start he set about

creating an environment that he regarded as being organic – an extension of nature. In 1919 he began to fill his home with anthropomorphic carvings ranging from furniture, such as the great *Adam and Eve Chair* and *Bed for Erna* (both of which are visible in paintings such as *The Living Room: Interior with Painter*, 1923), to small decorated boxes and trays. The adornment even extended to bedclothes and tablecloths, which were woven or embroidered with Kirchner's own designs (often in collaboration with the weaver Lise Gujer) in a style that is influenced by folk art and Coptic textiles. Thus, Kirchner eradicated divisions between art and craft. 17

It was the Bloomsbury group of artists, writers and intellectuals, and particularly those, such as Duncan Grant and Vanessa Bell, involved in Roger Fry's Omega Workshops who responded most pertinently in the twentieth century in Britain to *fin de siècle* calls to bring art and life into harmony. Lacking the democratic idealism of Morris's Arts and Crafts movement, Fry and his colleagues produced decorations for the social élite, yet their designs were based on the assumption of the moral superiority of peasant handicrafts and they were all obviously handmade. As Fry himself said in 1915, the Omega Workshops 'try to keep the spontaneous freshness of primitive or peasant work while satisfying the needs and expressing the feelings of modern cultivated man'. Interior design commissions had been integral to Omega's work, but the underlying Bohemian and markedly anti-Victorian nature of the group was to find its most distinctive outlet in Charleston, the house in Sussex occupied by Grant and Bell from the end of 1916. Its interior decoration grew organically – filling the house with furniture, textiles and pottery made by Grant, Bell and their friends.

THE ESCAPE INTO NATURE

The move to the Sussex countryside by Grant and Bell and Münter and Kandinsky's love of Murnau should be seen as part of the same tendency to seek out 'the good and simple life', which led so many artists to Pont-Aven. By the end of the nineteenth century a large number of rural artists' communities had been formed throughout Europe and the north-eastern seaboard of the United States. Some of the most well known are, besides those already mentioned, Worpswede near Bremen, Neu-Dachau near Munich, Skagen in Denmark and Abramtsevo in Russia. In Germany alone there were over 18 artists' groups working in rural areas at the turn of the century. This

cult of 'the going away' was inspired in part by the relatively cheap
cost of living in rural areas, but it was also fired by the 'contemporary
European obsession with the myth of the rural peasant as a figure of
great moral worth, uncorrupted by the sophistication and materia-
lism of the modern world' (Gill Perry, 'Primitivism and the
"Modern"'). Yet, this 'escape' into nature from urban, industrial
centres need not be regarded as wholly reactionary – the idea of
removing oneself temporarily from 'civilization' often stemmed
from the Primitivist assumption that revitalization of culture could
only spring from a period of regression to more direct modes of
living.

The ideologies that underpinned the artists' community at
Worpswede in Germany, established in the 1890s, were characterized
by the rejection of cosmopolitanism and the espousal of Romantic
beliefs that spiritual integrity and national purity were to be found
only in the countryside and among its inhabitants. By the end of the
nineteenth century, a large body of pseudo-scientific theory had
grown around the supposed moral and physical superiority of a
'Germanic' peasantry (*Volk*) which stretched across Europe from the
Netherlands to Poland and the Baltic states. The anti-democratic and
racist presuppositions of much of this theory are best exemplified in
the activities of the Monist League, founded in Jena by Haeckel and in

11 Fritz Mackensen *Prayers in the Moor* 1895

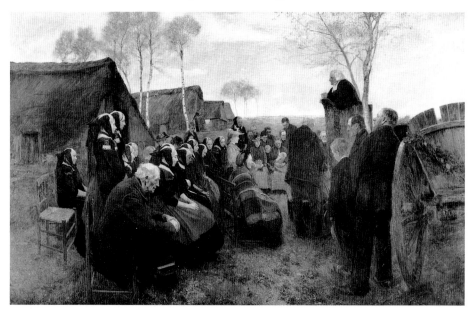

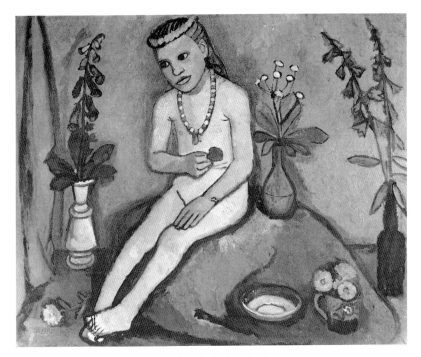

12 Paula Modersohn-Becker *Seated Nude Girl with Flowers* 1907

Julius Langbehn's book, *Rembrandt as Educator* (1890), which used the historical figure of Rembrandt as a vehicle for an argument wholeheartedly devoted to establishing the *Volkish* basis for German nationalism.

Although the Worpswede group shared J.-J. Rousseau's belief in the superiority of the 'natural man', it was as varied in its political outlook as it was in the painterly styles embraced by individuals. The latter ranged from a stern Realism inspired by Gustave Courbet's work from the mid-nineteenth century and Germany's sombre version of Impressionism, as exemplified in the work of Fritz Mackensen and Otto Modersohn, to the Art Nouveau works of others, such as Heinrich Vogeler and the sculptor Bernhard Hoetger. Despite the rather insular views of most of Worpswede's founder-members, later an Expressionist style emerged in the work of Hoetger, Georg Tappert and, not insignificantly, that of Modersohn's

33

wife, Paula Modersohn-Becker. Yet, despite the visual disparity
11 between images such as Mackensen's 'realist' *Prayers in the Moor*
12 (1895) and Modersohn-Becker's *Seated Nude Girl with Flowers* (1907),
which indicates a familiarity with contemporary artistic develop-
ments in France, both can be regarded as original and radical in the
context of the German art world, which was dominated at this time
by the authoritarian and reactionary attitudes of the Wilhelmine state.

A number of other artists sought out remote European locations;
for instance, Erich Heckel, Karl Schmidt-Rottluff and Max Pechstein,
members of the Brücke group, made trips to the coastal villages of
Dangast and Nidden. However, their visits were relatively solitary –
often partly inspired by a desire to practise nudism away from the
watchful eye of the authorities. While they argued a sense of
fellowship with the indigenous communities, these artists made no
attempt to settle or to share the life of the inhabitants. Pechstein
provides an almost perverse example of this by his frequent summer
sojourns in the remote fishing village of Nidden. On the one hand he
claimed to find a clear vision of the primitive in the people and
landscape, but on the other, and despite the difficulty posed by the
actual journey from Berlin, the works that resulted from his stays
there are not significantly different in feeling from those produced by
Pechstein and his Brücke colleagues in more easily accessible and less
savage environments, such as the Moritzburg ponds near Dresden and
the Baltic island of Fehmarn.

The bathing trips of the Brücke artists, particularly while based in
Dresden (1905–11), must be juxtaposed against the wider context of
contemporary German culture, which was well endowed with
several 'back to nature' movements, ranging from the Cosmics, the
Monist League and the various pseudo-philosophical systems erected
around the philosopher Friedrich Nietzsche's vitalism, to the German
Youth and Life-reform movements, vegetarianism and nudism.
Dresden, besides being an important artistic centre, provided a
particularly rich source for such tendencies. Heinrich Pudor, a major
advocate of nudism, had established himself on the Bohemian
intellectual outskirts of Dresden in the 1890s and the Brücke 'would
have had ample opportunity to become acquainted with the local
nudist movement promoted by Pudor who, in 1906, listed eleven
establishments in the Dresden area practising nudism' (Jill Lloyd,
German Expressionism: Primitivism and Modernity). These included Dr
Heinrich Lahmann's famous sanatorium at Weisser Hirsch, which
was visited by sometime Brücke member Nolde and his wife in the

34

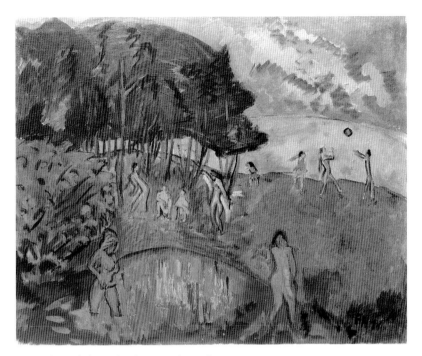

13 Erich Heckel *People Playing with a Ball* 1911

period 1907–10, and Heinrich Bilz's *Luft-Bad*. Bilz was a friend of Karl May, who wrote adventure stories, and both lived close to the Moritzburg ponds frequented by the Brücke during their summer bathing trips.

In the pictures of bathers by Heckel, Kirchner and Pechstein that arose from the Brücke's own practice of nudism the viewer is presented with self-reflexive images of the urban dweller celebrating his or her body in a setting that is seemingly closer to nature. These images are invariably of people who have undressed and cannot be misconstrued as Arcadian scenes of timeless innocence, although some notion of innocence, in the sense of liberation from bourgeois social convention, is implied. In Heckel's *Bathers in the Reeds* (1909 or 1910) and *People Playing with a Ball* (1911), or Pechstein's *The Black and Yellow Bathing Suit* (1910), for example, men and women conduct themselves with little more than a passing acknowledgment of the

13

spectator. Yet, perhaps surprisingly, the viewer is not cast in the role of voyeur – in Heckel's work especially, pictorial devices such as a crowded foreground, the cutting of important figures at the edge of the canvas and a shallow picture space invite rather than exclude the observer.

In Kirchner's depictions of bathers in particular the lack of the figures' self-consciousness allows for a reading that is more sympathetic – for traditionally they would be placed in a body of modernist art in which the male artist pursues the idea of his sexual and cultural domination over the female. The argument that Brücke bathing scenes are evidence of an early twentieth-century tendency to equate woman and nature is an over-simplification. In Kirchner's *Nudes Playing Under a Tree* (1910) and *Bathers at Moritzburg* (1909, overpainted in 1926), for example, females and males not only appear equally naked, but just as at home in their surroundings. The sex of the two men in his coloured woodcut, *Bathers Throwing Reeds* (1909) is clearly marked, but in all other respects they attain that same anonymity and fusion with nature as their female companions.

14 Ernst Ludwig Kirchner *Bathers Throwing Reeds* 1909

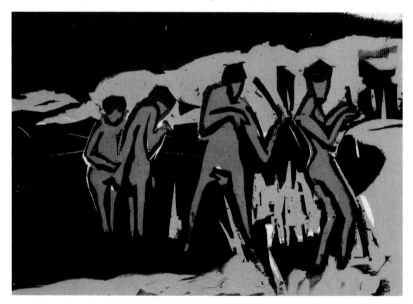

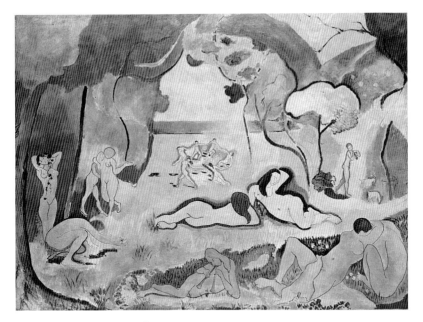

15 Henri Matisse *The Joy of Living* 1905–6

There is a sense of the way in which these images differ to ostensibly similar modern pictures, which is brought into sharp relief through a comparison of Kirchner's *Bathers at Moritzburg* and Matisse's *The Joy of Living* (1905–6). The overwhelming concern in the latter is, in fact, the creation of a vision of a Golden Age. Matisse's fragile, decorative nudes are removed from life into the timeless realm of high art by their Classical nudity, by the pipes they play and by the drapery that is laid tastefully across the pubic area of the woman in the foreground. Matisse's idyll can be compared to works by the French Symbolist painter Pierre-Cécile Puvis de Chavannes or even to paintings by the seventeenth-century French artist Nicolas Poussin, but *Bathers at Moritzburg* is totally different in its conception. In this painting the figures are offered emphatically to the viewer as modern Europeans bathing naked – rather than appealing to some 'lost' age, Kirchner implies the natural ideal through the prevailing cult of naturism.

15

37

It is tempting here to invoke Kirchner's favourite poet, the American Walt Whitman, whose *Leaves of Grass* (first edition 1855) proclaims its intent from the outset: 'The Female equally with the Male I sing.' The most eloquent statement of this is the artist's own 1912 Fehmarn painting, *Striding into the Sea* (1912), where the two main protagonists are differentiated only by the two sexual markers of penis and breasts. The shapes used to delineate their taut, gothic forms are not only echoed in each body, but also in the waves, dunes, lighthouse and sky. The bathing pictures are images of communion, not only with nature, but also between human beings.

THE AESTHETICS OF INNOCENCE: THE BLUE RIDER

The cult of nature that characterizes much of the Brücke's work is based on a belief in the relative innocence of the body in its 'natural', that is, unclothed, state. The act of undressing symbolized, for these artists, the removal of the complex social masks imposed by modern urban culture. However, all the modern Primitivists active before the First World War, from Gauguin to Picasso, also sought innocent, unspoiled views of the world in the art of 'primitive' groups, ranging from tribal and Far Eastern peoples to European peasants and children.

This is most clearly evident in the 1912 almanac edited by Kandinsky and Marc, *The Blue Rider*. From the start Kandinsky had conceived of the book as a showcase for the best of the new art in Europe. Essays were to be written not by critics but by artists and supported visually by the juxtaposition of a wide variety of art which was thought to share similar qualities to that of the modern West. Thus, alongside illustrations of works by French, German and Russian avant-garde artists, exemplified in the work of Picasso, Robert Delaunay, Kandinsky, Marc and Natalia Goncharova there are examples of 'savage' and Oriental art. It is, however, most of all Europe's own primitives, represented by medieval art, folk prints and glass paintings, and by naive artists' pictures and children's drawings which reflect the artistic claims made by the almanac. By presenting the visual material on equal terms Kandinsky and Marc achieved a levelling of the relative values of these objects, which in turn allowed audacious comparisons to be made – for instance, that the child's drawing is equal to a Picasso and that the naive artist Henri Rousseau and the Baroque master El Greco (1541–1614) are companions on the same spiritual journey.

38

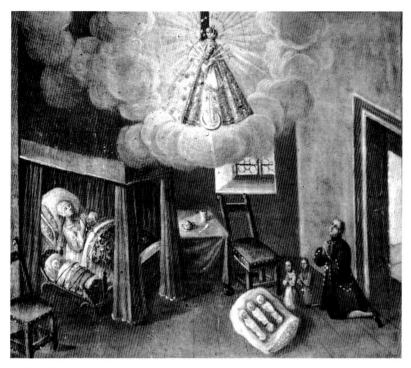

16 Bavarian votive painting

The artists associated with the Blue Rider recruited the primitive as a means of addressing the complexities of the modern world in terms that lay outside the post-Renaissance tradition. In his lyrical, anti-rationalistic essay 'Masks' from *The Blue Rider*, Auguste Macke, the German artist, makes analogies between objects and phenomena from the realms of art, nature and technology: 'The Egyptian Sphinx and the beauty spot stuck on the pretty cheek of a Parisian cocotte . . . the whirring of propellers and the neighing of horses, the cheers of a cavalry attack and the war paint of Indians. . . . Incomprehensible ideas express themselves in comprehensible forms.' Such a montage of images, with so many types of information, could be seen to exemplify the modern world, in which technological advances had made more information available to more people than at any other

time in history. Macke seems aware of this: 'In our complicated and confused era we have forms that absolutely enthral everyone in exactly the same way that the fire dance enthrals the African or the mysterious drumming of the fakir enthrals the Indian.... At the movies the professor marvels alongside the servant girl.' The choice of the cinema shows great astuteness, for it is in the early cinema that a levelling of the distinction between high and low culture occurs for the first time in post-Renaissance Europe – in film the most complicated means of representation are used to convey simple ideas in a direct and dramatic way.

Kandinsky was quick to point out the multiplicity of artistic styles contained in *The Blue Rider*. In his essay, 'On the Question of Form', he argued that style is in itself relative and reliant upon the contingencies of factors such as personality and nationality, and that connections must be sought instead in the 'spiritual' content of these forms – in a reality beyond objective appearances. And this can only be achieved when one creates freely from an 'inner necessity', utilizing any of and all the means at one's disposal. In Kandinsky's view it is the untrained, naive artist who keeps alive this spontaneous and expressive perception through even the most materialistic epochs: 'If a man without academic training, free of objective artistic knowledge paints something, he never produces an empty sham ... the works produced are not dead, but living.'

Nevertheless, when one looks closely at the illustrations published in the almanac one is struck not so much by their difference, but by a formal similarity – they are linked by the folk art much cherished by Marc, Kandinsky and their Munich colleagues, such as Macke, Münter and Alexei von Jawlensky. The tribal pieces, for example, have none of the formal distortion of the Kota reliquary figures and Grebo masks available in Paris, and a Sri Lankan 'disease mask' illustrated in *The Blue Rider* has formal elements which accord with the Russian *lubki* (folk prints) in the almanac. The criteria used when choosing the modern works, too, appear to reflect the same simplicity of means and lyricism as was found in the folk works; most evident in the case of Cézanne, who is represented here mainly by early paintings such as *Autumn* and *Winter* (1859–62), rather than the Post-Impressionist works on which his fame rests.

Not surprisingly, two of the moderns who are accorded great praise by Kandinsky in his essay are not painters by profession. For him the value of the work of the composer Arnold Schönberg and of Rousseau lay in the very awkwardness and obsessiveness of their

21
18

19

20

40

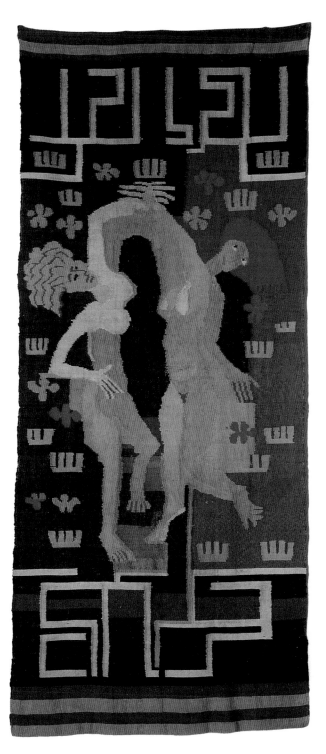

17 Ernst Ludwig Kirchner
(woven by Lise Gujer) *Two
Dancers* 1924

18 Gabriele Münter *Still Life with St George* 1911

19 Russian folk print

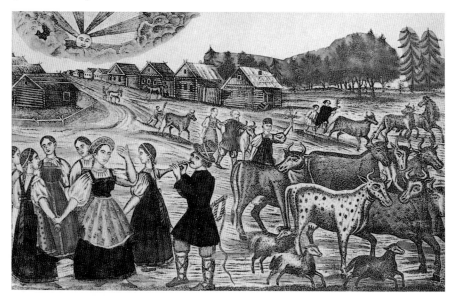

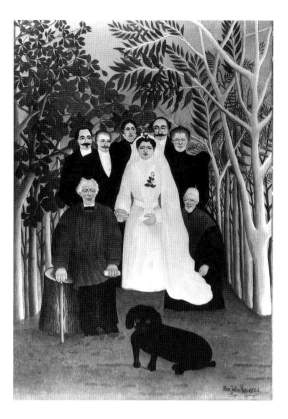

20 Henri Rousseau *The Wedding* 1905

forms. In their failure to achieve the technical mastery that they sought, they failed also to be coldly objective and, in Kandinsky's opinion, thereby created works of a 'greater realism', for 'In rendering the shell of an object simply and completely, one has already separated the object from its practical meaning and pealed forth its interior sounds.'

Kandinsky's background shows a clear indication of the depth of his primitivistic involvement with folk art. Besides his interest in the peasant way of life around Murnau alluded to earlier, his early *œuvre* is replete with images drawn from Russian folklore and religion, executed in a style that owes as much to Russian icons and *lubki* as it does to the Munich version of Art Nouveau (*Jugendstil*) – underlining the strong connection between Russian art and the Bavarian capital at this time.

More significantly, perhaps, it is now well known that much of this imagery is included in Kandinsky's 'abstract' work. For example, in a

43

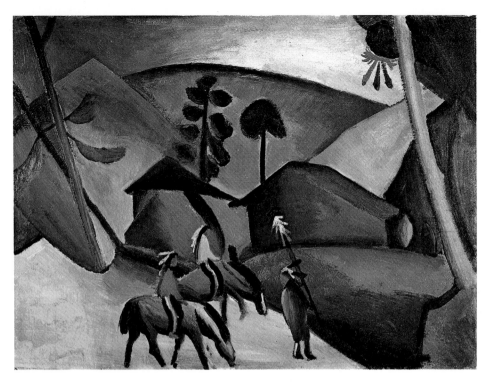

21 Auguste Macke *Indians on Horseback* 1911

22 glass painting, *All Saints I* (1911), he mimics the forms and technique
of traditional Bavarian religious work, such as that of the contempor-
ary glass painter Heinrich Rambold, who was known to the Blue
Rider artists. However, Kandinsky uses the medium to explore the
expressive possibilities of a repertoire of chiliastic imagery more
common in Russian prints, in which angels, saints (many of them
recognizably Russian) and the crucified Christ threaten to merge with
an enveloping landscape. This process seems almost complete in his
27 tumultuous, apocalyptic 'heroic abstractions', such as *Small Pleasures*
(1913) and *Improvisation: Gorge* (1914). In many cases the concealed
imagery of the final piece can be uncovered by looking at Kandinsky's
25 more figurative preparatory sketches, for instance, in *Picture with a*
White Border (1913). Earlier drawings, watercolours and even oil
sketches alert the viewer to the presence of a serpent, of the Bavarian
Alps and of the figure of St George driving his lance through a many-

44

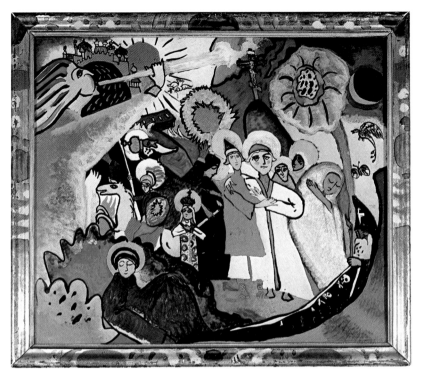

22 Wassily Kandinsky *All Saints I* 1911

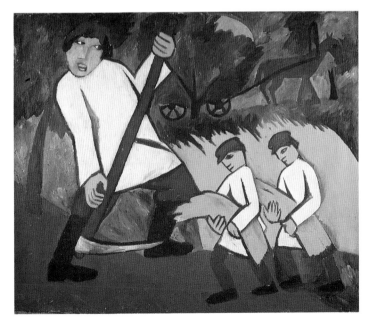

23 Natalia Goncharova *Haycutting* 1910

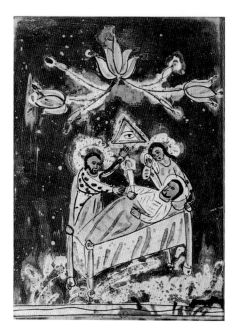

24 *Death of a Saint*, glass painting from Bavaria. After 1800

headed dragon. This can be traced ultimately to a Russian folk ceramic which was in Kandinsky's possession and was reproduced in *The Blue Rider Almanac*.

NEO-PRIMITIVISM IN RUSSIA

During his time in Munich, Kandinsky remained in contact with the Russian art world and some of its leading avant-gardists, such as Mikhail Larionov and the Burliuk brothers, were invited to participate in the Blue Rider project in 1911 and 1912. Similarly to their counterparts in Munich they shared an interest in the development of an independent modernist style through a synthesis of new developments in Paris, and indigenous folk and religious traditions. By the end of 1909 a Neo-Primitivist school had emerged in Moscow led by Larionov and his partner, Goncharova. The couple obviously had a cosmopolitan lifestyle and taste, but they professed a dislike for their urban environment. This is shown in their work, which is often characterized by peasant subjects and, in Larionov's case, by caricatures of provincial life, for instance, *The Hairdresser* and *Walk in a Provincial Town*.

25 (left) Wassily Kandinsky Study for *Picture with a White Border* 1913

26 (above) Wassily Kandinsky in his home at Ainmillerstrasse 36, Munich, 24 June 1911

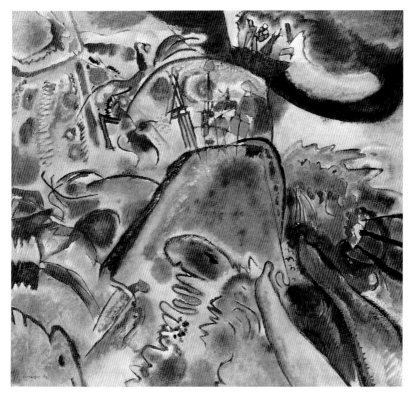

27 Wassily Kandinsky *Small Pleasures* 1913

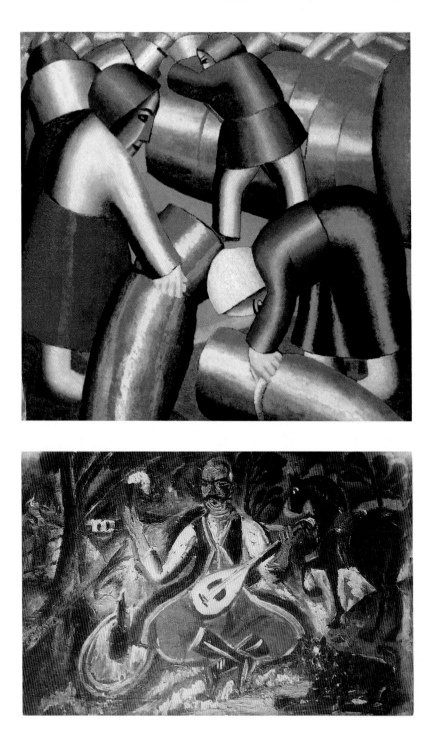

28 *(left)* Kasimir Malevich *Painterly Realism. Boy with Knapsack – Color Masses in the Fourth Dimension* 1915

29 *(opposite, above)* Kasimir Malevich *Taking in the Harvest* 1911

30 *(opposite, below)* David Burliuk *My Cossack Ancestor* c. 1908

Neo-Primitivist works such as Goncharova's *Haycutting* (1910) and Larionov's *The Baker* (c. 1910) both emphasize directness and simplicity as does French Post-Impressionist work. As with Gauguin and the Symbolist group, the Nabis, the Neo-Primitivists turned to primitive forms as a means of strengthening their modernist credentials. But where the former drew their inspiration from stained glass, Breton calvaries and *images d'Epinal*, the latter turned, in the words of the Russian painter Aleksandr Shevchenko (in 'Neoprimitivism', 1913), to 'icons, *lubki*, trays, signboards, fabrics of the East'. The simplified forms and ornate colour of icon paintings appropriated fairly directly in Goncharova's *Flight into Egypt* (1908–9) and in her earlier works contrast with the formal simplification and expressive distortion of works such as *Fishing* (1910) and *Dancing Peasants* (1911) which is thoroughly modern.

Similarly, in early Cubo-Futurist works by Kasimir Malevich and Vladimir Tatlin, both of whom were heavily indebted to the work of

23

28

49

Larionov and Goncharova, popular Russian forms were synthesized with French sources, such as Matisse's Fauvism and a wide range of Cubist manifestations, including the work of Fernand Léger. The latter's influence is evident in Malevich's *Taking in the Harvest* (1911) with its metallic, cylindrical forms. Malevich's depiction of peasants at work, however, owes more to the concerns of much nineteenth-century Realism than it does to the generally more urbane outlook of the Cubists and Italian Futurists. As Malevich later claimed: 'Goncharova and I worked more on the peasant level. Every work of ours had a content which, although expressed in primitive form, revealed a social concern.'

The interest in socially engaged subject matter might also be conceived in nationalistic terms. As with other European artists at this time, many Russian artists struggled to release themselves from the stranglehold of Parisian taste by creating an art that, though partly reliant on French precedents, supposedly reflected their distinct national and racial identity. This was attempted most clearly by a declared rejection of the West. Thus, in 1913 Shevchenko wrote: 'Neoprimitivism is a profoundly national phenomenon. . . . Yes, we are Asia, and are proud of this, because "Asia is the cradle of nations", a good half of our blood is Tartar, and we hail the East to come, the source and cradle of all culture, of all arts.' It is partly in this context that we should read Goncharova's *Fishing* and Malevich's *Peasants in Church* (1910–11), as well as images that draw on a particular racial past, such as David Burliuk's *My Cossack Ancestor* (c. 1908).

GRAFFITI

Another less obviously primitive influence, but still primitive nonetheless, can be discerned in Larionov's pictures of soldiers, which were probably painted between 1910 and 1911. In these works there is an interest in graffiti as well as in more traditional folk sources. This is evident not only in actual depictions of graffiti in *Soldiers* (1911), but also in the crude construction and seemingly amateurish draughtsmanship of the painting. Once again a relationship between primitive source and subject is implied. Larionov regarded the soldier, like the prostitute, as someone who is not subject to over elaborate social convention, and whose rude manners and direct speech represent the stripping of these social accretions. The pictures' construction, with graffiti and salacious epithets, corresponds to the earthy and therefore more direct and 'real' personalities of Larionov's subject matter.

31 Mikhail Larionov *Soldiers* 1911

Throughout much of the modern movement in art the nineteenth-century Symbolist interest in caricature was extended to lavatorial scrawlings which began to be regarded by some as the authentic, primitive expression of urban man. Perhaps encouraged by the literary circles in which he moved in the first years of the twentieth century, Picasso experimented with caricature. The results are often influenced as much by graffiti as by popular illustrated magazines – this is most obvious in a crude pornographic drawing from 1905, *Obliging Woman*. Similarly, graffiti are an important and potent 32 primitive source in the German painter George Grosz's most bitingly acidic drawings after 1914, which lay bare the terrible vulnerabilities of Berlin society. The effect on the viewer is equally strong in both the aggressive tumult of works such as *Pandemonium* (1914) and *The Golddigger* (1916), and the spare, almost childlike whimsy that often depicts the most awful subjects, as is the case in *Murder* (1916). 33

51

32 *(above, left)* Pablo Picasso
Obliging Woman 1905

33 *(above, right)* George Grosz
Murder 1916

34 Jean Dubuffet *'Il tient la flûte
et le couteau'* 1947

Nowhere is an interest in the styles and physicality of graffiti more apparent than in certain works by Jean Dubuffet, such as *Portrait of Jean Paulhan* (1946) and '*Il tient la flûte et le couteau*' (1947). In images of this sort the artist seems to attack the painted surface with the aggression of one scoring marks into a wall. 34

If the production of graffiti could be understood as a sort of psychological safety valve – a relatively harmless release of socially unacceptable desires – then the drawings of the insane, often similar in form, were commonly regarded as symptoms of mental diseases that placed their producers firmly outside what was considered to be normal society. This group of 'outsiders' was often literally removed from the community and isolated in mental institutions. The compulsive nature of the creative outpourings of the insane, perhaps not surprisingly, led a number of artists and psychologists to develop interests in these works which they believed paralleled those of other notionally primitive groups.

Klee's interest in the art of the insane began before the First World War, but it is in his works produced between around 1918 and 1925 (that is, after the artist's meeting with the psychiatrist and art historian

35 Paul Klee *Portrait of a Mad Person* 1925

Hans Prinzhorn, whose pivotal book, *Artistry of the Mentally Ill* was published in 1922) that it is most clearly evident. In *Oppressed Little Gentlemen* (1919) and *Portrait of a Mad Person* (1925), for example, the obsessive, 'primitive' mark-making of drawings by schizophrenics is reclaimed, through Klee's complex, ironic intellect, as a means of presenting direct images of outsiders themselves. The creative potential of madness, mediated particularly through the writings of Sigmund Freud and Prinzhorn, was a key factor in much Surrealist art of the 1920s and 1930s, but it was in the work of Dubuffet after 1942 that the earlier interests of Klee were translated into a high art style that more closely approached the brutal immediacy of much insane production.

35

THE DISCOVERY OF CHILD ART

The undermining of the socialization process implied in acts of graffiti or in the drawings of the insane still implies adult acts of renunciation or social rejection. In view of this it now seems inevitable that the

36 Paul Klee *Child as Hermit* 1920

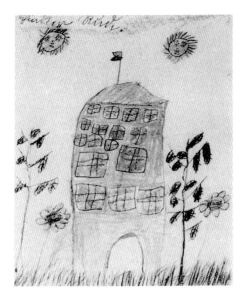
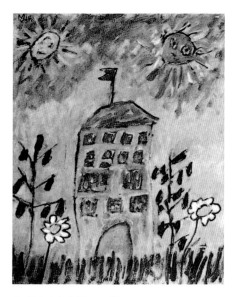

37 Child's drawing of a house 38 Gabriele Münter *House* 1914

modernist search for a European form of artistic expression untainted
by convention should have settled upon the child. The redesignation
of children's drawings as art is part of the same late nineteenth-century
Symbolist effort to discover authentic modes of expression which
fuelled serious artistic interest in craft and non-European art. Indeed,
one of those largely responsible for bringing child art into the gallery,
the Austrian educational reformer Franz Cizek, was closely linked to
the progressive artists of the Vienna Secession.

The drawings by children that were illustrated in *The Blue Rider* are
realistic in intent, though naive in execution, and on these stylistic
grounds it can be surmised that they were probably produced by
children aged between about eleven and thirteen. The works are
striking in their formal similarities not to tribal art, but to pictures
reproduced in the almanac by Rousseau, Schönberg and peasants. The
Blue Rider artist most closely associated with the influence of child
art, Klee, drew an explicit analogy between the art of children,
primitive peoples and his colleagues in a review of the first Blue Rider
exhibition in 1911:

These [Blue Rider pictures] are primitive beginnings in art, such as one usually finds in ethnographic collections or at home in one's nursery. Do not laugh, reader! Children also have artistic ability, and there is wisdom in their having it! The more helpless they are, the more instructive are the examples they furnish us; and they must be preserved free from corruption from an early age. Parallel phenomena are provided by works of the mentally diseased; neither childish behaviour nor madness are insulting words here, as they commonly are. All this is to be taken very seriously . . . when it comes to reforming today's art.

Such sentiments became something of a touchstone for many progressive artists until well after mid-century, as was evidenced in the work of Klee in the 1920s and 1930s and in others, such as Joan Miro, Dubuffet, Enrico Baj and Karel Appel. In *Child as Hermit* (1920), for example, Klee reveals the intensity of one's childhood feelings through subtle manipulation of a childlike graphic style. In the case of artists such as Dubuffet, who came later to the art of children, visual subtlety is characteristically abandoned in the cause of directness of expression. In such images as *Mother and Child* (1956), therefore, Dubuffet gives us a reworking of the Christian theme of the Virgin and Child through a brutalist reconstruction of the methods of a very young child. In 1933 the British critic Herbert Read claimed that modern art had seen 'a deliberate attempt to reach back to the naivety and fresh simplicity of the childlike outlook', and he is entirely representative of his times in arguing that 'We can learn more of the essential nature of art from its earliest manifestations on primitive man (and in children) than from its intellectual elaboration in great periods of culture.'

Kandinsky's stated aim in collecting images for the *Blue Rider* in 1911 had been simply that the works should have been formed through an 'inner necessity', rather than that they be 'primitive'. Nevertheless, his views on the nature and 'spiritual' value of children's drawings are articulated along the same theoretical line as those regarding other primitives. He claims, for example, that 'the child is indifferent to practical meaning since he looks at everything with fresh eyes, and he still has the natural ability to absorb the thing as such. . . . Without exception, in each child's drawing the inner sound of the subject is revealed automatically.' For Kandinsky, then, while the child is working he or she is unconsciously concerned with 'internals', revealing the 'inner life' of forms: 'There is an enormous

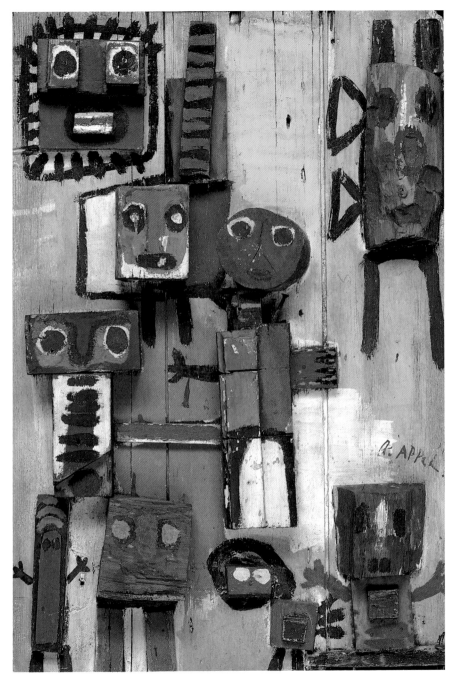

39 Karel Appel *Questioning Children* 1949

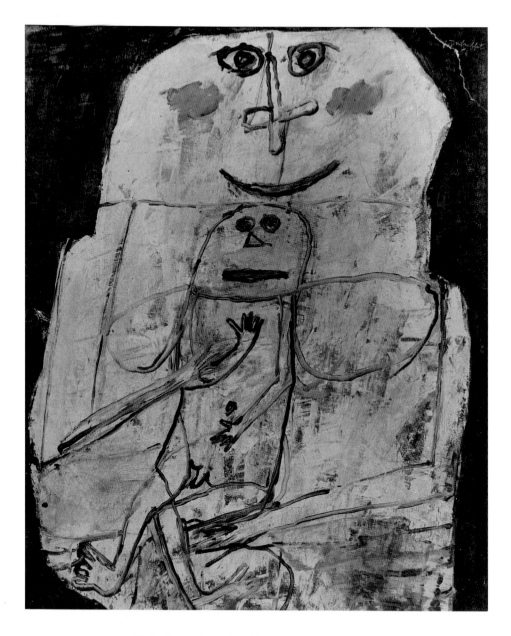

40 Jean Dubuffet *Mother and Child* 1956

unconscious power in the child that expresses itself [in his drawings] and that raises his work to the level of adults' work – sometimes even higher!' On the other hand, he says: 'An academically trained person . . . excels in learning practical meanings and losing the ability to hear his inner sound. He produces a "correct" drawing that is dead.' It is perhaps unsurprising, though, to find such artists as Klee, Jawlensky and Münter occasionally reverting to the academic practice of copying from child art as a means of learning. Two glass paintings by Klee from 1905, *Girl with a Doll* and *Paul and Fritz*, were intended to resemble children's drawings in their flatness and crude technique, although they clearly bear the stamp of the artist's ironic humour. More remarkable in its faithfulness to a child's original is Münter's *House* (1914). Yet, we should not overlook the fact that in choosing to 37, 38 transpose the child's drawing in the medium of oil paint, she makes a claim for the seriousness and important status of her source.

THE EUROPEAN BODY AS PRIMITIVE

Primitivism invariably contains within it some form of the myth of the artist as an outsider. It is argued that because artists operate at the edges of society, their vision assumes a degree of objectivity which allows them to scrutinize and to judge. Thus, although partly informed by a desire to represent non-European types, the general intentions that lie behind Primitivism in modern art appear more often to be motivated by a will to create a picture of Europe's own 'Others' – that is, members of those groups that, similarly to the artist, deviate in some way from the cultural and social standards set by Western civilization. These include not only peasants, gypsies, children and the insane, but other 'outsiders', such as prostitutes, criminals, and circus and variety performers.

Many modern life subjects bring into play conventional early twentieth-century beliefs about the fundamental difference between the features of primitive and civilized peoples as an integral part of the representation. This extends much further than differences in skin colour or hair types to facial and other body features, notably those relating to primary and secondary sex characteristics in both men and women. Thus, the bodies of white Europeans are often rendered strange not only by employing an anti-academic, modernist style, but also through the use of elements of supposedly primitive body types. In this way conventional ideas about the primitive are used as a means of challenging Europe's image of itself.

41 Ernst Ludwig Kirchner *Fränzi in Front of a Carved Chair* 1910

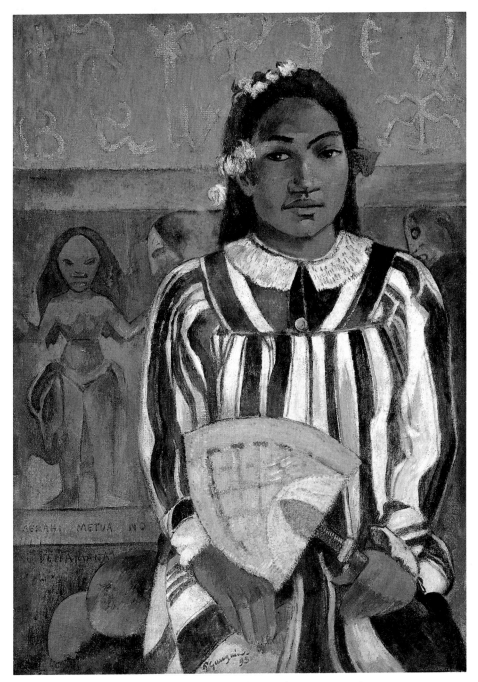

42 Paul Gauguin *Merahi Metua No Tehamana (Tehamana has many parents)* 1892

In the early twentieth century the 'normal' woman was regarded in biological terms to be altogether more primitive than her male counterpart. A large body of theory purporting to deal with the 'woman problem', though invariably written by men, was generated, notably *Woman* (1885) by Hermann Ploss and *Studies in the Psychology of Sex* (1903) by Havelock Ellis. Both men dealt with what they saw as normal and deviant female types, for example, the mother and innocent child, as opposed to the prostitute and the sexually precocious child. Similarly, by drawing comparative material from a wide range of cultural sources they implied a racial commonality between civilized and primitive women that was never argued for the European male. In biological terms the female body was deemed to be less specialized and women were generally typed as being essentially instinctive as opposed to rational thinkers. This conveniently situated them in a position closer to nature and so in this way the generic woman was defined, silenced and contained in male discourses of culture in precisely the same way as the savage. It is no coincidence, for example, that Pechstein's image of female fecundity should be entitled *Early Morning* (1911). The curving form of the apparently pregnant, exoticized woman is echoed in the arching sweep of the primordial landscape, suggesting that here creation can be understood simultaneously as a literal dawn, the dawn of time and as the promise of new life. Similarly, Marc's *Red Woman* (1912) is made continuous with the nature she inhabits through her colour and the tattooed curves of her body, which are reflected in the landscape.

43

44

The 'normal' woman was supposed to become sexually aware only at the moment of menarche, but even then one of the main instruments of control employed in European culture was an insistence that modesty was not only a biologically determined and essentially feminine quality, but one that became manifest at puberty. The apparent lack of modesty in adult women was usually regarded as the result of incomplete psychological and even physical development or degeneration and, once again, the actions of the sexualized woman were compared to those of the savage and the child. This is an important part of the Primitivism in pictures such as Picasso's *Les Demoiselles d'Avignon* (1907) or Kirchner's *Nude with Painted Face* (1910), which subvert the contemporary viewer's expectations by depicting self-assured women who are not bound by the social conventions of self-conscious modesty.

61

Although women were generally regarded as, in some way, being more primitive than men in Europe in the first part of the twentieth

43 Max Pechstein *Early Morning* 1911

century, it would be a mistake to describe all modernist represen-
tations of women in terms of Primitivism. We should instead look for
examples of Primitivism in works that appear to challenge dominant
descriptions of women and the child – these are to be found not in
supposedly archetypal images of the ideal woman as virgin or mother,
but in depictions of the women who lie outside this ideal and whose
difference is normalized through the artist's modernist style.

Fruitful examples of this can be found in works by Kirchner which
developed from a desire to equate art and life through addressing
sensuality and the experience of modern life. In his nude portraits,
such as *Girl Under a Japanese Umbrella* (1909), the model meets the
artist's gaze and confronts him at the same physical level. In this work
the close proximity of the artist outside the picture to the represented
model, together with the sexual poses of the background studio
decorations, indicate their other roles as lovers. Distortions and the
blurring of form can be seen in terms of the optical effects of their
physical closeness and it is significant that the visual impact of the
painting is very different when viewed close to. It is unsettling not

44 Franz Marc *Red Woman* 1912

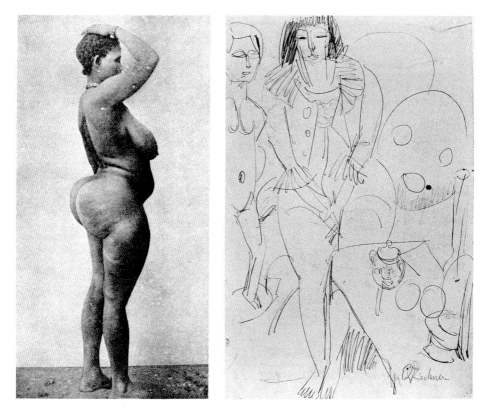

45 *(left)* Hottentot woman with steatopygia and crural obesity

46 *(right)* Ernst Ludwig Kirchner *Erna in a Short Jacket with Wooden Figure* 1912

because of the violence of Kirchner's formal distortions, but because the artist freely offers to the viewer an image of female sexuality and sensual intimacy.

 Kirchner's Primitivism is also subtly manifested in his pictorial use of a physical condition that had come to be seen as a specific sign of the primitive sexuality of African women, namely steatopygia – 45 protruding buttocks. In Kirchner's depictions of black models, such as *Negro Couple* (1911) and *Three Negro Nudes* (1911), the supposed 69 hypersexuality of the women is indicated not by the sexual act, but by the shape of their bodies. Significantly, in, for instance, *Interior with Nudes* (1910), *Nude in Tub* (1911) and *Two Nudes in a Room* (1914) Kirchner emphasized the proportions of thighs and buttocks in

images of white Europeans in precisely the same way, often implying a more pronounced steatopygia than in his images of blacks. His use of conventional signs of primitivity should be read in the context of his perception of these women's own relative liberation from the constraints that early twentieth-century European society placed upon the display of sexuality. This is cleverly indicated in the related

46 drawing (*Erna in a Short Jacket*) for *Seated Woman with Wood Sculpture* (1912) in which the active sexuality of the woman is sublimated in the features of the pseudo-primitive sculpture at her side.

A number of Primitivist images of young girls, usually referred to as Fränzi and Marzella, also appear in the work of Kirchner and other members of the Brücke between 1910 and 1911. The girls are always abstracted from their real context as urban, lower-class children and they are depicted as playing out other roles within the pseudo-primitive surroundings of the Brücke studios or the Moritzburg ponds. Usually the children's gaze engages directly with the spectator – an act that can be seen in early twentieth-century terms to be either innocent or sexually charged. However, in pictures such as Heckel's

47, 41 *Standing Child* (1910) and Kirchner's *Fränzi in Front of a Carved Chair* (1910) the subject is apparently fully sexually aware. In the latter work the child is dressed in fashionable adult clothes and she sits on a carved chair with a flat, anthropomorphic backrest. There are obvious tensions between areas of relatively naturalistic colour and the unreal green colour of Fränzi's face, but this should not be read as a mask, for this is a picture in which certain masks are removed.

The original inspiration of *Fränzi in Front of a Carved Chair* may well have been Gauguin's 1892 portrait of his thirteen-year-old

42 Tahitian mistress, *Merahi Metua No Tehamana (Tehamana has many parents)*, but the content of the two paintings is very different. Despite living in Tahiti, Gauguin's picture is really a fictional representation showing his fantasy of the stereotypical Tahitian savage. Gauguin fabricates Tehamana's incomplete Westernization by juxtaposing the Christian part of her, embodied in her European 'Sunday best', with the presence of pre-Christian superstition, symbolized by the idol and early writing behind her. Kirchner inverts Gauguin's image of the exotic as Fränzi, despite her arbitrarily coloured face, is physically a European urban child. However, her stiff bodice and the extreme frontality of her pose give her an iconic quality that isolates her from the rest of the picture and concentrates the viewer's gaze on her oversized red lips, which function as a powerful indication of her sexuality. This is reinforced by the manufactured exoticism of the

47 Erich Heckel *Standing Child*
1910

This is an image of Fränzi in front of the same studio mural that is in Kirchner's *Negro Couple* (1911). Here the urban child appears to be part of nature, a creature from a savage, primordial world. Contemporary beliefs in the psychologically 'primitive' state of woman are reinforced through the symbol of the sexualized female child. The Primitivism of the piece is further emphasized by Heckel's harsh use of the woodcut medium.

pseudo-primitive chair and wall-hanging, which act as vital-erotic symbols of the natural, that is, in this case, the sexually uninhibited.

The attempt to throw off the restraints of cultural convention can be seen as a characteristic common to most artistic developments in the twentieth century. Nevertheless, we should only view such attempts in terms of Primitivism when the ideal that is raised against convention consists of a desire to rediscover less complex ways of living, or a yearning for the natural. Nature, in this sense, was synonymous with the primitive – embracing a complex set of ideas, ranging from visions of the primordial landscape to the part of the human mind which was untouched by the learning process that one underwent in the 'civilized' West. In the first part of the twentieth century it was usually argued that European women and children were closer to nature and, therefore, more primitive than men. But, modern Primitivists turned this received wisdom on its head. True, they continued to see women and children as more natural beings, but they raised this up as an ideal to which all, whether male or female, should aspire. The broad ranging search for the primitive that, as we shall see in the next chapter, took modern artists far beyond the boundaries of Europe, should be viewed against the background of this idealization of the feminine and the childlike.

Savage Exoticism

THE DISTANT BODY

In the previous chapter we saw how modern European artists' dissatisfaction with their own culture led to a desire to discover simpler, more 'natural' alternatives in Western groups – such as children, peasants and the insane – who were perceived as closer to primitive states of being. In their admiration for primitive ways of life, artists throughout Europe and the United States established colonies in rural areas within their own countries, where they hoped to absorb something of the primitive world-view. However, the search for the primitive is equated to some extent with a search for the unknown and it might reasonably follow that although the peasant – the primitive close by – offered the promise of the unknown to modern artists, he was found, ultimately, to contain too much of the culture that the Primitivist wanted to escape. Thus, since the sixteenth century, if not before, the European yearning for the simple life has often meant turning outwards to 'tribal' peoples – first in South America, and subsequently in Africa, Oceania and North America.

The idea of the 'savage' demonstrably living in, or close to, a state of nature can be traced back at least to the French writer Montaigne's famous description of the people of Brazil in 'On Cannibals' (1580):

> This is a nation ... in which there is no kind of commerce, no knowledge of letters, no science of numbers, no title of magistrate or of political superior ... no divisions of property, only leisurely occupations, no respect for any kinship but the common ties, no clothes, no agriculture, no metals, no use of corn or wine. The very words denoting lying, treason, deceit, greed, envy, slander, and forgiveness have never been heard.

The absence of domestication and institutions of learning characteristic, according to Montaigne, of the civilized nation, are counteracted by the absence of the vices of civilization. Thus, he says: 'I do not believe, from what I have been told about these people, that there is anything barbarous or savage about them.'

Montaigne's 'cannibals' were people of the New World, but the image of 'the noble savage', which later took hold most strongly in the popular mind (during the eighteenth century), was that of the inhabitants of Oceania. The voyages to the South Seas of the explorers Louis-Antoine de Bougainville and Captain James Cook brought back to Europe descriptions of islanders whose existence was apparently carefree and idyllic. If Montaigne was able to ruminate upon the fact that his 'cannibals' were the descendants of the lost people of Atlantis, then for some of the first European explorers of the South Seas, here was to be found the remains of the biblical Garden of Eden. Of the Tahitians, for example, Bougainville wrote: 'I never saw men better made.' And of their way of life: 'One would think himself in the Elysian fields. . . . Everyone gathers fruit from the first tree he meets with, or takes some in any house he enters. . . . Everywhere we found hospitality, ease, innocent joy, and every appearance of human happiness among them.'

It was precisely this image of an earthly paradise that drew Gauguin to Tahiti at the end of the nineteenth century when, spurred on by his experience of the colonial pavilions at the Paris *Exposition Universelle* of 1889, he decided to leave France in search of the primitive. Gauguin first planned to go to Africa and in letters to Bernard, written in mid-1890, he voiced his dreams about the island of Madagascar:

> Life [there] doesn't cost a thing for a person who wants to live like the natives. Hunting suffices to supply you easily with food. Consequently, if I can close a deal, I am going to . . . live free and create art. [. . .] Out there, having a woman is compulsory, so to speak, which will give me a model every day. And I guarantee you that a Madagascan woman has just as much heart as any Frenchwoman and is far less calculating.

Even before setting out for the tropics Gauguin gives an insight into the futility of his quest – at the end of the same year he told the French painter Odilon Redon: 'Madagascar is too near the civilized world; I shall go [instead] to Tahiti.'

The disillusionment that Gauguin discovered from his reading was reconfirmed in his experience of Oceania, where his attempts to lead the life of a savage were hampered by what he considered to be the corrupting influences of civilization, embodied in the colonial administration of the islands and the resulting destruction of indigenous culture and religion. He also found himself physically unprepared for primitive life. On arriving in Tahiti in June 1891,

69

48 Paul Gauguin *The Man with the Axe* 1891

Gauguin had professed himself saddened to have found what he perceived as the ruins of Bougainville's Utopia: 'It was all over – nothing but civilized people left.... To have travelled so far only to find the very thing from which I had fled! The dream which led me to Tahiti was cruelly contradicted by the present: it was the Tahiti of times past that I loved.' Moreover, as he wrote in 1893 in his account of his first stay in Tahiti, *Noa Noa*:

> The food is there, certainly, on the trees, on the mountain slopes, in the sea, but one has to climb a high tree, to go up the mountain and come back laden with heavy burdens; to be able to catch fish [or] dive and tear from the sea-bottom the shells firmly attached to the rocks. So there I was, a civilized man, for the time being definitely inferior to the savage.

70

49 Paul Gauguin *Nave Nave Moe (Fragrant Water)* 1894

It is, however, a mark of his dogged Primitivism that he continued in his attempt to 'go native' by living outside the colonial towns and by moving ever outwards, away from Europe. In 1901, two years before his death, he decided to go to the Marquesas Islands where, he said: 'there is still some cannibalism. I think that there, the altogether wild element, the complete solitude will give me a last burst of enthusiasm which will rejuvenate my imagination.'

Despite the obvious hardship endured by Gauguin in the South Seas, the paintings he sent home to France were almost without exception images of noble savages living in harmony with a fertile and bountiful nature. In pictures such as *Eaha oe feii (What, Are You Jealous?)* (1892) and *Te Nave Nave Fenua (Fragrant Earth)* (1892) the traditional depiction of the female nude is transformed into a doubly powerful image for his Parisian audience of a generalized exotic 'Woman' in a fully feminized world. With crude evolutionist

71

reasoning Gauguin extended this feminization to the Tahitian males, referring to the 'androgynous aspect of the savage' of both sexes as owing to their presumed underdeveloped state of physiological specialization. This accounts for the similarity of the male and female figures in *The Man with the Axe* (1891) and serves as the artist's justification to himself for the homosexual fantasy related in *Noa Noa*: 'His lithe animal body had graceful contours, he walked in front of me sexless.... I had a sort of presentiment of [sexual] crime.'

Gauguin's representation of Tahiti – through his pictures and in *Noa Noa* – consisted mainly of an attempt to reconstruct imaginatively a lost time before the European discovery of the island. Paintings such as *Nave Nave Moe (Fragrant Water)* (1894) offer an Edenic glimpse of this past and evoke a knowledge of an ancient religion that antedates Christianity itself. The artist claimed a connection with Tahitian history through his young *vahine* (female partner), Tehamana who, he said, related stories of the old ways to him at night – this link is made in visual terms through Gauguin's juxtaposition of contemporary photographs of *Tahitiennes* and images of their gods in his manuscript copy of *Noa Noa*. In spite of this Tahiti was in 1890, in fact, a place that had broken almost entirely with its old religion and Gauguin's source of information was not the Tahitian people, but accounts first published by European travellers a century earlier. The stories recounted by Gauguin in *Noa Noa* are, as the art historian Nicholas Wadley points out, lifted verbatim from a book published in Paris in 1837. That Gauguin's unspoilt Tahiti is a fiction is further demonstrated by comparing two almost identical pictures painted within a year of each other: *Two Tahitian Women on the Beach* (1891) and *Parau Api (Women on the Beach)* (1892). The former is like a piece of ethnographic reportage, for while the girl on the left in both pictures wears 'native' dress, in this one, the figure on the right wears shapeless missionary garb (though significantly the cloth for both was made in France for export to the colonies). In the latter picture manifest references to Westernized costume are completely excised.

Shortly after his death in 1903 Gauguin's life assumed almost heroic status in the eyes of many artists – most notably those associated with the German Expressionist groups the Brücke and the Blue Rider. If Gauguin's admiration of the primitive way of life was marked by a realization of its 'otherness' and of his need to renounce civilization, Pechstein – whose journey to the Palau Islands in 1914 was clearly modelled on Gauguin's stay in Tahiti – admitted to no such problem: 'I felt the most wonderful unity around me, and I breathed it in with

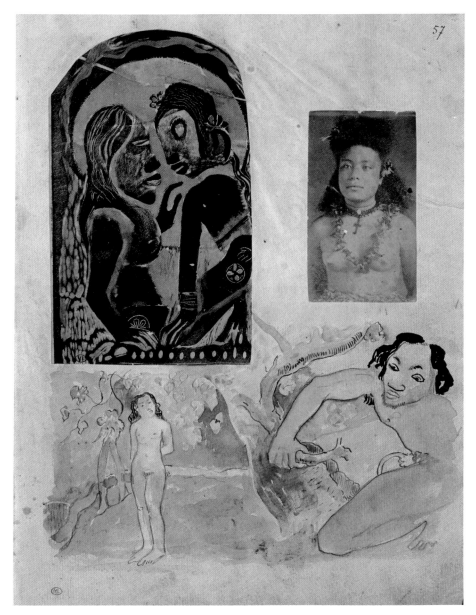

50 Paul Gauguin. Page 57 from the Louvre manuscript of *Noa Noa*, with a woodcut of
Hina and Tefatou from *Te Atua*, photograph of Tahitian girl and a watercolour 1894

an unbounded feeling of happiness.' On the whole, though, modern artists had no real desire to 'go native' – their aim was instead to present the primitive as a mirror to their notion of modernity, that is, to reinvigorate, rather than to destroy Western society by confronting it with its deepest memories. Pechstein, for example, proclaims the possibility of adapting easily to the way of life because of his empathy with primitive peoples without actually identifying himself as a primitive.

While it is true that Pechstein and Nolde (who had been a member of the Brücke briefly between 1906 and 1907) went on trips to the South Seas shortly before the outbreak of the First World War, actual journeys were by no means a prerequisite for the realization of the kind of Primitivist styles and subject matter that are inspired by Gauguin's Tahitian work. This is particularly true of the Brücke artists, Heckel, Kirchner *and* Pechstein, partly because of their work that resulted not from exotic travelling, but from summer bathing trips to Moritzburg, near Dresden, and the German coast between 1909 and 1914, as well as in pictures set in their studios in Dresden and later Berlin which, from around the end of 1909, had been extensively decorated in a 'primitive' manner.

59
68, 75

PICTURING THE EXOTIC

Images of 'otherness' are central to Primitivism and representations of 'primitive' peoples, from within and without the West, abound in modern art. However, the identification of a work of art as Primitivist does not therefore mean the admission of every image whose subject matter includes 'primitive' types. We have already seen how the progressive art of Gauguin and his colleagues in Pont-Aven consisted of a synthesis of primitive subject matter and a Primitivist style that owed something to Breton folk arts and crafts, whereas that of their more conventional contemporaries, such as Dagnan-Bouveret, continued to present Breton life in the highly illusionistic styles required of academic art. The same argument can be brought to bear on Western images of non-European primitive types, such as 'the savage' and, especially in the nineteenth century, the Oriental. For this reason, it will be useful here to attempt to clarify some of the differences and similarities between Primitivism in modern art and the mainly nineteenth-century tradition of Orientalist painting.

Primitivism in modern art is predominantly about making the familiar strange or about maintaining the strangeness of unfamiliar

74

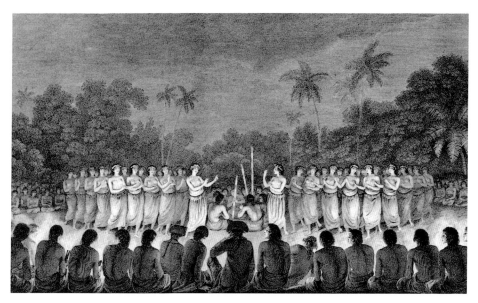

51 John Webber *A Night Dance by Women, in Hapaee* 1784

experiences as a means of questioning the received wisdom of Western culture. This contrasts with the general trend in European art since the Renaissance, which has sought to render the experience of new cultures in a visual language that contains and neutralizes the threat of the unknown by absorbing it into recognized systems of representation. It has been argued that the underlying effect of the West's contact with other cultures has always been fundamentally disruptive, not only to the pattern of existence of newly colonized peoples, but also to the fabric of Western thought and experience itself through the process of containment and incorporation. As the art historian Bernard Smith points out, Western colonialist contact was an essential factor in the rupture of neoclassical values in art at the close of the eighteenth century:

> In the challenge to neo-classical values . . . the Near East gradually undermined the authority of classical models by revealing monumental art which antedated Greece and Rome, while the Pacific drew attention to forms of art produced by people living a life more primitive and closer to nature than the Greeks and

75

52 Jean-Léon Gérôme *The Whirling Dervishes c.* 1895

Romans. It is to be remembered that in the eighteenth century much of the appeal of the Greek as opposed to the Roman was itself grounded in an enthusiasm for the simple, bare, monumental, and primitive. Johann Winckelmann, although the prophet of neo-classicism, had stimulated an interest in the origin of art by treating the arts themselves as susceptible to growth, change, and decay, and laid stress upon the climatic conditions of the area, in studying the formation and the perfection of art.

At the same time, Smith continues, 'European observers sought to come to grips with the realities of the Pacific by interpreting them in familiar terms' and in the eighteenth century this still meant measuring them by the standards of the Enlightenment and its ideas about classical antiquity. This is clear in most contemporary images of Oceanic peoples. For instance, the stylized scene depicted in John Webber's *A Night Dance by Women, in Hapaee* (1784) is reminiscent more of European theatrical conventions than any dance actually

51

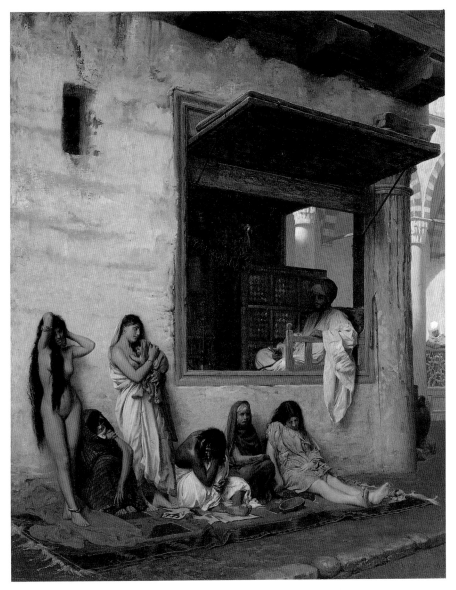

53 Jean-Léon Gérôme *Slave Market* early 1860s

witnessed on Captain Cook's voyage to the South Seas. Similarly, in Arthur Devis's painting, *Ludee, one of the Wives of Abba Thule* (1788), the wife of a Tahitian king is depicted in traditional European style in a half-length portrait format and three-quarter view pose. The woman's features conform to eighteenth-century Western notions of feminine beauty and her hair is coiffured in a European style, comparable to portraits of European women by the likes of Romney or Reynolds. Ultimately, the use of Western conventions of portraiture serves to emphasize the sense of her difference, which is explicitly stated by the artist in her implied nakedness, her dark skin – especially when compared with the exaggeratedly pale female complexions fashionable in the portraits of late eighteenth-century Europe – and most notably the tattooed patterns on her arms, which in this context are literally the mark of her savagery.

In his important book *Orientalism* (1978), the cultural critic Edward Said explores the complex set of ideas that characterize Europe's relationship with its oldest colonies in the Near and Middle East. Said defines Orientalism as 'a Western style for dominating, restructuring, and having authority over the Orient' – a programme that was justified in the eyes of post-Enlightenment culture through a value system which depicted the Oriental not only as different to the European, but as culturally, technologically, militarily and often genetically inferior. According to Said: 'Orientals were rarely seen or looked at; they were seen through, analysed not as citizens, or even people, but as problems to be solved.'

There are obvious similarities between Said's description of Orientalism and the ideas underlying definitions of the primitive. Both relate to colonialism as the arbiter of knowledge about 'subject peoples'. Similarly to the Oriental, the primitive has been allowed to speak only through the voice of his Western interpreters, for whom the world is divided between Europeans and non-Europeans. However, Said's description of the Orientalists' image of an East irredeemably alien to the West implies that Orientalism cannot be used as a means of questioning European cultural conventions in the way that Primitivism can.

Orientalist painting is traditionally identified with nineteenth-century academic art (although in fact this is not exclusively the case); that is, precisely the form of painting emphatically rejected by modern artists. Jean-Léon Gérôme is often considered the paradigmatic Orientalist painter. He is a nineteenth-century French academic artist, only fairly recently rescued from the critical wilderness of

the museum vaults. The key to his Orientalist paintings lies in the virtually photographic clarity of his technique. Images such as *The Snake Charmer* and *The Whirling Dervishes* (*c.* 1895) can, as the 52 American art historian Linda Nochlin has pointed out: 'most profitably be considered as a visual document of 19th-century colonialist ideology, an iconic distillation of the Westerner's notion of the Oriental couched in the language of a would-be transparent naturalism'. However, in these images the viewer is never 'invited to identify with the audience' – instead, a psychological distance is maintained and the Western gaze 'is meant to include both the spectacle and its spectators as objects of picturesque delectation'.

Such paintings as Gérôme's *The Whirling Dervishes* or the British Orientalist John Frederick Lewis's *The Bezestein Bazaar of El Khan Khalil, Cairo* (1872) that seemingly picture the Oriental in ethnographic terms, are haunted, however, as Nochlin says, by certain absences. One important absence from the paintings is that of the Western colonial or touristic presence, even though the presence of the white man is always implied in the artist's controlling *gaze* – 'the gaze which brings the Oriental world into being'.

Ultimately, Nochlin concludes, the supposedly objective vision of nineteenth-century Orientalist painters signifies 'taxidermy rather than ethnography'. These images have 'something of the sense of specimens stuffed and mounted within settings of irreproachable accuracy and displayed in airless cases.' It is tempting to read this passage in a broader cultural sense, as evidence of the nineteenth-century scientific desire to classify and collect 'the world'. Along with the contents of the glass cases in the ethnographic museums, or the tableaux vivants constructed for sideshows and colonial exhibitions, much of the academic painting of the nineteenth century is typified by highly illusionistic representations of human 'racial' and social types, whose precise identity is invariably supported by a carefully researched array of key cultural markers. This is true, for example, of such icons of Victorian 'modern life' painting as Ford Madox Brown's *Work* (1852–65) and Holman Hunt's *The Awakening Conscience* (1853). In both class and manners are attested to not only by physiognomy and clothing, but by a deluge of detailed marginalia, such as tools, flowers, books and items of furniture. Gérôme himself, it must be said, was not simply a painter of the Orient – his *œuvre* is replete with other subjects, not least his so-called 'troubadour' works which depict his fantasy of life in medieval Europe.

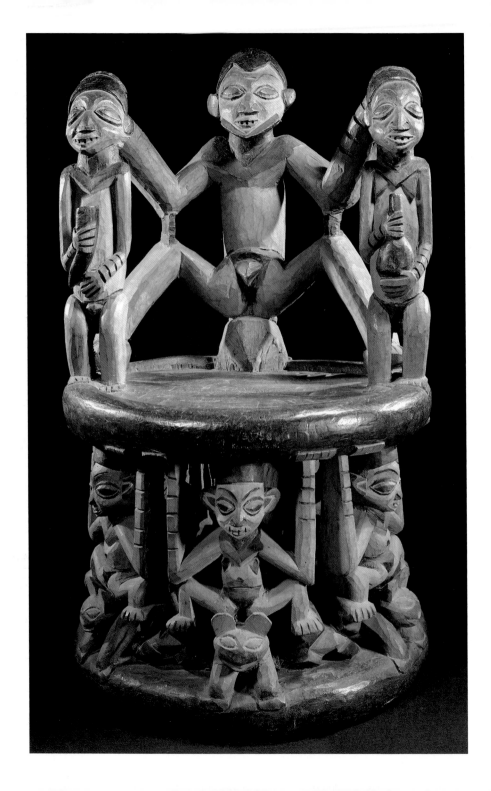

55 Max Pechstein *Palau Triptych* 1917

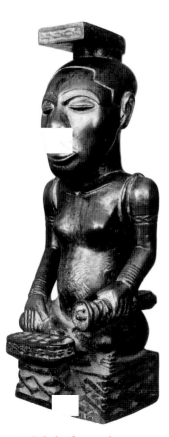

Pechstein's mature style was an eclectic mixture of Oceanic, African and modern French prototypes. The debt to Cézanne and Cubism is clear in *Still Life in Grey* in which an African chief's stool takes the part of the compotier used more in Cubist work from around 1909–10. In *Palau Triptych*, though, 'primitive' Oceanic and African sculpture transcends its identity as still-life object and is absorbed within the artist's painterly language.

56 Bakuba figure of a man squatting from Zaire

◀ 54 Cameroon chief's stool from Western Grasslands. Before 1910

57 Max Pechstein *Still Life in Grey* 1913

The supposed ethnographical accuracy of Gérôme's Orientalist paintings has an interesting parallel in the 'historical' works of Sir Lawrence Alma-Tadema, whose fame rested largely upon his pictorial reconstructions of the people and buildings of ancient Rome. Similarly to Gérôme, Alma-Tadema was scrupulous in his search for historical accuracy (he spent part of his honeymoon on the site of the excavation at Pompeii measuring the ruins and carefully inspecting the marble), which was not lost on his contemporary audience. Pictures such as *A Roman Emperor* (1871) or *An apodyterium* (1886) were praised for the accuracy of their historical details rather than for their specific content.

A comparison can be usefully made here of *An apodyterium* with Gérôme's *Slave Market* (early 1860s). Both depict a group of women who occupy relatively little of the picture space, which is in turn articulated by anonymous 'close-ups' of what appear to be large pieces of architecture. Historical detail, whose function is to specify the subject of the pictures, is relegated to the position of marginalia. For instance, in Gérôme's painting a glimpse of the sunlit colonnade of a mosque at the right-hand edge of the picture informs the viewer that this is set in the East; in Alma-Tadema's, some slender, wrought-iron lamp holders placed against a wall, Roman numerals on locker doors, cut at the top edge of the picture, and a sunlit row of Corinthian columns at the back of the picture space, which are revealed through half-closed doors, place the image firmly in the time of Imperial Rome. At the same time, in both pictures the (male) viewer is offered an eroticized vision of women, which is made more powerful by an impossibility of actual physical contact – over and above the fact that these are pictures, rather than real situations, which implies a sort of culturally endorsed voyeurism. In *Slave Market* the viewer is separated from the scene by geography, as well as by the fact that these women are *literally* the property of another man. In *An apodyterium* it is the gulf of time and setting that distances the viewer – an apodyterium is the dressing room of a women's bath.

When seen as part of the mainstream, academic tradition, it is possible to assume that the underlying ideologies of nineteenth-century Orientalist painting reflect those dominant in European culture. In other words, the Orientalist painter (and he or she is almost certainly another sort of painter as well) pictures the Orient in a prevailing Western style which remains unaffected by the way in which the Oriental represents him- or herself. This becomes more problematical in the case of certain works by modern artists who

tackled Oriental subjects, such as Matisse and the Dutch Fauvist Kees van Dongen. Both painters represent the Orient in a recognizably European manner, though this is no longer the illusionism of their academic predecessors. In Matisse's many 'odalisques' from the 1920s, for example, Oriental scenes are pictured in the familiar decorative style of his images of women, but it must be remembered that this was a style modulated by the influence of the artist's experience of African sculpture and, more particularly, of his interest in the decorative possibilities of Oriental carpets and patterned textiles.

Images of non-Europeans and European women, displaced and given an exotic character, appear in the work of many early twentieth-century Western artists, particularly those living in France and Germany. Matisse's 'odalisques', for example, with their connotations – unavoidable in early twentieth-century Europe – of 'white slavery' and socially unacceptable indulgences, continue a pictorial tradition that can be traced back, even in this particular form, to Eugène Delacroix and his contemporaries, for example, his famous *Women of Algiers* (1834). Similarly, the documents of Oriental life and place brought back from North Africa by such artists as Matisse, Klee and the Austrian Expressionist Oskar Kokoschka, or images of Palestine by the British painter David Bomberg, must be seen, in spite of their expressive distortions of form and colour, in the light of a well-established Orientalist topographical tradition.

The drawings and paintings made by Kokoschka during a trip to Tunisia in 1928 and shortly afterwards lend themselves easily to consideration within Orientalism. Kokoschka's North African journey must be seen as part of what might be described as a twentieth-century Grand Tour, or as he said, travels half-way around the world 'to paint a modern *Orbis Pictus*'. He began this undertaking sometime after the First World War, partly at the urging of the Berlin art dealer and collector, Paul Cassirer. In Kokoschka's words, the *Orbis Pictus* 'pictured men of all nations as belonging to one family differing only in colour, language, religion, in their dwellings, habits, activities and sciences, and showed that divisions were due to geography and climate.' Clearly, in this description, the list of differences is comprehensive and this is underscored by Kokoschka's uncritical acceptance of a need to distinguish between the general 'types' of humanity and to classify them accordingly.

The point is important, for although Kokoschka's portraits, *The Marabout of Temecine* and *Arab Women* (both 1928) may be likened stylistically to near contemporary portraits of Europeans such as those

of Marczell von Nemes (1928) and Elza Temary (1926–27), the comparison serves not to blur the viewer's awareness of difference but, rather, to heighten it. The sense of voyeurism, of a visual pleasure usually reserved for other eyes, is far more powerful and immediate in the case of the unidentified *Arab Women* than in the portrait of Elza Temary. The two Arab women, fully clothed, though, significantly un-veiled, loom large in the foreground of the picture, but they are overseen at a distance by an anonymous male Bedouin. The nude image of Elza Temary, on the other hand, is characterized by the cool even-handedness of the life class in both the poise of the sitter and in the artist's treatment of her body. Despite her nudity, the figure is bound to Europe both culturally and historically by her hairstyle, pearl necklace and pet spaniel. In contrast, the essential otherness of the Arab women is revealed not only by their clothing, but by the characteristic tattooing on the chin and forearm of the right-hand figure. Kokoschka himself alluded to the erotic appeal of these 'exotic' women in a letter to his friend and sometime lover, Anna Kallin: 'I have to admit, I flirted with two Bedouin women for two whole days, and in the process managed to complete my first painting. Tomorrow, the caravan moves off again. A sparkling picture. How to flirt in Arabic.'

IMAGINING THE PRIMITIVE

North Africa is, of course, a constituent part of the geographical Orient and the complicity of artists such as Klee and Kokoschka in conventional ideas about the Orient should be self-evident. However, there is a more problematic group of modern pictures – those with African and Oceanic subjects, which are more properly part of a wider 'colonial discourse' – of which Orientalism is only one aspect. 55 Pechstein's *Palau Triptych* (1917), painted from drawings and from memory after his return from the South Seas at the outbreak of the First World War, is possibly one of the best examples of this. In one sense Pechstein provides a closely observed image of domestic life in the Palau Islands, including apparently 'authentic' renderings of dwellings, boats and topography. In addition, though, the sophisticated contemporary viewer of Pechstein's work would have been given the impression here that the artist's own style has been altered by his experience of the *art* of the Palau Islands, as well as by its life – Pechstein invited his public to presume that his modern European style contained something of the visual language used by the people of

84

Palau to produce images of themselves. And since Germany had been in contact with Palau since the mid-nineteenth century, the evidence of its artefacts was readily available in the ethnographic museums of Berlin, Dresden and other German state capitals.

Thus, Pechstein's Primitivism appears at first to undermine the main premise on which, according to Said, Orientalism is defined; that is, the 'exteriority' of the Western viewer. Where the Orientalist painter emphasizes his position outside the Orient by means of a highly illusionistic style, Pechstein's modern style helps to suggest his involvement with the primitive. This is seemingly confirmed in the artist's memoirs, where he claims to have fitted easily into the 'savage' way of life during his stay in the Palau Islands in 1914:

> Since I grew up among simple people amidst nature, I readily came to terms with the abundance of new impressions.... Out of the deepest feeling of community I could approach the South Sea Islanders as a brother. Just as I had sailed, fished, and woven nets with the people of Monterosso al Mare, so here it was also easy to learn to steer a canoe through the coral reef.

However, the question of the real extent of the artist's absorption into Palau life remains. The approving comparison of this life with a simple European fishing community should be noted, for it is an indicator of Pechstein's broad-ranging notion of primitive society. Moreover, the artist (then a member of the Brücke) had been first exposed to the art of Palau as early as 1909–10, in the form of decorative house beams in the Staatliche Museum für Völkerkunde in Dresden. Similarly to his colleagues he had quickly appropriated elements of the Palau style into his work. By the time he actually made the journey to the South Seas, his style (if not his artistic vision) was predisposed to represent the people of Palau in a particular, Primitivist manner.

In fact, the Palau beams were not the only primitive sources that had influenced Pechstein – he had studied sculpture from other parts of Oceania, as well as from Africa in the ethnographic museums in Dresden and Berlin. Often he included ethnographic objects in still-life paintings, such as *Still Life in Grey* (1913), whose model is a chief's 57 stool from Cameroon. It should come as no surprise, then, that clear 54 comparisons can be made between Pechstein's stylized treatment of the figures in *Palau Triptych* and the decorated house beams in Dresden, especially in the depiction of the dwellings and the two canoes that occupy the central panel. Other figures, too, are subjected

to an awkward formal stylization that is largely absent from drawings made in Palau or from some derivative prints. This adds to the frieze-like quality of the painting. However, the influence of African sculpture in *Palau Triptych* should not be overlooked. The proportions of many of the figures and particularly their tilted heads with pointed chins are reminiscent not so much of Oceanic sculpture, but of carved figures from Zaire, examples of which Pechstein probably saw in the Berlin ethnographic museum.

56

The connection with African art is made explicit in another Palau painting from 1917. *In the Bordel, Palau* depicts two couples in one of the men's clubhouses, painted in the same manner as the figures in *Palau Triptych*. Significantly, though, two of the lovers are sitting astride the same Cameroon stool that appears in *Still Life in Grey*. Pechstein would surely not have expected everyone in his audience to miss this fact, but he presumably intended the stool to function merely as an easily comprehensible, and therefore useful, marker for the primitive.

The Primitivism in Pechstein's images of Palau around 1917 is informed by an attempt to synthesize subject matter and style – a tendency that I believe to be very important in understanding the nature of much Primitivism in modern art. However, the popularity in Germany of Pechstein's images of Palau people in the 1920s is partly attributable to a method much more akin to the academic Orientalism of the preceding century. In these works the artist was able to combine the production of apparently objective representations with the styles of other, more vaguely defined, exotic sources. The composition of his painting, *Women with Colourful Rug (Friends)* (1920) is, however, related not so much to non-European art as to contemporary ethnographic photographs. Many of these were reproduced as postcards, as well as being used to provide illustrations of 'racial types' in the many pseudo-scientific studies on race and sex that were published in Europe before the Second World War. In the manner of such photographs, which were often staged using appropriate props in a photographic studio, Pechstein reduces the space surrounding the figures to a minimum, merely alluding to some exotic, but anonymous landscape.

The dynamic relationship operating in Primitivism between subject matter and style is, as we have seen, one of the fundamental elements of representation that separates it from Orientalism. Whereas the nineteenth-century Orientalist painters bring a style belonging fully to traditional Western modes of representation to

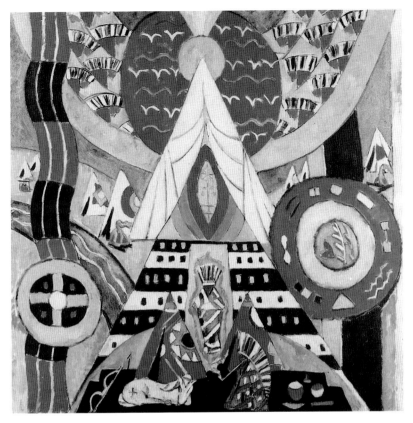

58 Marsden Hartley *Indian Composition* 1914

their subject matter, this order in works by artists such as Pechstein, Matisse or the American painter Marsden Hartley, to name but a few, 58 is modulated by the influence of the primitive itself – whether as artefact or idea. This can be demonstrated not only in representations of actual primitive peoples, but also in works that appear to be unspecific in their cultural reference.

In Schmidt-Rottluff's *Three Nudes – Dunes at Nidden* (1913), for 59 example, there is none of the apparent reportage of Orientalist nudes, which always seem to specify culture and place. The women in Schmidt-Rottluff's picture carry no signs of their particular identity, either as individuals or as racial types. They are not wearing jewelry or

87

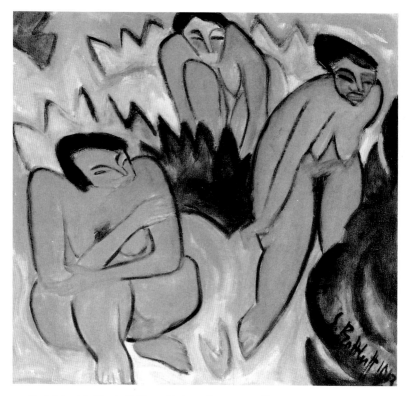

59 Karl Schmidt-Rottluff *Three Nudes – Dunes at Nidden* 1913

clothing in the picture and there is no conventional sign of either savagery or civilization. In a sense this image is activated by an emptying of cultural signs. Where we might expect an Arcadian image or modern-day bathing subject, Schmidt-Rottluff presents us simply with a freely worked depiction of three naked women whose large, rounded forms are contrasted to the dynamic zigzags of the dune grass. The anonymity of the scene is reinforced by the artist's use of a non-naturalistic vermillion colour for both the women's flesh and the sand, and by a very shallow picture space – the picture plane has been tipped forward to the extent that geographical points of reference are excluded.

The simplicity of the large, flat forms in *Three Nudes* might owe something to the influence of Matisse's later Fauvist paintings of

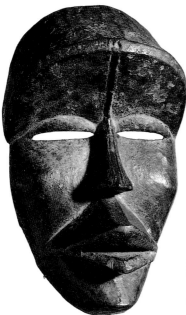

60 *(left)* Dan mask from the Ivory Coast or from Liberia. Collected 1952

61 *(below)* Pablo Picasso *Les Demoiselles d'Avignon* 1907

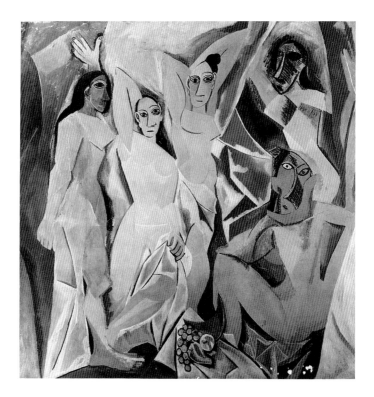

around 1909–10, but the particular style of this picture would not have been possible without the 'primitive' precedents of African sculpture and especially the same carved house beams from Palau that had influenced Pechstein. The conflation of Africa and Oceania is particularly clear in Schmidt-Rottluff's *Still Life with Negro Sculpture* (1913). Here the artist represents two African terracotta pipe bowls in a manner that reflects more closely the style of the Palau reliefs. Moreover, this 'African/Oceanic' style is extended to the whole of the picture surface. There are what might be called latent references to other cultures in this painting that allude to the primitive without specifying it precisely.

Similarly, the women in *Three Nudes* are not exclusively recognizable as white Europeans on vacation in the Baltic town of Nidden, as the title might suggest, since all identifying cultural markers have been omitted. It is important to stress that this extends beyond the subject of the representation to the manner of representation. Arguably, the cultural non-specificity of this work and its lack of a sense of racial particularity denies the voyeuristic and racist reading to which Orientalist nudes, such as Gérôme's *Moorish Bath* (c. 1870), with its white bather and black servant, so easily lend themselves.

61 The Primitivism of Picasso's pivotal painting *Les Demoiselles d'Avignon* (1907) is usually discussed in terms of certain formal similarities that exist between elements in the picture and African and
60 Iberian sculpture, particularly in the 'mask-like' faces of the two women on the right of the picture. Because the *Demoiselles* has often been seen as a crucially important picture in the history of modern art many critics have tried to preserve its claim to originality by denying the direct influence of African art, or by claiming some sort of 'affinity' – either formal, or psychological – between the art practice of Picasso and primitive carvers. It is almost certain that Picasso was influenced by his experience of tribal art while painting the *Demoiselles*, but at least one writer has attempted to rescue the artist from the Modernist claims and counter-claims for the work's status as a piece of radical formal innovation by arguing that the picture was actually conceived as an overtly anti-colonial statement, and that his use of African masks was central to this.

The American art historian Patricia Leighten argues in 'The White Peril and *L'Art nègre*' that the *Demoiselles* emerged out of 'scandals and fiery debates over French colonial policy in Africa that took place in 1905–6 and the resulting outcry of anticolonial opposition from anarchists and socialists'. She is, though, too emphatic in her assertion

that the picture, and especially its African 'rhetoric', reflects Picasso's 'political indignation', not least because it begs the very important question as to whether the artist actually intended references to Africa to operate on a manifest level in this work.

There is little doubt that the few people who saw the *Demoiselles* before 1918 did not perceive it as an anti-colonial statement and it seems clear that it was almost certainly *not* the artist's intention that the viewer should read the faces of the right-hand women as African masks. Indeed, it might be argued that when the recognition of a formal borrowing from African art is the viewer's primary response to these faces the picture will fail to make its strongest expressive impact. Also known as *The Philosophical Brothel*, it was the picture's 'ugliness', taken as a whole, that shocked contemporary viewers in Picasso's circle, such as André Salmon, Leo Stein and Daniel-Henry Kahnweiler. As John Berger has written: the *Demoiselles* 'was meant to shock. It was a raging, frontal attack, not against sexual "immorality", but against life as Picasso found it – the waste, the disease, the ugliness, and the ruthlessness of it. . . . The dislocations in this picture are the result of aggression, not aesthetics.' This may have been what Picasso's friend Salmon meant when, whilst admitting the stylistic importance of the 'African' precedent, he defined the picture's expressive power wholly in terms of its European context: 'Picasso inevitably presented us with an appearance of the world that did not conform to the way in which we had learned to see it. . . . For the first time in Picasso's work, the expression of the faces is neither tragic nor passionate. These are masks almost entirely freed from humanity.' The women in the *Demoiselles*, therefore, operate not as signs for the 'otherness' of the colonial 'primitive', but an 'otherness' internal to Western culture, based on their presumed dangerous sexuality.

THE PRIMITIVE IN THE CITY

In the first part of the twentieth century Western artists sought to expose themselves to the primitive wherever it could be found. As well as the 'going away' to the countryside or to Europe's colonies, artists often did not even need to travel outside their own city. Early in 1910, for example, Kirchner reported from Dresden to his Brücke colleague Heckel, who was in Italy, that the ethnographic museum had reopened: 'the famous Benin bronzes are still on show, as well as some things by the Pueblos of Mexico, and some African

62 Carte de visite depicting American Indians scalping a white man *c.* 1880

sculptures.... A circus is here again, and Samoans and Africans are coming to the zoo this summer.' This untroubled switch from museum to circus, from high culture to popular culture should be seen as inevitable in the history of Primitivism. Indeed, the broad range of modern artists' original exposure of the primitive belonged to an experience that had been available to the public since the first large colonial exhibitions in Britain and France in the mid-nineteenth century, if not before.

63 At the Paris *Exposition Universelle* in 1889, so-called *villages indigènes* were constructed on the Champs-de-Mars in which the Parisian visitor was invited to see primitive peoples going about their everyday lives, wearing their national costumes. This was an innovation followed in imperial exhibitions for the next thirty years. The reasons behind exhibiting examples of subject peoples were

92

63 Kanaka village, New Caledonia, shown at the *Exposition Universelle*, Paris 1889.
Engraving after a drawing by Louis Tinayre, published in *Le Monde illustré*, 27
June 1889

64 *The Blacks Visiting the Whites* from *Fliegender Blätter* 1905

largely twofold. Firstly, it showed the extent of the territories of the mother country; and secondly, it indicated the lower evolutionary stages that the West believed these cultures represented.

Despite the scientific pretexts of many of the simulations of primitive life, the overwhelming experience among contemporary Western viewers was that of exotic spectacle. This is borne out by guide-book descriptions as well as published accounts of villages. For example, while assuring the reader that all attempts are being made to 'raise the standard' of the lives of the Senegalese through Western education, the official guide to the 1908 Franco-British Exhibition in London promises the visitor, for the first time in Europe, 'a cruel-looking stockade' containing people 'dwelling in huts constructed in the most simple way' who will perform 'weird chants and rhythmic dancing'.

The tendency to concentrate on the strangeness of the colonial reconstructions is emphasized in contemporary illustrations in the

62

65 *The Whites Visiting the Blacks* from *Fliegender Blätter* 1905

popular press. An engraving of the Kanaka Village at the 1889 *Exposition Universelle*, for example, contains a group of Parisian sightseers. A number of supposedly primitive carvings (whose 'hideous' features owe more to European caricaturists such as James Gillray and Honoré Daumier than to actual New Caledonian pieces) separate the viewer outside the picture from those within. The spectators stare excitedly through the window of one of the huts, as if into a cage. We know that the hut contains 'natives' by the presence of a black woman close to the window, who meets our gaze, but we can only imagine the scene that has so engaged the viewers within the picture.

In a later pair of images from a 1905 German periodical we find the issue of cultural identity raised head on. In *The Whites Visiting the Blacks* and *The Blacks Visiting the Whites* comparisons between savage and European are constantly invited. Spear-bearing African dancers and musicians in one picture are replaced by an orchestra and cancan

65

64

95

dancers in the other, and blacks in leopard-skin costumes are juxtaposed with fashionably dressed European women and a dandified man. At the same time, however, comparison often implies that positive value judgments should be retained for the primitive rather than the civilized. For example, a mixed group of Africans sharing simple fare in *The Whites Visiting the Blacks* is replaced by beer-swilling Prussians in the second picture. Similarly, Europe is symbolized by a background of an industrial cityscape that virtually occludes the sky, while aside from a few simple huts, Africa is depicted as being natural and unspoilt.

However, this is not by any means an uncomplicated primitivizing image of the triumph of nature over culture. The Europe of *The Blacks Visiting the Whites* does not represent the conservative values of ordinary bourgeois citizens, but what this class saw as the flippant modernism of Art Nouveau aestheticism, 'tainted' as it was by influence from the East and elsewhere. In both images Social-Darwinist fears of miscegenation are implied by the close proximity of distinct groups of white women with a young girl and African men. Whereas the savages are contained behind fences in *The Whites Visiting the Blacks*, in the second picture Europe pours into Africa from every direction, by means of apparently peaceful technology – such as the balloon, automobile and bicycle – and a column of soldiers that advances purposefully out of the compound.

Exhibitions of tribal peoples were also popular in Germany and Austria from the end of the nineteenth century, including reconstructions of villages from India (1905), Sudan (1909), Africa (1910) and Samoa (1910) at the Dresden Zoo (Kirchner refers to the latter two in his letter to Heckel). At the same time, the circus and variety theatres often presented spectacles of the 'primitive' – exotic acts, including African and Indian dance troupes (which were often composed of European artistes) and American Jazz musicians. Such acts appear in countless works by the Brücke artists and others. American Wild West shows, which came to Dresden in 1906 and 1907 as stages in European tours, probably also account in part for the many Brücke pictures of girls playing with bows and arrows, such as Kirchner's *Fränzi with a Bow and Arrow* and *Nude Firing a Bow* (both 1910).

The Brücke's exposure to the primitive was, then, wide-ranging. Moreover, it was part of an experience available to every urban dweller in Wilhelmine Germany and elsewhere in Europe. This included artists such as Grosz, whose autobiography, *A Small Yes and a Big No* (1955), reminds us that the living primitive was an

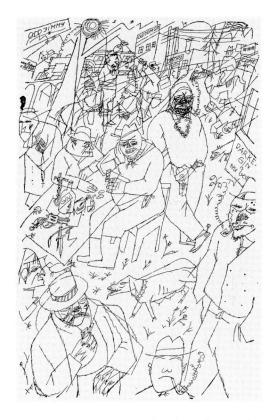

66 George Grosz
Old Jimmy 1916

amorphous category that Europeans often confused with popular
entertainment. He notes, for example, the importance of early
influences such as 'penny dreadfuls' and May's Wild West stories, as
well as his experience of the early cinema in forming his understand-
ing of 'savage' peoples. The results of this youthful consumption of
popular literature are best represented in drawings from around 1916,
such as *The Golddigger*, *Texas Scene for My Friend Chingachgook* and
Old Jimmy. In addition, Grosz tells us: 66

> We loved the amusement parks, where itinerant performers and
> their families lived in colourful caravans. On one occasion we came
> across a green, red and gold booth with 'The Tango in a Variety of
> Guises' written up in gold letters. The tango was all the rage at the
> time, and inside six girls, each dressed like Carmen, and a
> gentleman in orange tails – a symbol of the tango – displayed all

their skills. I was fascinated, made a lot of sketches, and back at home painted a picture full of orange, green and gold. The Spanish girls, needless to say, were all of them Berliners born and bred.

The Brücke artists, too, were fascinated by this area of society, which provided popular entertainment for, while being rejected by, dominant culture. They filled their sketchbooks with drawings of dancers and artistes and it was within this peripheral culture that they found their girlfriends and models. It is also against this broad-ranging background of 'outsiders' that we should address the Primitivism that pervades their famous decorated studios.

THE BRÜCKE STUDIOS

The first Brücke studio decorations coincide with the earliest known use of so-called primitive forms in the work of the Brücke artists, which came not from near-contemporary African or Oceanic sources, but from sixth-century India. A studio mural painted by Heckel in 1909, but now known only through a photograph,

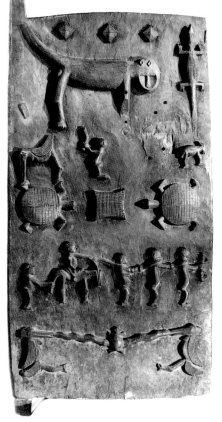

67 Senufo door from the Ivory Coast

68 Ernst Ludwig Kirchner's
studio, Dresden 1910

contained two standing figures that were derived from figures in
Buddhist paintings from Ajanta, India. However, the studio mural is
still some way from the Brücke environments visible in photographs
of Kirchner's Dresden studio which were in place by the spring of
1910. Here, and later in Berlin, we see wall-hangings, bedclothes and
furniture made either by the artists or to their designs. The visual
impact of this decoration undoubtedly owes much to a mixture of
primitive precedents, from Palau carvings and African sculpture,
particularly from the Cameroons, to Javanese shadow puppets –
which were sometimes used in the variety theatres and later made an
appearance in *The Blue Rider* (1912) – as well as Ajanta paintings.

68, 71

67

This notwithstanding, the primitive feel of much of the decoration
is reminiscent of the same emphasis on the value of spontaneous and
emotional use of materials that had been championed by the young
Goethe in the eighteenth century. This had resurfaced in the late-

nineteenth-century Arts and Crafts aesthetic throughout Europe – variously termed Art Nouveau, Liberty Style and *Jugendstil*. Goethe had once said: 'Art is formative long before it is beautiful, and it is still true and great art. . . . And so the savage articulates his coconut shell, his feathers, his body with fantastical lines, hideous forms and gaudy colours. And even if this making visibly expressive is made up of the most arbitrary forms, they will still harmonise without any obvious relationship between them, for a single feeling has created a characteristic whole. Now this characteristic art is the only true art.'

Perhaps in reference to this sentiment, the formal qualities of the figures painted in the roundels of studio hangings and those painted on to the walls of the Brücke studios clearly relate to Palau prototypes. However, the overtly erotic subject matter – the pictures depict various acts of sexual intercourse that would certainly have been viewed as deviant by contemporary medical and psychiatric standards – refers to a perceived relationship between artistic creation and the sexual act. And this is, here, closely linked to Kirchner's awareness of Oriental erotic writings such as the *Thousand and One Nights* and *The Perfumed Garden*.

It is almost certain that the Brücke painters shared the generally held belief that *Urmenschen* (people living in a state of nature) still existed in the form of certain non-European peoples. Yet, there are no grounds for supposing that they ever came across such a person. It is true that they thought that they could free themselves to some extent from the constricting demands of society by adopting Bohemian lifestyles and that they valued what they saw as the less inhibited actions of children and peasants. Unlike Nolde and Pechstein, Kirchner never left Europe; his only actual experience of so-called primitive peoples was confined to the circus, Wild West shows and exhibitions at the zoological gardens. In these contexts the primitive becomes a doubly potent fiction, for the viewer is constantly placed before acts that require a suspension of disbelief.

This is clear in paintings such as Kirchner's *Negro Couple* (1911), which depicts Sam and Milly, two black performers from the *Cirkus Schumann*, in Heckel's Dresden studio. Their blackness is enough to type them as African for the Brücke painters and their contemporary audience and, therefore, primitive in terms of popular racial theory. Kirchner emphasizes this by implying the hypersexuality of the couple through the use of visual signs, for instance, Sam's exaggeratedly long penis and Milly's large buttocks. However, because of the studio setting, the pair cannot be identified unequivocally with tribal

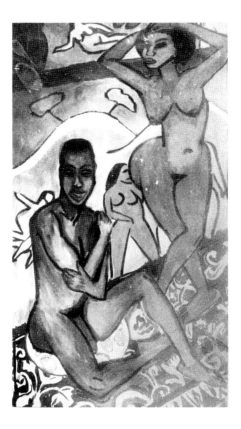

69 Ernst Ludwig Kirchner
Negro Couple 1911

blacks resident in Africa. The point is seemingly underscored by the
mode of representation chosen by the artist, which constitutes what
could be called a 'composite primitivism'.

In the first place, the manifest formal influences on the treatment of
the actual bodies of the couple are those of sixteenth-century Ajanta
painting and the work of Gauguin – and not African tribal sculpture.
In addition, the bathers and landscape in the background are
identifiable as part of the mural in Heckel's studio, which relies
heavily upon the precedent of Ajanta paintings and Palau carvings.
Finally, the floor is covered by an ornately patterned rug, presumably
of Eastern origin. This conflation of generalized markers for the
primitive reinforces the assumption that it is possible to reconstruct
the primitive only through use of fragments, and that the authentic
savages already belong to the historical past – or put bluntly, that they

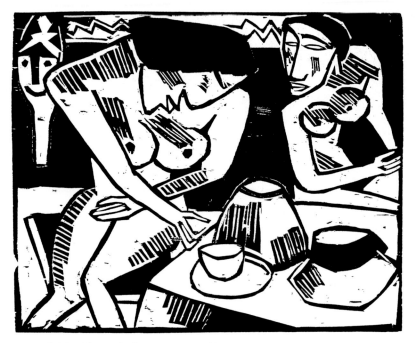

70 Karl Schmidt-Rottluff *Women at a Table* 1914

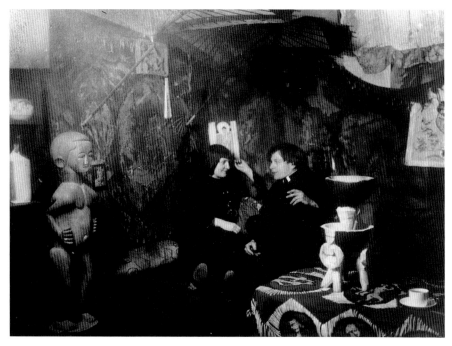

71 Ernst Ludwig Kirchner and Erna Schilling in the MUIM-Institute, Berlin-Wilmersdorf
c. 1912

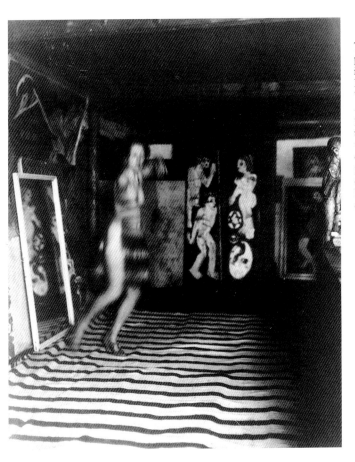

This is one of a number of powerful, primitivistic studio images of models by Schmidt-Rottluff *(opposite, above)*. Here 'primitive' sources as diverse as African masks and Ajanta paintings are unified by the stark black and white of the woodcut medium. The high degree of stylization is, perhaps, testimony to the distance he kept from the bohemian lifestyles of the other core Brücke members.

72 The dancer Nina Hard in the 'Haus in den Lärchen' at Davos 1921

are already extinct. In this sense, *Negro Couple* comes to function as a reconstruction, or an approximation, of something that is unattainable or lost.

Kirchner's Primitivism should not be seen, therefore, in terms of a dialogue with the geographically or historically remote primitive. Instead, it belongs in the context of his bohemianism, which placed him at the periphery of conventional society, and his attempts to construct images of Europe's outsiders via an artistic language that was itself different to the academic norm. The Brücke studios serve as the setting for countless images of male and female nude figures, but they should not be regarded as merely unusual backdrops for life-paintings. In the first place, they were both studio and living quarters – a clear continuation of the general Art Nouveau ideal of blurring the

distinction between art and life. In addition, the models used for these studio works were the girlfriends, friends and acquaintances – including a number of children – of the Brücke artists and often the painters themselves. Moreover, both models and painters often went naked in the studios. The sense of community that the Brücke painters strove to achieve with their models in the studio pictures, and that is mediated through the primitive studio environment itself, points to the intimacy of works such as Heckel's *Girl with Pineapple* (1910), Kirchner's *Two Nudes with Sculpture* (1911) and Schmidt-Rottluff's powerfully stylized *Women at a Table* (1914).

Although there was nothing particularly unusual in the Brücke's practice of nudism at the Moritzburg ponds, near Dresden, the self-conscious bohemianism of their studio life after about 1909 remained strange. It was essentially different, not just to the characteristics of the cities in which they were contained, but more importantly to the typical bourgeois home that represented (perhaps with the exception of Pechstein) the artists' own background and the home environment of almost all their patrons and critics.

This is not to say that one did not expect to come across the primitive in the city at other times and outside the bourgeois home. Grosz describes the sense of unreality conjured in a Berlin night-club in his satirical account of a 'Cannibals' Ball' held shortly before the First World War by the artist Jules Pascin who worked mainly in France and the United States:

> The posters for the ball showed a savage with bared teeth, his foot raised as in a tribal dance, and dressed in a tailcoat, a white tie that had slipped down into a rather curious position, and nothing else. The ballroom was cleverly decorated to resemble tents surrounding a giant red cardboard cauldron embellished with a painted skull and crossbones. Inside the cauldron two half-naked artists were being 'roasted'. [. . .] The flames under the cauldron were in fact flapping strips of paper lit up from below. They were animated by a wind machine and provided the only illumination in the room, which gave the impression of a dense forest clearing. When the machine was eventually switched off, you could just make out small red table lamps here and there and the glow of cigars and cigarettes. The effect was of tiny fireflies, a bit of the African jungle right there in West Berlin.

For Grosz the 'primitive' remains unquestionably exotic; he is merely a visitor who will return afterwards to his normal life. Yet, for

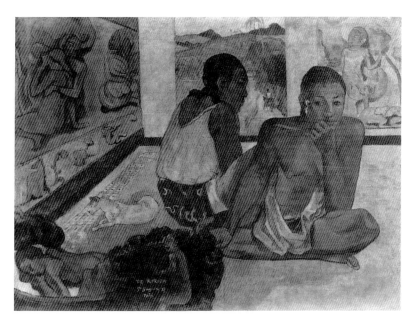

73 *(above)* Paul Gauguin
Te Rerioa (The Dream) 1897

74 *(below)* Baluba headrest
supported by a pair of women
wrestling from Zaire

75 *(right)* Ernst Ludwig Kirchner
Nude behind a Curtain, Fränzi
1910–26

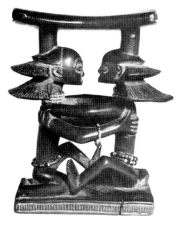

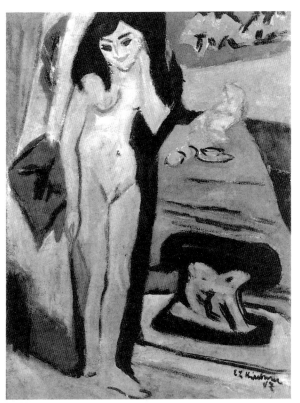

the Brücke, and particularly for Kirchner, the primitive studios-cum-living spaces represented precisely their day-to-day working and social environments. In this way, the decorated studios should not be read as essays in escapism, but, rather as an effective and convenient means of situating the artists outside (or at least on the periphery of) bourgeois society, whilst allowing for a continued and necessary engagement with that very society. Through this the painters of the Brücke departed fundamentally from others such as Matisse, who used exotic studio objects simply as decorative props in much the same way as academic painters at the end of the nineteenth century. Thus, Matisse's interiors of the 1920s, such as *The Moorish Screen* (1921) and *Decorative Figure on an Ornamental Background* (1927), which are ostensibly related to Brücke studio works of the previous decade, remain characteristically Orientalist in their identity.

Brücke studio Primitivism, then, relied upon the creation of a convincing interrelationship of figures and setting. This was achieved mainly in two ways. Firstly, by means of a progressive modern style, which drew upon recent French art, especially Fauvism and 73, 74 Gauguin's later work, as well as notionally primitive forms and secondly, through the artists' choice of particular types of model. The various Brücke styles in Dresden and Berlin, and, in the case of Kirchner, work in Switzerland made long after the group's dissolution, consist of a broad, expressive handling of forms that unify the human figure and its surroundings. In the studio works the rough 75 construction of the actual decoration and furnishings is transferred to the forms of the models. In addition, the models for these works may be identified as outsiders themselves (with the occasional, though notable, exceptions of portraits of middle-class patrons). In view of the broad-ranging definitions of the primitive discussed so far, as well as those with black bodies, these outsiders might also include European types, such as variety artists and peasants, and in cases where the Brücke artists were concerned with the sexualized body, we can add to this list representations of women and children, and in particular the female child.

Stylistic Primitivism

In previous chapters we have seen some of the ways in which artists have been attracted to the primitive through their belief in the relatively uncomplicated existences of 'primitive' groups, such as peasants and tribal peoples. I have argued that, in the case of Primitivism in modern art, the ways in which these groups were represented involved the invention of visual styles whose influences included primitive arts and crafts. The resulting 'stylistic primitivism' has been an enormously important feature in the history of modern art precisely because of the radical effect it had on the appearance of the art of pioneers such as Picasso, and the sculptors Brancusi and Jacques Lipchitz, to name but a few. However, if formal influences remain the most obvious way in which we can make the connection between an artist's thoughts about the primitive and particular pieces of primitive art, it is equally obvious that little is explained if we merely identify and demonstrate that such borrowings have occurred. Questions must also be asked about why they happened.

Artists were initially drawn towards primitive objects in the first part of the twentieth century by virtue of their physical appearance (which does not mean their perceived aesthetic qualities). However, the importance credited to appearance was informed by certain pre-existing expectations as to the nature of the creative impulse that supposedly lay behind their production. Artists went to primitive art expecting to find in it qualities that they presumed to be absent in contemporary European art. For example, the Art Nouveau taste for decorative pattern enabled Gauguin to discover a sense of mystery in the stylization of Marquesan sculpture, whereas contemporary ethnologists saw evidence only of 'degeneration' of naturalistic forms. However, a generation or so later, such artists as Picasso in France and members of the Brücke in Germany rejected Art Nouveau decoration as decadent in itself. The qualities they sought in the primitive were ones that suggested an intuitive and expressionist creative method, and they believed that they could find this in African art.

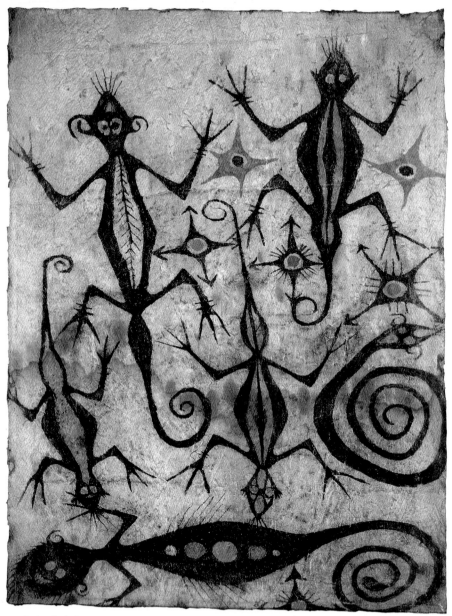

76 Loin cloth from Irian Jaya, Indonesia

77 *(right)* Paul Klee
Picture Album 1937

78 *(below, left)* Max Pechstein
Moon 1919

79 *(below, right)* Maori female
figure from New Zealand

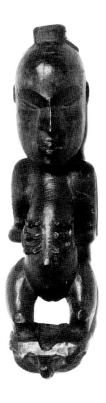

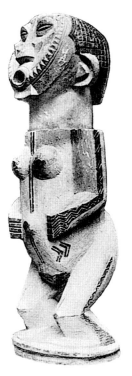

Many modern artists' stylistic Primitivism comprises a rich variety of 'primitive' sources, making it impossible to identify specific borrowings. Thus, although there are obvious similarities between Maori figures and Pechstein's *Moon*, the latter owes as much to African precedents as Oceanic ones. Similarly, while the formal structure of Klee's *Picture Album* is reminiscent of Indonesian loin cloths, its richly diverse sources include Australian bark painting, New Guinea sculpture and Bambara cloths from Mali.

Traditionally, writers on modern art have made generalized distinctions between African and Oceanic sculpture, seeing the former as more 'volumetric' and more rigorously 'stylized' than the latter – even arguing that African art corresponds to a 'Classic' style in contrast to the 'Romantic' tendencies of Oceanic work, although there are many instances, as in the case of Pechstein's *Moon* (1919) and Klee's *Picture Album* (1937), in which the influence of both African and Oceanic work can be discerned in the same piece. Similarly, African art is usually equated with Cubism and formalist concerns in Western art before the mid-1920s, whereas Oceanic art is regarded as the preserve of the Surrealist preoccupation with the unconscious after around 1924. For instance, the American art historian William Rubin writes typically:

> Most Oceanic and all Northwest Coast sculpture (a special favourite of the Surrealists) seems to me to have a more visible if symbolic relation to narrative statement than African art. To this extent we can understand why Cubism, which is an 'iconic' art, would lead its makers to Africa, while Surrealism, which is a symbolically 'storytelling' art, would lead its practitioners to Melanesia, Micronesia, and the Americas.

The extent to which such Western art-historical evaluations are of use in helping us to understand African and Oceanic works is debatable, but they do tell us about the kinds of interests that attracted artists at different times to tribal models.

When artists made use of primitive art they adopted a critical stance not to the primitive itself but, rather, to the civilized norms of their own society. This was either a way of proposing actual social change or a critique of established Western artistic practice. Much has been made of the moderns' use of the tribal art of Africa, Oceania and North America for inspiration, models and confirmation of their own artistic development. But, to these we must add other kinds of non-European art which at the time were widely held to be primitive, such as Egyptian and pre-Columbian art, Benin sculpture and Indian Buddhist painting.

It is conventionally stated that modern artists were the first to recognize tribal works as art and to incorporate its forms into an already rich repository of primitive types. Modern artists were intrigued at first by the utter difference of these primitive forms, an idea that was partly fuelled by the physical distance between Europe and their places of origin. The artists soon discovered in them a vital

78

77

76, 79

alternative to the European illusionistic tradition in painting and sculpture, as in the art of Classical Greece and the Italian Renaissance, but which now survived in what came to be regarded as the ossified and moribund forms of academic art.

Indeed, the moderns' elevation of tribal objects to the status of high art has profoundly affected the ways in which we have been expected to view such work during the course of the twentieth century. Goldwater (in 'Judgements of Primitive Art, 1905–1965', 1969) argues that artists are a sort of cultural channel through which the value of primitive art has been communicated: 'Granted the primitive arts have influenced the modern artist for the last fifty or sixty years – and so through him have affected our artistic understanding – it is also through the eyes of the modern artist that we have learned to see and appreciate certain qualities of the primitive arts.' We should be wary, though, of the 'elective affinity' implied here – the very fact that the West assumed the right to redesignate tribal objects is itself significant. We must ask ourselves whether or not the qualities perceived in these objects by Western artists correspond in any way to those that exist for them in their original contexts. It is also worth remembering here that we are not concerned with the actual discovery and collection of tribal artefacts (they had been on public view in ethnographic museums since the eighteenth century), but the newly formed assumption that they were works of art in the European sense.

THE DISCOVERY OF PRIMITIVE ART

There has been much debate about the 'discovery' of African sculpture by artists at the beginning of the twentieth century. It is impossible to be precise about this, but it is now generally accepted that it was probably the Fauve painters Maurice de Vlaminck and André Derain who first acquired African pieces in Paris early in 1906 – one of the first of which was a Fang mask from the Gabon of famously indifferent quality – and that they were quickly followed by Matisse, who had become interested in West African sculpture after a trip to North Africa in March 1906. Their appropriation of primitive art coincided with a renewed interest in Paris in the later work of Cézanne, with its emphasis on structure and modelling, apparently in opposition to the decorative surfaces of the then fashionable Neo-Impressionist work of Paul Signac and others. Together with Cézanne's paintings, African carvings are usually seen as the most important influences behind the new concern with sculptural effects

85

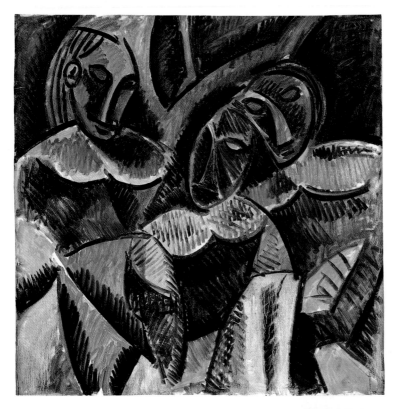

80 *(above)* Pablo Picasso *Three Figures Under a Tree* 1907

81 *(right)* Pablo Picasso in his studio in the Bateau-Lavoir, Paris 1908

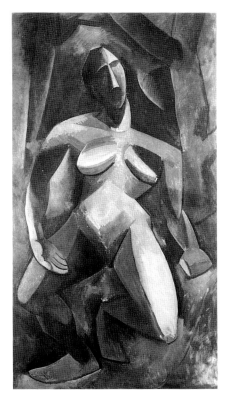

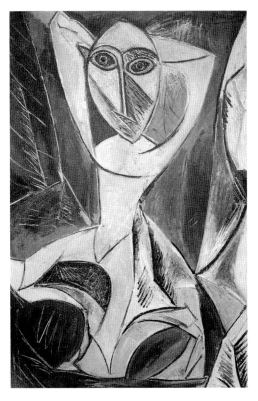

82 *(above, left)* Pablo Picasso
The Dryad (Nude in the Forest) 1908

83 *(above right)* Pablo Picasso
*Nude with Raised Arms (The Dancer
of Avignon)* 1907

84 *(right)* Kota reliquary figure
from the People's Republic of the
Congo

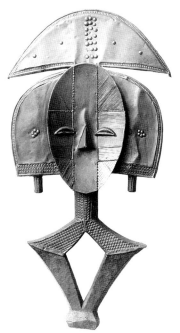

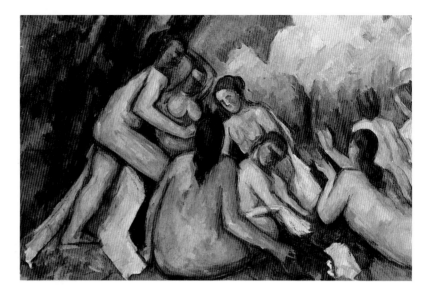

85 Paul Cézanne *The Large Bathers* (detail) 1900–6

and colour planes in the work of Matisse (for example, *Blue Nude*
82 *(Souvenir of Biskra))* and Picasso (for example, *The Dryad (Nude in the
Forest))* after 1906.

The artistic discovery of African art was not, however, a sudden
event. There had been a growing general interest in non-naturalistic
art since at least the end of the nineteenth century, which was evident
through the Impressionists' interest in Japanese woodcuts. Moreover,
in the first years of the twentieth century a number of large art
exhibitions that lay outside the recognized European tradition were
held in Paris, including Islamic art (1904), Japanese art (1905) and
ancient Iberian art (1906). All of these helped pave the way for interest
in tribal artefacts. In much contemporary criticism interest in this kind
of production was in turn regarded as reflective of 'Post-Impressio-
nist' concerns, though less naturalistic and more powerfully symbolic.

Important aesthetic judgments (both negative and positive) made
about primitive art by modern artists thus affected the pictorial
structure of their work. The choice of one primitive form rather than
another was determined partly through modern artists' desire to
undermine the conventions of immediately preceding tendencies.

114

Their aim was to challenge the familiar ideas of the unprepared spectator. Picasso is a case in point. Similarly to many others of his generation he sought at times to question common assumptions about art and life through appeals to artefacts and ideas considered to be outside the European tradition, and often outside the designation 'art'. Thus, despite the fact that at the end of the nineteenth century Impressionist painting had been greatly influenced by Japanese prints, the general public acceptance of both by 1906 severely restricted their ability to shock contemporary viewers out of their cultural complacency. Through the conscious redefinition of tribal objects as art by avant-garde painters, at least for a short period, the artefacts were able to retain in large measure their profoundly unfamiliar identity, something that was necessary if they were to be of use to a modern art driven by its antagonism towards dominant aesthetic opinion.

PICASSO, CUBISM AND TRIBAL ART

Any aspect of Primitivism that arises in the visual arts is, in certain respects, 'stylistic'. I use the term here specifically, however, to refer to the formal influence of primitive art in modern painting and sculpture. Although such influences are usually quickly subsumed within the European artist's individual style, their importance should not be denied. In Picasso's work, for instance, between around 1907 and the beginning of 1909, we witness the artist working through his encounter with tribal sculpture towards a point at which its forms are fully assimilated in his painterly style. Consequently, direct borrowings from African art are clearly evident in the large oil sketch, *Three Figures Under a Tree* (1907), but by 1908–9 when he had reached a 80 definitive statement of this composition in *Three Women* this was no longer the case.

Writers have long attested to the particular formal influence of Kota reliquary figures in certain pictures by Picasso from his so-called 84 'Negro period', for instance, *Head*, or the series of 'Dancing Figures', all from 1907. In *Nude with Raised Arms (The Dancer of Avignon)*, for 83 example, there are obvious stylistic parallels with the African source – the arms of Picasso's figure are raised behind its head and surround the face in a way that reminds us of the characteristic heads of Kota figures. Similarly, the coarse, scratched modelling in *Nude with Raised Arms* echoes the rough surface of the metal in the African work.

Picasso's introduction to African sculpture around 1907 coincided with a radical change in the appearance of his paintings, which might

be seen to threaten the claims often made for his originality. Perhaps in defence of this, Goldwater argues in *Primitivism in Modern Art* that there were significant differences in the quality of expression in *Nude with Raised Arms* and the African piece. He describes the Kota reliquary figure as: 'static, hieratic, impersonal', whereas Picasso's painting is 'all movement and violence. Its intensity is of an entirely different order.' This interpretation accords with Goldwater's own relatively sophisticated anthropological knowledge, but there is no reason to believe that Picasso himself perceived the Kota figures in this way. On the contrary, there is evidence that he read into African sculpture precisely those expressive qualities that he wished to achieve in his own work at that time. For example, in the famous account of his discovery of African art at the Trocadéro museum, Paris, in the spring of 1907, related much later by one of his partners Françoise Gilot, Picasso concentrated not so much on the formal qualities of tribal sculpture (beyond assertions of their ugliness in comparison to conventional aesthetics), but on what he saw as their magical (even expressionist) elements:

> Men had made those masks and other objects for a sacred purpose, a magic purpose, as a kind of mediation between themselves and the unknown hostile forces that surrounded them, in order to overcome their fear and horror by giving it a form and an image. At that moment I realized that this was what painting was all about. Painting isn't an aesthetic operation; it's a form of magic designed as mediation between this strange, hostile world and us, a way of seizing power by giving form to our terrors as well as our desires. When I came to that realization, I knew I had found my way.

It may have been that the wording of this statement was primarily a result of Picasso's later friendship with people more conversant with anthropology than he, such as André Malraux and Michel Leiris. Even so, we are presented here with an indication of the way in which Picasso attempted to recruit what he saw as the power of 'primitive' forms to embody ideas differently from the narrative and conventional symbolism of his own earlier works from the Blue and Rose periods. Nevertheless, the iconography of *Nude with Raised Arms* is in fact closer to the intimate nudes of Degas or even Picasso's own *The Blue Room* (1901) than to African masks or sculptures. The sexual connotations inherent in privileged male views of naked women engaged in private tasks, such as bathing, retain a degree of ambiguity in *The Blue Room*, but the 'safe' familiarity afforded by more

traditional means of representation is violently challenged in confrontational pictures such as *Nude with Raised Arms*. Here Picasso asks us (mistakenly) to recognize in his expressive gestures a direct emotional intensity that is shared with African sculpture.

African masks and figures, mainly from the Ivory Coast, Gabon and the Congo, are probably the most common influences in Parisian artistic circles in the years before 1918. In sculpture, especially, there are many instances of the important role played by such works. Brancusi's *Little French Girl* (1914–18) is a case in point. Formal similarities can be drawn between this work and much West African figure sculpture if we compare, for example, the stiff, frontal pose of *Little French Girl* with a Kulango figure from the Ivory Coast. The characteristic 'closed form' and apparent abstraction of both pieces would have been seized on by Brancusi's contemporaries as a significant similarity, as indeed would their shared method of construction – direct carving. The Primitivism that relates the forms of African sculpture to original humanity is also clear in Brancusi's composite sculpture, *Adam and Eve* (1916–21), in which a variety of African prototypes have been subjected to a sophisticated process of abstraction that unifies the piece formally.

The German writer on modern and primitive art Carl Einstein confirmed the avant-garde's belief in the 'modern' character of tribal art in his *African Sculpture* (1915), written after a stay in Paris where he had met members of artistic circles around Picasso. According to Einstein, African sculptures are self-contained: 'oriented not toward the viewer, but in terms of themselves'. They function, he continued, not so much as representations, but as things in themselves: 'The art object is real because it is closed form. Since it is self-contained and extremely powerful, the sense of distance between it and the viewer will necessarily produce an art of enormous intensity.' The intimacy of the dialogue between artists and their materials implied by the process of direct carving further emphasizes the myth of 'authentic' and 'pure' creation often used to describe both tribal works and hieratic sculptures in stone and wood by modern Europeans such as Brancusi and his protégé Amedeo Modigliani.

A number of other sculptors appeared to seize more particularly on the stylized geometric quality characteristic of much African work. Henri Gaudier-Brzeska, for example, working out of Cubo-Futurist interests between 1913 and 1914, distilled the simplified volumes of his Nigerian tribal sources into a radically less complex geometry in drawings such as *Caritas* (1914). Similarly, the Cubist sculptures

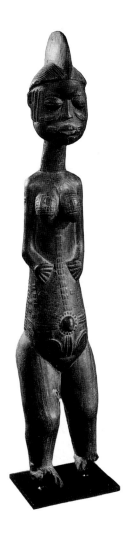

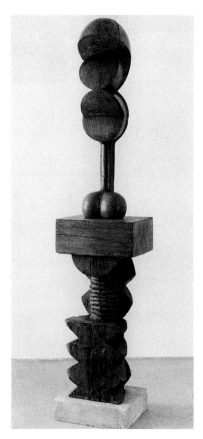

86 *(left)* Kulango figure from the Ivory Coast

87 *(above)* Constantin Brancusi *Adam and Eve* 1916–21

produced by Lipchitz from around 1918 seem to synthesize and absorb the artist's experience of Picasso's Cubist paintings and constructions, and his own earlier works, in which the direct formal influence of African models is apparent, such as *Mother and Child* (1914) and *Detachable Figure* (1915). Thus, it can be reasonably argued

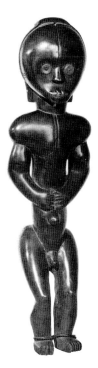

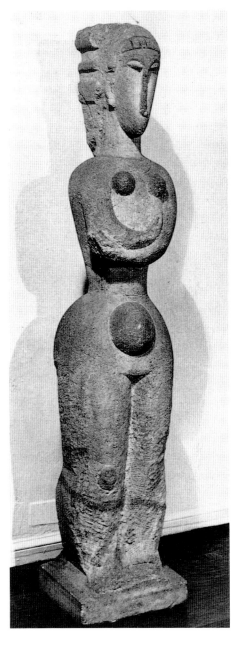

88 *(above)* Fang figure of a man standing from Gabon

89 *(right)* Amedeo Modigliani *Standing Nude c.* 1911–12

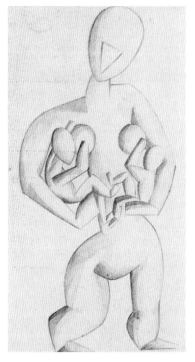

90 *(above, left)* Henri Gaudier-Brzeska *Caritas* 1914

91 *(above, right)* Jacques Lipchitz *Guitar Player* 1918

91 that his *Guitar Player* (1918) recalls African works while not relying on the viewer's recognition of specific examples as prototypes.

One of the most intriguing instances of the documented formal influence of primitive art concerns Picasso's important Cubist relief, 92, 93 *Guitar* (1912) and a Grebo mask from the Ivory Coast in the artist's possession. At first sight *Guitar* appears to owe nothing to African art, but the artist himself is reported to have spoken of the connection with the African mask. Whereas we might ordinarily think of eyes as receding features on the facial plane, in Grebo masks they characteristically project forward from a flat base board, in the same plane as noses and mouths. This introduces the possibility of reading the space around the protruding eye cylinders as a sculptural volume. This perception enabled Picasso to arrive at a similar solution to the problem of indicating the invisible front plane of his *Guitar*. He projected the hole forward as a hollow cylinder.

92 *(left)* Pablo Picasso *Guitar* 1912

93 *(above)* Grebo mask from the Ivory Coast or from Liberia

Many writers, among them Picasso's dealer, Kahnweiler ('Negro Art and Cubism', 1948), have argued that the synthesis of African and European forms can be explained by the similarities of intention between modern and tribal artists. According to him, though, the function of African sculpture was to corroborate developments already under way, rather than to instigate them. Thus:

> At the outset, Cubist art was *static* to the point of appearing almost frozen. In Negro art it rediscovered another static art.... Negro sculpture itself pre-eminently possessed the *cubic existence* in real space by which genuine sculpture can be recognized. On the other hand, its very marked character as a 'sign' preserved it from any confusion with human beings living in the same space.... Negro sculpture permitted [the Cubists] to see clearly into the problems which had been confused by the evolution of European art, and to find a solution which, by avoiding every art of illusion, resulted in the liberty to which they aspired.

In spite of the fact that the two qualities Kahnweiler emphasized as central to the affinity between primitive art and Cubism are pre-eminently sculptural, in his analysis African carvings exercised their most profound influence not on modern sculpture, but on painting.

For Kahnweiler, African sculpture and Cubist painting share a common psychological base, which is illustrated by the German art historian Wilhelm Worringer's once influential idea, as described in his *Abstraction and Empathy* (1908), of the existence of a compelling 'urge to abstraction' among primitive artists. This arises, he says, from a sense of 'a great inner unrest inspired in man by the phenomena of the outside world', which results in 'an immense spiritual dread of space', precisely because it is 'space which links things to one another ... and because space is the one thing it is impossible to individualize.' Worringer argues that so long as a work of art 'is still dependent upon space, it is unable to appear to us in its closed material individuality.' In sculpture, though, the problem of producing representational images while abstracting them from their environment can be avoided through the use of 'closed form' – 'All endeavour was therefore directed toward the single form set free from space.'

What part, then, could African sculpture play in the development of painting in which images in 'closed form' could not be an option? In the first place, if the Cubist painters were faced with the problem of how to construct a pictorial space in which objects might be situated, while at the same time removing them from the incomprehensible

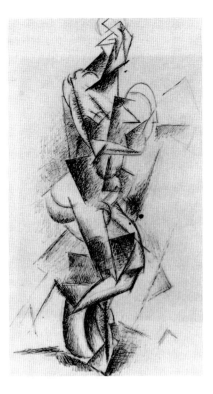

94 Pablo Picasso *Nude* 1910

space that linked them to the external world, African sculpture
confirmed the possibility of such an undertaking. Indeed, almost all
the figure compositions painted by Braque and Picasso between 1909
and 1910 consist of a centrally placed single form. The women in
Picasso's *Nude* (1910) and Braque's *Female Figure* (1910–11), for 94
example, while not conforming to traditional forms of represen-
tation, can be easily distinguished against indistinct backgrounds. In
other works, though, such as Picasso's *Woman* (1910) and *'Ma Jolie'*
(1911–12) or Braque's *The Portuguese* (1911), the solitary figure seems
to be subsumed by the fractured picture space, almost to the point of
dissolving.

The small pictorial planes, or 'facets', used by both Picasso and
Braque to construct their pictures appear to be related to the
simplified geometric surfaces of certain African and Oceanic
prototypes, such as figures from the Ivory Coast, Gabon and New
Caledonia. This direct connection is, perhaps, most clear in images

such as *Bather* (1909) and *Nude* (1910) by Picasso, in which the figures have more recognizably 'African' features. However, the value of the Cubist facet lies not so much in the geometricizing of the human body, but in the possibility it raises of constructing a pictorial space that has the same effect in painting as the closed form in sculpture. Cubist 'space' possesses an internal logic distinct from external reality – one that contains, connects and seals objects.

EXPRESSIONIST APPEALS TO THE PRIMITIVE

In Germany the first kinds of tribal sculpture that modern artists turned to around 1909 were probably from Oceania rather than Africa. The reason for this lies partly in the strong decorative interests, comparable with those of the Fauves in France, of artists associated with the Brücke group after 1906, notably Heckel, Kirchner, Pechstein, Schmidt-Rottluff and others, such as Marc and Macke in Munich around 1911, which often led them to seek out primitive forms that emphasized surface pattern rather than volumetry. Another important factor was a growing interest among artists in Germany specifically in the South Seas Islands, generated by the mythology surrounding Gauguin's adventure in Tahiti and the Marquesas Islands in the last years of the nineteenth century.

As we have seen in the previous chapter the first demonstrable influence of Oceanic art in the work of the Brücke artists can be traced to 1909 when the group were inspired by coloured relief carvings from the Palau Islands in Micronesia which they saw in the Dresden ethnographic museum. Palau had been a German colony since 1899, but the objects in question had been in the museum since 1881. The beams, which are structural supports for buildings, depict domestic and mythological scenes from the islands, played out in long processional sequences by figures whose genitals are exaggerated in order to emphasize their sexuality. This must have been one of the qualities that first drew the attention of Heckel and Kirchner, whose own work was closely concerned with human sexuality at that time, as is evident in Kirchner's coloured lithograph, *Love Scene* (1908). The Brücke would also have been drawn to what they saw as the rough painterly qualities of the Palau carvings, which probably confirmed the importance of the formal simplifications, owing much to French Fauvism and found throughout their work at that time, such as Schmidt-Rottluff's *Bursting Dam* (1910) or Kirchner's *Nude Couple in the Sun* (1910). Moreover, the non-naturalistic low relief of the beams

and the fact that they were coloured seems to have enriched the Brücke's use of the woodcut medium. The simplicity and rough-hewn feel of Kirchner's *Bathers Throwing Reeds* (1909) surely owes much to the Palau precedent. 14

It is no coincidence that the most important tribal influence on the early Brücke style came from painterly low relief carvings, since the Brücke artists were obsessed at the time with problems of the functions of the decorative in their work. The type of primitive art which exercised perhaps the greatest influence on Kirchner and Heckel was neither sculptural in form nor tribal in origin, but consisted of sixteenth-century Indian paintings from the Buddhist cave temples of Ajanta, which the painters knew not from objects in museums, but from high-quality colour reproductions in a book by John Griffiths. In 1966 the American art historian Donald Gordon published drawings by Kirchner that are obviously copies of Ajanta originals, and he showed that the painting *Five Bathers by a Lake* (1911) is closely related to a group of figures in Ajanta Cave II. Similarly, a small painting of Buddha that appears in several photographs of Kirchner's studios in Dresden and Berlin is a copy after figures in Cave X. However, as with Picasso, such direct formal influences were quickly absorbed and incorporated in Kirchner's individual style in such works as his iconic *Half-Length Nude with Hat* (1911). It is in these works, where the influence of primitive prototypes is far from clear, that we find some of the artist's most powerful images. 95 96 97

The importance of primitive prototypes in the work of the Brücke artists is further complicated by the influence exerted by Gauguin. His example encouraged the Brücke painters to seek models in primitive art, but, more precisely, primitive types (such as the Buddhist paintings of Ajanta) which corresponded closely to his own style after arriving in the South Seas in 1891. Kirchner and Heckel had known of Ajanta since 1908 and they had probably seen Gauguin's work in the original at least by 1906.

The manifest formal influence of primitive art in Gauguin's work is usually dismissed as negligible when compared to his debt to French Post-Impressionism. However, such accounts do not take stock of the clear influence of Eastern 'court' arts as *primitive* source material (which is undoubtedly how Gauguin viewed this type of production). Once this is realized, the close connection between the Brücke painters' discovery of Gauguin and Ajanta becomes clear. Gauguin's debt to Javanese art is well known, as shown, for example, in a comparison of the artist's *Ia Orana Maria* (1891) with a relief from the

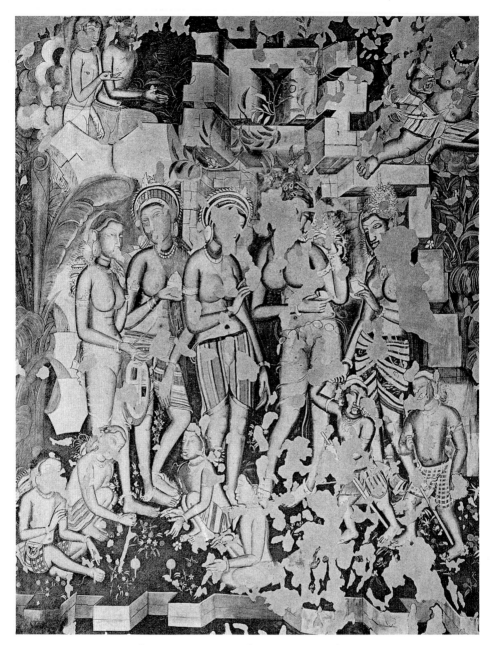

95 *Five Figures*, Ajanta wall painting, Cave II. 2nd century BC–AD 7th century

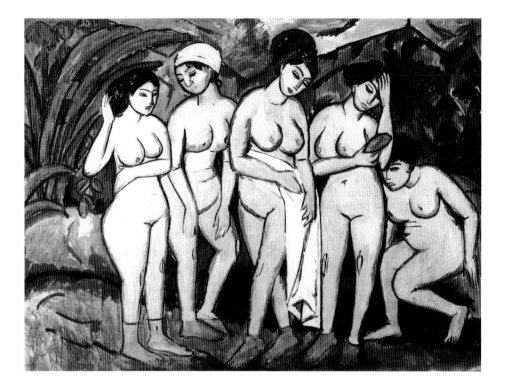

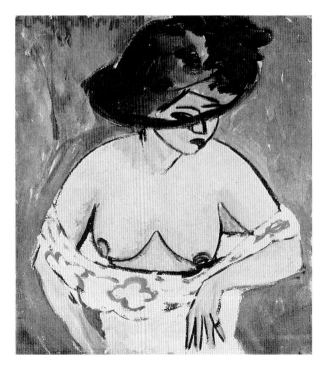

96 (above)
Ernst Ludwig Kirchner
Five Bathers by a Lake 1911

97 (left)
Ernst Ludwig Kirchner
Half-Length Nude with Hat
1911

127

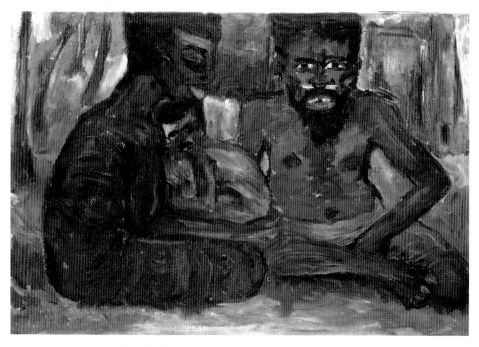

98 Emil Nolde *Family* 1914

temple of Borobudur, Java. The Javanese precedent is also apparent in the proportions of the figures in paintings such as *Te Nave Nave Fenua (Fragrant Earth)* (1892) and *Two Tahitian Women* (1899). In addition, there are clear formal similarities between such works by Gauguin and typical female figures in the Ajanta paintings, which he could not have known, but which themselves share a certain formal correspondence between the Javanese pieces. Although some of Kirchner's paintings of around 1911 are closely related to particular works by Gauguin or the Ajanta muralists, there are a number of 'Post-Impressionist' nude subjects, dating from around 1909 (that is, shortly after Kirchner's and Heckel's first introduction to Gauguin and Ajanta) whose subjects also correspond to the characteristic physiognomy of Ajanta figures. They do, however, lack the stylization of the 1911 paintings. This first, more tentative influence of both Ajanta

128

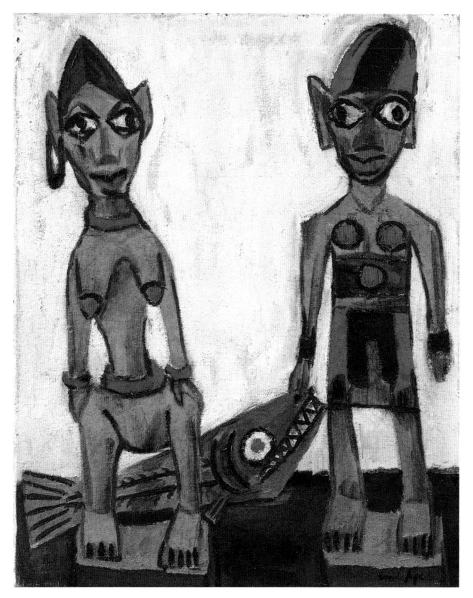

99 Emil Nolde *Man, Fish and Woman* 1912

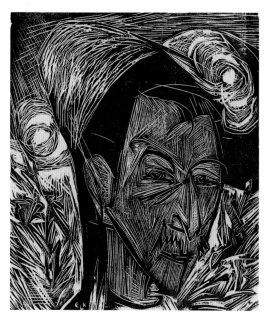

100 Ernst Ludwig Kirchner
Portrait of David Mueller 1919

and Gauguin can be seen in paintings such as *Two Nudes on Carpets* and
Nude with Raised Arms (both 1909).

Such convoluted routes of 'primitive' influence raise interesting
questions about the importance of the role played by specific
primitive forms in modern art. It is sometimes argued that the rough,
simplified forms usually associated with stylistic primitivism are
primarily the result of a desire to strip away the complexities of
civilized views of the world and to rediscover fundamentals of form
and feeling. In painting this tendency is at its most insistent in works
associated with Expressionism, notably the wild, animated landscapes
of Vlaminck and Nolde, and the violently distorted figures of early
99 Brücke work. In images such as Nolde's *Man, Fish and Woman* (1912)
98 and *Family* (1914) the figures are drawn roughly and without
concessions to conventional aesthetics. Movement around forms is
often described only by broad, gestural brushmarks, and the artist
employs an intense and dramatic palette. Effects such as these are often
carried still further in the woodcut medium which, by definition,
does not lend itself easily to complex, illusionistic renderings of form.
In the hands of the Brücke, who carved directly into their blocks
without preparatory drawing, the results were often intensely
physical. This is as true of the gouging and splintering of the block

evident in such works as Heckel's *Woman with Raised Arms* (1910), as it is of the calligraphic incisions characteristic of Kirchner's Swiss woodcuts, such as *Portrait of David Mueller* (1919). 100

The importance that was often placed on the creative process is clearly articulated in Nolde's praise of savage art. 'Why is it that we artists love to see the unsophisticated artefacts of the primitives?' he asks. The answer for Nolde lies in the holistic process at work in their productions: 'Primitive people begin making things with their fingers, with material in their hands. Their work expresses the pleasure of making. What we enjoy, probably, is the intense and often grotesque expression of energy, of life.' Nolde unsurprisingly contrasted this 'authentic' simplicity with what he saw as 'the saccharinely tasteful . . . over-bred, pale and decadent' official arts and crafts of Europe. Significantly, as we shall see in the next chapter, by emphasizing the value modern artists placed on what they saw as the primitive modes of creation that lay *behind* primitive art, in preference to primitive forms themselves, the way is left open for a definition of Primitivism that includes a broad range of visually distinct works of art with no formal connection to primitive objects. This is evident in, for example, Hans Arp's torn-paper works and some of the sculpture of Constantin Brancusi, Henry Moore and Barbara Hepworth. 101

101 Barbara Hepworth *Nesting Stones* 1937

102 Adolph Gottlieb *The Oracle c.* 1947

In Search of the Primordial

Interest in the character of the primitive creative impulse was an increasingly important aspect in the development of Primitivism in modern art during the first half of the twentieth century. We have seen that Social-Darwinist thought, popularized mainly through magazines and the colonial exhibitions, placed primitive peoples nearer to beginnings, that is, closer to the origins of humanity. Thus, we should not be surprised to encounter, as early as 1912 in the work of Kandinsky, Klee, Marc and Arp, a type of cultural Primitivism (*see* pp. 20–21) that is informed by what they perceived to be primitive ways of seeing and primal modes of thought. This represents an attempt on the part of Western artists to retreat from 'reason' and thereby gain access to the very sources of creativity itself, which they believed was exemplified in its most authentic and liberated form in the minds of children, tribal peoples and the insane.

The conventional belief that held the primitive mentality to be different in substance to the civilized one was current until well after the Second World War. Consequently, we find examples of this type of Primitivism not only in such movements as Dada and Expressionism, but also throughout Surrealism from its inception in 1924 to aspects of Abstract Expressionism and even some experimental art of the 1960s. It is worth remembering, though, that the notion of the primitive as a homogeneous category has no real underlying common denominator, other than the assumptions of a discredited Social-Darwinism. Today, it would be impossible to claim legitimately, as it seemed to be until mid-century, that the psychologies of peoples from the whole of Central and Southern Africa, and of the native peoples of North America and Oceania are fundamentally indistinguishable. It would be equally unrealistic now to draw an equation between the thought patterns of these cultures and those of children. However, we should not lose sight of the fact that notions of the primitive that had been used conventionally as part of the Western mechanisms of domination and control over 'outsiders' were afforded enormous positive value by artists as far removed in time and place from each

103 Maori *Madonna and Child* from New Zealand 1840

104 Emil Nolde *The Twelve-Year-Old Christ* 1911

other as Klee, Gottlieb and the German sculptor Joseph Beuys, to name but a few. They pursued ideas about the primitive mentality, not as a means of reaffirming the West's dominance, but as a way of attacking it.

102

THE RETREAT FROM REASON

It is often argued that the rise of Primitivism at the turn of the twentieth century is coincidental with a decline of humanitarian values in European culture and that its importance at this time was due, at least in part, to a growing disjunction between a rapidly increasing technological and scientific complexity, and the ability of the individual to comprehend these changes. Scientists' pursuit of objective knowledge about the material universe often led to a rejection of previously held beliefs with their replacement by further questions. Thus, for example, Kandinsky claimed in 'Reminiscences' (1913) that one of the important events that helped him to turn away

135

105 Paula Modersohn-Becker *Reclining Mother and Child* 1906

from the forms of the external world and embrace abstraction in his art was the splitting of the atom by Ernest Rutherford. Kandinsky equated this 'with the collapse of the whole world.... Everything became uncertain, precarious and insubstantial.' Even the Italian Futurists' enthusiastic embrace of technology, from the time of the poet Filippo Tommaso Marinetti's 'The Founding and Manifesto of Futurism' (1909) to its demise amidst the catastrophe of the First World War, was based more on Romantic awe than on any pretence to rational understanding of an age driven by 'eternal, omnipresent speed'.

In response to the failure of reason, the atavistic return to more primitive modes of feeling seemed to many to offer a way of negotiating the reality of this suddenly fragmented world. In the case of many artists, such as Nolde, this sometimes meant an interest in primitive, non-denominational Christianity, which he regarded as more vital than contemporary forms and which manifested itself in

works such as *The Twelve-Year-Old Christ* (1911), in the depiction of 104
what he saw as strong racial types. This is now a discredited Social
Darwinist position that has interestingly been called into question by
the merging of old traditions and Christianity in much tribal work, as
is the case in the Maori *Madonna and Child* (1840). Beginning around 103
1910, especially in much German Expressionist art and the work of
Russians such as Kasimir Malevich and Mikhail Matiushin, the
tendency was to reject external reality and to rely on the creative
revelations provided by one's inner sight. Similarly to the English and
German Romantics of the early nineteenth century, artists such as
Kandinsky and Nolde relied upon a holistic vision that saw nature as a
vital, organic system with which ecstatic communion was desirable.
The reliance on one's own mind is clear in Jawlensky's claim that the
true artist 'does not create what exists in nature nor even what might
exist in nature. Nature serves him only as a key to the organ in his
soul.... The artist expresses only what he has within himself, not
what he sees with his eyes.' In Germany works resulting from such

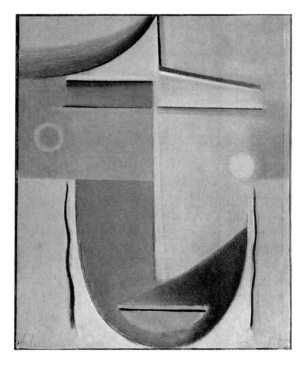

106 Alexei Jawlensky
Love 1925

107 Franz Marc *Birth of the Wolf* 1913

sentiments oscillated between the symbolic figuration of Marc's *Birth* 107
of the Wolf (1913) or Otto Dix's cosmogonic *Pregnant Woman* (1919), 111
and such abstractions as Kandinsky's *Picture with Three Spots* (1914)
and Jawlensky's *Love* (1925), in which nature and emotion are intuited 106
as spiritual revelation.

The rejection of the urban environment implied by the Romantic
interest in nature is strongest in the early twentieth century in the art
of the Brücke painter Nolde. His search for an unspoilt, primeval
landscape led him away from the city to the inhospitable coast and
marshlands of his native Schleswig-Holstein. He represented this area
as a turbulent, brooding animate presence, pregnant with life, but
continuously threatening to overcome its tiny human inhabitants. As
Nolde himself said: 'Everything which is primeval and elemental
captures my imagination. The vast raging ocean is still in its elemental
state, the wind, the sun and the starry sky are more or less what they
were 50,000 years ago.' Thus, in *Autumn Evening* (1924) a tiny village 108
on the horizon is pressed dangerously between echoing expanses of
sky and wetland, and, characteristically, the boats in *Smoking Steamers*
(1910) are engulfed by a soup of sea, sky and smoke that continually
threatens to dissolve into formlessness.

108 Emil Nolde *Autumn Evening* 1924

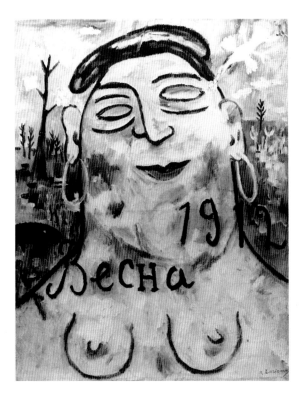

109 Mikhail Larionov
Spring 1912

It was a desire to experience fast-disappearing primordial regions and their inhabitants that took Nolde on a journey to Russia, the Far East and New Guinea between 1913 and 1914. In his journals he voiced his fears of the destruction caused by colonialism, resulting in the loss of the 'precious primary spiritual values' of the primordial peoples (*Urmenschen*) who 'live in their nature, are one with it and a part of the entire universe'. Always pessimistic about their future at the hands of Europeans, he conceived of his images of these peoples and their land as a way of holding on to 'a bit of primordial being'.

In Expressionist images of the human figure attempts to commune with a nature that was spiritual throughout led, typically, to a rejection of the desire to capture individual character and the emergence of a tendency to represent archetypal states of being. For example, in *Reclining Mother and Child* (1906) the Worpswede painter Modersohn-Becker allows the spectator a privileged view of an intensely private image of utter naturalness and contentment. The physical closeness of the naked woman and her suckling child suggests

140

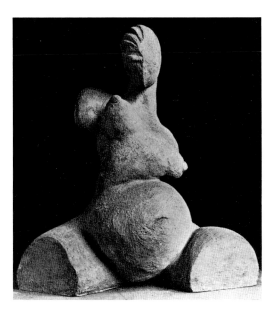

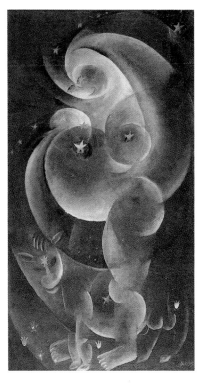

110 *(above)* Gela Forster *Conception c.* 1919

111 *(right)* Otto Dix *Pregnant Woman* 1919

a connection as intimate as that which existed before the umbilical cord was severed. Yet, the discomfort of voyeurism is avoided by the artist's generalization of the two figures' features and the space that they occupy. Their particular identities transcended, they serve to celebrate the experience of a primal bond.

Works by artists associated with Herwarth Walden's Galerie Der Sturm in Berlin, such as Oswald Herzog, Wilhelm Morgner and Hans Siebert von Heister, as well as the Russians Mikhail Larionov and Marc Chagall often seem to indicate a holistic awareness of the primitive in the sense of an atavistic yearning to engage with the cosmic continuum. Von Heister's *Anger* (1919) and Herzog's sculpture, *Enjoyment* (*c.* 1920) are attempts specifically to find equivalents in paint for the emotions themselves, while the crude, primitive draughtsmanship in Larionov's *Spring* (1912) indicates the 109 eternal seasonal cycle and at the same time trumpets his modernism.

Expressionism also embraced Nietzsche's idea that creativity is intuitive rather than rational, and that artistic creation can be equated

with the primitive procreative urge. This is particularly relevant to the movement's second generation that came to artistic maturity at the end of the First World War. It resulted either in works in which cosmogonic and sexual subject matter were collapsed into one, as in Dix's *Pregnant Woman* or Gela Forster's *Conception* (*c.* 1919), or it was sublimated in Utopian images of 'spiritual' overcoming; most obviously in Constantin von Mitschke-Collande's series of woodcuts, *The Inspired Way* (1919).

111, 110

The knowledge that they, as well as older Expressionists such as Kokoschka, gained about the primitive came from a strange mixture of sources. These ranged from early anthropological treatises, such as Johann Jakob Bachofen's *Mutterrecht* (1861) and Sir James Frazer's *The Golden Bough* (1890), to Otto Weininger's paranoid and eccentric (though at the time widely lauded) book, *Sex and Character* (1903). In all of these – and not least in Kokoschka's early cosmogonic play *Murderer Hope of Woman* (1909) and related drawings – the tendency was to destroy distinctions between the cosmologies and legends of ancient races and contemporary tribal peoples and to treat them as mutually informative in a way that would later be systematized in the Swiss psychologist C. G. Jung's theories of the 'archetype' and the 'collective unconscious'.

112

Artists' interest in myth and mystical views of nature often led to the apparent abandonment of the object altogether in their work. Abstract art has usually proved resistant to theories of Primitivism that insist on the direct formal influence of the primitive artefact, but when considered in relation to early anthropological beliefs concerning primitive creativity, the Primitivism of many abstract artists becomes clear. Much rests in this case on the profound influence (both direct and indirect) throughout Europe of Worringer, initially through his book, *Abstraction and Empathy* (1908), and subsequently through articles written for avant-garde periodicals, for instance, *Der Sturm* (Storm).

Abstraction and Empathy was Worringer's attempt to explain the great visual differences between works of art separated by time and/or culture essentially in terms of their relative position between two opposing creative urges, which he described as the 'need for empathy' and the 'urge to abstraction'. These correspond approximately to *mimesis* (illusionism) and *ornament* (flat pattern) in visual art. He argued that: 'the urge to abstraction stands at the beginning of every art', slowly receding in the European tradition and 'making way for the urge to empathy', but remaining more or less unchanged in

142

112 Oskar Kokoschka
Murderer Hope of Woman
1909

'savage peoples'. In Worringer's theory the prevailing psychological conditions that are favourable to abstraction are a 'great inner unrest' inspired by the experience of the outside world. But, 'the precondition for the urge to empathy is a happy pantheistic relationship of confidence between man and nature', in which man aspires to dominance. This does not necessarily elevate reason above intuition or mean the superiority of Westerner over primitive. Rather, for Worringer, it makes 'primitive man' something of a seer. Although the primitive urge to divest the 'things' of the external world of their 'caprice and obscurity in the world-picture' by giving them values of 'necessity' and 'regularity' stems initially from feelings of alienation and spiritual helplessness, it also allows primitive vision to penetrate *behind* appearances: 'it is as though', says Worringer, 'the instinct for the "thing in itself" were most powerful in primitive man'.

143

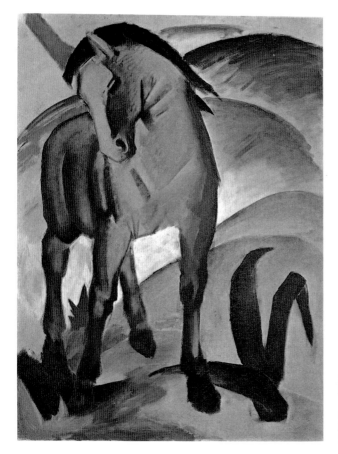

113 *(left)* Franz Marc
Blue Horse I 1911

114 *(opposite)*
Franz Marc *Cows,
Yellow-Red-Green* 1912

The conditions that led to the creative output of primitive peoples appeared to many of Worringer's artist readers, such as Kandinsky, Klee, the Dadaist Hugo Ball and later the sculptor Henry Moore, to parallel those under which they themselves laboured. The appeal of his ideas lay precisely in the ease with which they could be transposed by apologists for the new aesthetic and reapplied to developments in modern art. Kandinsky, for example, whose abstract works of 1913 and 1914 have a distinctly apocalyptic flavour, spoke in his important book *Concerning the Spiritual in Art* (1912) of the modern artist's 'sympathy' and 'spiritual relationship' with the primitive, arising because of the 'nightmare of materialism which has turned modern life into an evil, useless game'. Equally telling is Klee's lyrical transformation of Worringer's thesis from around the same time:

144

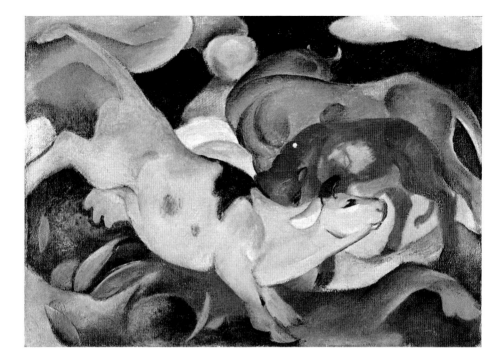

'The more horrible the world is (as today) the more abstract art will be, whereas a happy world produces a realistic art.'

For some, however, all humanity was irredeemably tainted by evil-doing and false desires so they looked elsewhere in their Primitivist search for a vision that beheld the cosmos in its pristine clarity. In the case of the Blue Rider painter Marc this meant attempting to interpret the world through the eyes of animals. As early as 1908 he wrote in a letter: 'I am trying to enhance my sensitiveness for the organic rhythm that I feel in all things, and I am trying to feel pantheistically the rapture of the flow of "blood" in nature, in the trees, in the animals, in the air.... I can see no more successful way towards an "animaliza-tion" of art, as I like to call it, than the painting of animals. That's why I've taken it up.' In such paintings as *Blue Horse I* (1911) and *Cows, Yellow-Red-Green* (1912) Marc provides an image of creatures moving with easy dignity and in complete harmony with nature. The animal in *The Dog Before the World* (1912) presides sage-like and with its back turned to the viewer over a brightly coloured, tumescent landscape, and over its shoulders we are offered a glimpse of God's Creation. This recalls the human presences in the work of the German

113, 114

145

Romantic painter, Caspar David Friedrich. Humans and animals do appear together in some works by Marc, but in *Shepherds* (*c.* 1911) it is the figures who sleep while a cow and blue horse keep silent watch.

ZÜRICH DADA

Like Expressionism's second wave, Dada was a modern movement that grew out of the horror of the First World War. However, although many Dadaists had previously declared themselves Expressionists and Futurists, by 1917 the relationship between Dada and Expressionism was one of enmity. Dada accused Expressionism of false spirituality and ridiculed its Utopian dreams of a revolution through art. In 1920, five years after Dada's first appearance at the Cabaret Voltaire in Zürich, the poet Richard Huelsenbeck went as far as to proclaim that: 'Under the pretext of turning inward, the Expressionists in literature and painting have banded together into a generation which is already looking forward to honourable mention in the histories of literature and art and aspiring to the most respectable civic distinctions.' The aim of Dada, on the other hand, was primarily to shock.

The Dadaists wanted to destroy the cultural complacency that they saw as having finally brought Europe to its knees with the onset of the First World War. In the midst of a European society that rationalized the apocalypse and comforted itself with Romantic justifications the Zürich Dadaists sought to question the psychology that allowed this to occur and to offer alternative ways of seeing. Dada relied for maximum effect on its performances held at the Cabaret Voltaire, when audiences would be constantly subjected to a defamiliarizing barrage of sound, music, poetry and spectacle. But, according to the Romanian artist Marcel Janco: 'People came not for amusement, but to take part in that wonderful atmosphere of mental regeneration.... Mankind was suffering, and its fetishes collapsed one after another.'

The Zürich Dadaists were interested in tribal art. For instance, Hugo Ball experimented with the phonetics of 'Negro' languages, and the Romanian poet Tristan Tzara collected African and Oceanic sculpture from as early as 1916. Janco made masks and costumes that were reminiscent of African prototypes, and his poster from 1918 advertising an event at the Cabaret Voltaire contains two Africanized figures. At first glance they appear to be representations of sculpture, occupying a real if crudely constructed space, but they are drawn as if animate. The figures are ugly in conventional terms and compose

116

146

115 Hannah Höch *The Sweet One* from the series
'From an Ethnographical Museum' 1926

parodies of traditional academic poses. Here Janco uses the primitive to challenge aesthetic sensibility.

115 Dadaist concern for the tribal, though, was only one aspect in a complex Primitivism that relied upon a bewildering array of sources in the cause of upsetting the expectations of the hapless viewer and penetrating cultural excrescences. In their search for what Ball called 'the innermost alchemy of the word' they turned to 'primitive' sources from popular culture and Jazz music to alchemical and mystical Christian writings and Eastern religions. The Zürich Dadaists always maintained that their nihilism and cultural pessimism served the purpose of renewal. As Ball himself asked: 'From where should calm and simplicity come, if no undermining, and no spring-cleaning of the warped base preceded it?'

The programme invitation to an 'author's evening' of 'music, dance, theory, poetry, pictures and costume' on 14 July 1916 does little to alert the prospective spectator to the shock of the Dada experience. However, something of this is presumably contained in Tzara's later Dadaist 'description' of the same evening, which exhibits something of the confusion of a film reel, a montage of discontinuous and disparate fragments:

> Before a dense crowd, Tzara manifests, we want we want we want to piss in various colours, Huelsenbeck manifests, Ball manifests, Arp explanation, Janco my pictures . . . the big box is brought on, Huelsenbeck against 200, Flyyyyyyybuttons accentuated by the very big box and bell-ringing with the left foot, protests shouting smashing the windowpanes killing demolitions fighting the police interruption. Hostilities resumed: cubist dance Janco costumes, each his big box on head, noises, negro music/trabatgea bonoooooooo oo ooooo/5 literary experiments, Tzara in tuxedo explains, at the curtain, dry, sober, for the animals, the new aesthetic: gymnastic poem, concert for vowels, bruitist poem, static poem chemical arrangement of notions.

Although Tzara presents us with a complex, preconceived agitation, certain primitivistic elements inform and intensify the performance. Explanation in note form is punctuated by words ripped from context and letters made to ape the function of description. The audience are subjected to a barrage of unusual elements whose juxtaposition with the expected only serves to heighten the sense of dizziness. Thus, when viewed as an expression of

basic feelings and ideas unspoilt by traditional Western values, the primitive becomes an essential ingredient.

In the light of Tzara's description Janco's costumes and masks can be seen to be instrumental. They are at once primitive by way of their construction and stylistic similarity to African masks, but also in the manner of their use and their low status as objects within the post-Renaissance Western artistic tradition. They were, said Arp, 'terrifying, most of them daubed with bloody red' and constructed out of 'cardboard, paper, horse-hair, wire and cloth'. Like African dance masks, Janco's were unbound by traditional Western restrictions on the mixing of media, since they were produced solely with their projected use in mind and not with a view to their preservation as high art. Ball compared their effect, when in use, directly with early anthropological explanations of primitive ritual. They had, he wrote: 'the same degree of reality as that possessed by an idol of a moloch into whose red-hot arms infant victims were placed.' They were fetishistic vehicles that deconstructed personalities: 'The masks quite simply demand that their wearers assume the movements of some tragically absurd dance.' Inevitably the masks and costumes were damaged in use: 'The big box . . . the cannons, ripping of cardboard costumes the public flings itself', Tzara gibbers. And, like tribal objects, they were repaired and eventually discarded. One result, which can be seen from a Dada-Primitivist point of view as positive, is that post-Dada culture

116 Marcel Janco *Mask* 1919

has precious few of these objects to install in its museums and make soporific. By their destruction the masks remain within their own domain, so to speak, and in this way retain their 'magic'.

The Dada world-view is often distinctly mystical in character, but whereas the Expressionists longed for fusion with nature, either through a literal or introjected loss of identity, the Dadaists always retained the sense of self-hood within the whole. In Expressionist painting and poetry man is spirit imprisoned within nature, whereas a Dadaist such as Arp experienced no such alienation – for him matter and spirit were one, and humankind was an integral part of an organic universe in a continuous process of flux and re-creation, driven by the laws of chance. Arp and his Zürich contemporaries believed that a true work of art does not exist above nature, but that it takes its place within the natural order, as a concrete manifestation of the primal organic process of becoming. This is nowhere clearer than in the amorphous shapes of Arp's wooden reliefs such as *Forest* and *Portrait of Tristan Tzara's Shadows* (both 1916).

Arp's abstract torn paperworks from his time in Zürich and the early 1930s are collected under the generic title *Arranged According to the Laws of Chance*. The chance discovery is central to the idea that found objects, such as roots, pebbles and even manufactured articles, might become art simply through being chosen by the artist. The sculptor Moore, who owed much to Arp's precedent, later provided one of the clearest accounts of this tendency in an essay on the genesis of his work ('Sculpture', 1938): 'Out of the millions of pebbles passed in walking along the shore, I choose out to see with excitement only those which fit in with my existing form-interest at the time.... There are universal shapes to which everybody is subconsciously conditioned and to which they can respond if their conscious control does not shut them off. Pebbles show nature's way of working stone. Some of the pebbles I pick up have holes right through them.'

AT THE WELL-SPRINGS OF CREATION

The primitive that Arp turned to both as visual artist and as poet can be defined in psychological terms, as a process of anti-sense/reason (*Gegensinn*), rather than as formal borrowings from primitive art. Arp's work, as is the case with much twentieth-century sculpture, such as Moore's *Knife Edge Two Piece* (1962), Jacob Epstein's *Female Figure* (1913) and Hepworth's *Pierced Form (Amulet)* (1962), belongs to the vitalist tradition in modern art that equates artistic creation with

117 Hans Arp *Portrait of Tristan Tzara's Shadows* 1916, repainted *c.* 1950

creative processes in nature. Arp makes this clear in a well-known passage from his autobiography, *On My Way*: 'We do not want to copy nature, we do not want to reproduce, we want to produce ... like a plant that produces a fruit. ... We want to produce directly and not through interpretation.' His wash-drawings, woodcuts and reliefs are the result of his search for essentials and the primitive form of things. 'In Ascona', he says, 'with brush and ink I drew broken-off branches, root, grasses, stones, which the lake had washed ashore. I simplified these forms and integrated their essentials in dynamic ovals, images of the eternal transformation and coming-to-be of bodies.'

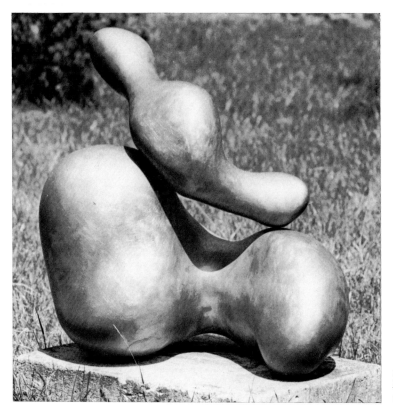

118 Hans Arp
Human Concretion
1933

In 1933 Arp began a series of abstract sculptures to which he gave
the generic title *Human Concretion*. In these he sought to embody the
idea of art as something that grows according to natural laws. Arp
preferred the term 'concrete' to 'abstract' because he believed that it
avoided all connections with the notion of art's reliance on things that
already existed. He said: 'Concretion designates solidification, the
mass of the stone, the plant, the animal, the man. . . . I want my work
to find its humble place in the woods, the mountains, in nature.'
However, the work of art was often viewed as a focus for the
gathering of creative forces. In *Amphora of the Muse* (1959), for
example, stone is shaped into the alchemist's hermetic vessel in which
the union of contraries takes place, mediating symbolically between
matter and spirit.

It is precisely this intercession between our senses and the
undifferentiated forces of Creation (*Urgrund*) that also motivated

118

119

Klee. The deeper the artist looks into natural forms, he said, 'the more readily he can extend his view from the present to the past, the more deeply he is impressed by the one essential image of creation itself, as Genesis . . . stretching from past to the future. Genesis eternal!' The process of evolution and growth is the key element in many of Klee's works, such as *Botanical Theatre* (1924, reworked 1934) and *Cacodaemonic* (1916). His example pervades much later abstract work – from Willi Baumeister's *Rock Garden* (1939), Joan Miro's *The Red Sun* (1948) and Hans Hofmann's *Equinox* (1958) to Giuseppe Penone's *Breath I* (1978) and Rebecca Horn's *Metamorphosis of Beatrice* (1984).

 124, 125
126
127
128, 129

Artistic creation of this kind is often reliant on a type of feeling that sees matter not as lifeless and inert, but as animate, possessing its own unique spirit. It is right to compare this with the idea of the 'animistic sensibility', which early anthropology viewed as an integral compo-

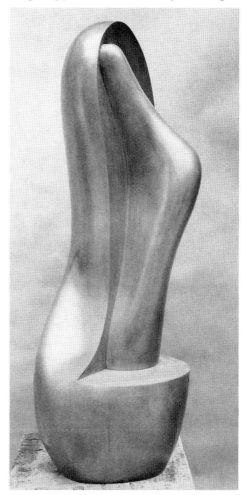

119 Hans Arp
Amphora of the Muse 1959

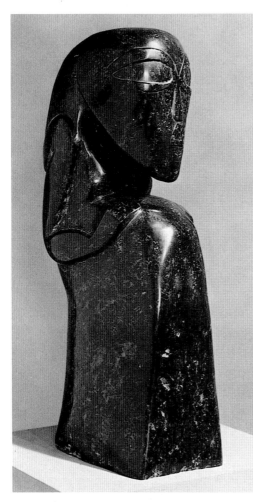

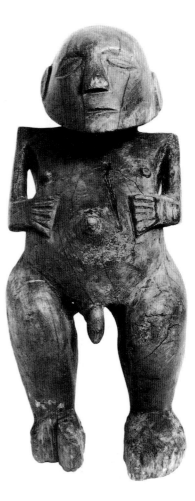

120 *(above)* Jacob Epstein *Female Figure* 1913

121 *(right)* Tahitian standing figure in the form of a man from the Society Islands, Central Polynesia. Collected 1821–24

122 *(left)* Barbara Hepworth
Pierced Form (Amulet) 1962

123 *(below)* Henry Moore *Knife
Edge Two Piece* 1962

124 Paul Klee *Botanical Theatre* 1924, reworked 1934

125 Paul Klee *Cacodaemonic* 1916

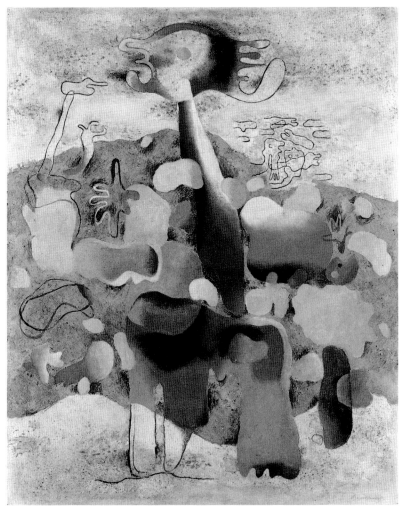

126 Willi Baumeister *Rock Garden* 1939

nent in the world-views of the savage, the child and the neurotic. In *Totem and Taboo* (1913) Freud, whose work in this area is heavily indebted to such men as Frazer, author of *The Golden Bough*, defines animism through a comparison with 'the very remarkable conceptions of nature and the world of those primitive races known to us from history and from our own times. These races populate the world with a multitude of spiritual beings which are benevolent or

127 Hans Hofmann
Equinox 1958

malevolent to them ... they also consider that not only animals and plants, but inanimate things as well, are animated by them.' He describes 'animistic conceptions' as 'the necessary psychological product of the myth-forming consciousness' and perceives animism as a primitive stage in mankind's psychic development towards a fully mature, 'scientific' view of the world. Freud subsequently compares this explicitly with 'the stages of the libidinous evolution of the individual' from 'narcism', resulting from the primitive belief in the 'omnipotence of thought', to a stage at which, 'having renounced the pleasure principle ... he seeks his object in the outer world'.

The animistic sensibility is related to attempts to return to a more primitive way of seeing, or what has sometimes been called 'primary vision', as opposed to ordinary adult perception that orders the world in utilitarian terms as a set of causes or means. Primary vision is a form of 'pure' perception that frees artists from theoretical and practical concerns, allowing them to experience the immediate expressiveness

158

128 *(right)* Giuseppe Penone
Breath I 1978

129 *(below)* Rebecca Horn
Metamorphosis of Beatrice
1984 (detail)

of things – everything is a presence and nothing is an *it*. We find examples of the operation of this type of 'perceptual primitivism' throughout the practice of artists working at the Bauhaus in Germany in the 1920s and 1930s, such as Johannes Itten, Kandinsky and Klee. Another Bauhaus artist, Baumeister, later provided an emphatic statement of primary vision's importance in his book *The Unknown in Art* (1960): 'Prior to our bodily and utilitarian sight there exists an original state of vision. One might call it "concrete vision". It transcends the intellect and understands all appearances as purely visual phenomena ... the artist possesses the ability to see things in a "dematerialized" way, and the world assumes a strange depth and vastness.'

Much abstraction contains implicit Primitivist appeals to the syncretistic vision of young children who, impervious to component detail, perceive reality as an undifferentiated living whole. Spontaneous paintings and drawings by very young children are often valued for their supposed formal-abstract qualities and compared to works by artists such as Klee, Miro, Dubuffet and Wols. However, although a child's depiction might appear abstract to adults, a three-year-old's picture of 'dollies', for example, is, to its producer, a correct rendering of the subject. In superficially similar modern works childhood vision is only briefly regained at a complex and highly structured level.

It is frequently claimed that the primary vision of the savage, as well as that of the child, is integral with invocations of the 'mythic' and the 'magical' in art. Lévi-Strauss argues in *The Savage Mind* that the chief value of myths and rites is 'to preserve until the present time the remains of methods of observation and reflection which were ... precisely adapted to discoveries of a certain type: those which nature authorized, from the starting point of a speculative organization and exploitation of the sensible world in sensible terms.' Myths are shared collectively by individual cultural groups and, in this sense, they are simultaneously related to the present *and* jumbled signposts to a primordial past. Whereas Freud dismissed primitive thought because it made the savage 'the hapless child of the moment', Lévi-Strauss (while preferring to see it as something 'prior' to civilized thought) counsels that 'magical thought is not to be regarded as a beginning, a rudiment'. The quality of 'completeness', coupled with the notion that magical thought stands *before* civilization, might help to explain its appeal to modern Primitivists in search of a personal myth for their times, beginning with Surrealism in the 1920s and 1930s.

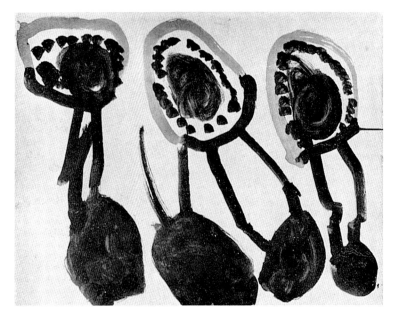

130 Child's drawing of dollies

THE SURREALIST EXPERIMENT

Surrealism inherited much from Dada. Similarly to the Dadaists, Surrealists attacked and subverted conventional methodologies and beliefs, but where the former proposed no systematic replacement for the culture they sought to undermine, the Surrealists attempted to introduce a new set of values supported by an alternative philosophical tradition, peopled by unfashionable and anonymous heroes. The Surrealists were among the first artists to read seriously Freud's psychoanalytical theories of the unconscious as proposed in such books as *Interpretation of Dreams* (1900) and *Psychopathology of Everyday Life* (1901). It was from Freud that André Breton took his lead in *The First Surrealist Manifesto* (1924), in which he argued that the key to erecting this proposed new system lay in harnessing the unconscious mind. He wrote: 'If the depths of our mind contain within it strange forces capable of augmenting those on the surface, or of waging a victorious battle against them, there is every reason to

seize them – first to seize them, then, if need be, to submit them to the control of our reason.'

Access to the unconscious could be gained, Breton believed, through dreams, altered states of mind and automatic techniques that relied on the effects of chance. In the visual arts the German painter

136 Max Ernst used the techniques of *frottage* (rubbing) and *grattage* (scraping) throughout the 1920s and 1930s in order to tease strange creatures into a shadowy existence from the chance marks thus created. More unpredictable effects arise from the use of decalcomania (paper transfers of paint spills), which the Surrealists 'rediscovered' in around 1935 and used to create suggestive, random abstractions. Several of these were illustrated in No. 8 of the Surrealist magazine, *Minotaure*, including ones by the painters Oscar Dominguez and Yves

131 Tanguy, as well as by Breton himself. But the suggestive possibilities of decalcomania were put to their most complex use by Ernst – 'as a means of forcing inspiration', as he put it – in figurative works made while living in the United States. These included *The Harmonious Breakfast* (1939) and *Europe After the Rain II* (1940–42).

The Surrealist appeal to the unconscious can be regarded as Primitivist in so far as psychological reliance upon its operations was considered at the time, not least via their reading of Freud, to belong to a much earlier period in human development, that is, prior to the growth of conscious, rational thought, as with children and tribal peoples. More importantly, perhaps, through their knowledge of the work of Freud and Jung, as well as such ethnologists as Lévy-Bruhl and Marcel Mauss, the Surrealists believed that unconscious thought was mythic in character. They considered the seemingly irrational (and therefore primitive) rituals that are central to tribal cultures (and that are mirrored in children's play) to reveal a more profound knowledge about the world than conscious thought, which relies too heavily on appearances and the expected. The unconscious, on the contrary, allows access to the hidden content of experiences and things.

Breton himself argued that the only true works of art of the age were Surrealist because they expressed its unseen elements. He believed that the perceptual Primitivism involved in revealing the workings of the unconscious demanded that the only real depictions are those that give us back the 'freshness of the emotions of childhood'. This was to be found 'only at the approach of the fantastic, at a point where human reason loses its control.' Here, he says in 'Limits Not Frontiers of Surrealism' (1937): 'the most

131 André Breton *Decalcomania* 1936

profound emotion of the individual has the fullest opportunity to
express itself: emotion unsuitable for projection in the framework of
the real world and which has no other solution in its urgency than to
rely on symbols and myths.'

Significantly, it is through perceptual Primitivism, as defined
here, that the commonplace is most strangely transformed by the
Surrealists. In *Two Children are Threatened by a Nightingale* (1924), for 132
example, Ernst employs a mixture of the painted image, and a real
tiny wooden gate and door in order to create the sense of the uncanny
that pervades the nearly familiar. Imaginative reworkings of old
master paintings by the Spanish artist Joan Miro, such as *Dutch Interior* 133
II (1928), also rely on an intuitive perception which reveals a seething,
amorphous animation connecting figures, objects and space.

Masson sought to expose the workings of the unconscious through
automatic drawings such as *Why didst thou bring me forth from the
womb?* (1923) and *Furious Suns* (1925), which are characterized by the

132 Max Ernst *Two Children are Threatened by a Nightingale* 1924

ambiguity of their subject matter. This is a consequence of the undirected (automatic) nature of the mark making in the early stages of the drawings, during which time Masson waited for indications of the emergence of subject matter before consciously establishing recognizable figurative elements. The resulting images were very often sexual, and particularly feminine, in nature – corresponding to Freud's belief that the unconscious reveals repressed sexuality and one's dreams of otherness. Masson offers his viewers images of the process of metamorphosis. The visual ambiguity that is such an important feature of these works is central to the sense of flux and continual reinvention of the world, possible only through contact with the irrational, the unconscious, which Freud considered to be the infantile (that is, primitive) part of our psychology.

Like other Surrealists, Masson believed that women, in general, remained in closer contact with the unconscious than men, and in his

164

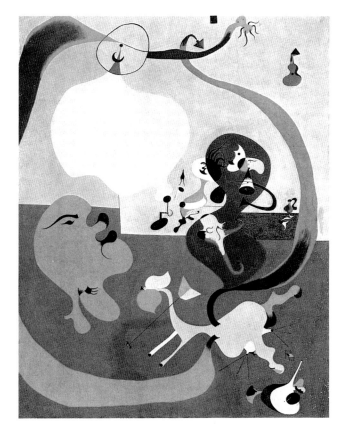

133 Joan Miro
Dutch Interior II 1928

work the female has the dual function of being an object of desire and a symbol of humanity's primitive bonds with the creative forces of nature. The supposed connection between woman and earth, sexuality and natural creation is made explicit in images of women where paint is mixed with sand and earth, such as *Figure* (1927) and *The Earth* (1939). However, the desire to represent that primordial place at which the human psyche exists in unity with nature is nowhere clearer than in Masson's interest in the theme of metamorphosis. This was a common narrative subject in Renaissance art, usually influenced by Classical writings by the Roman poet Ovid and others, but through his reading of Frazer's *Golden Bough* Masson extended the content of his narrative to parallel myths from tribal cultures. The composition of his *Metamorphoses* (1939) is reminiscent of traditional Adam and Eve subjects, though Masson's figures appear to be constructed entirely from vegetation, animals and birds. This is a

134 *(left)* Victor Brauner *The Birth of Matter* 1940

135 *(opposite)* Max Ernst *The Elephant Celebes* 1921

painting that attempts to overcome rational vision and pierce the surface appearance, thereby spanning the chasm between the conscious and unconscious self.

Frazer's *The Golden Bough*, from which Surrealists such as Masson, Ernst and Victor Brauner often drew inspiration, functioned as a hugely influential sourcebook of myths and legends from all times and cultures. Although Frazer's purpose had been to map out universal patterns of human thought behind the apparent diversity of lifestyles, its thematic structure seemed to them to offer a way out of the objective chronological ordering of data demanded by Western science. In this way, Brauner could create generalized mythical hybrids in such paintings as *The Birth of Matter* (1940), and Ernst was able to evoke the mythic sensibility through the juxtaposition of culturally distinct images. For instance, in *The Elephant Celebes* (1921)

134

135

166

an African corn bin is demonized through mechanization, while in *La Belle Jardinière* (1923) the ghostly male foil to a woman and dove is a curious mixture of tattooed Marquesan and Green Man from Western European folklore. Elsewhere, as in *The Sea and the Rain* (1925) and *Vision Induced by the Nocturnal Aspect of the Porte Sainte-Denis* (1927), Ernst suggests the laying bare of primal memories of mythic places and creatures through a manipulation of chance effects gained partly by the use of techniques such as *frottage*. In his *Forest* pictures he constructs almost endless transformations of recurrent motifs through *frottage* and other associative and intuitive methods. Compare this with Lévi-Strauss's description of the process of 'mythical thought' that, he says, 'builds up structured sets, not directly with other structured sets, but by using the remains and debris of events'. In this way, 'Mythical thought . . . is imprisoned in the events

136
137

136 Max Ernst *The Sea and the Rain*
1925

and experiences which it never tires of ordering and re-ordering in its search to find them a meaning.' This is the source of its lack of historical perspective, but 'it also acts as a liberator by its protest against the idea that anything can be meaningless'. In the domain of myth, every thing is potentially of use.

SURREALISM AND PRIMITIVE ART

Surrealism has a particular and relatively well-documented relationship with so-called primitive art. There is a fondness among many Surrealists for African and Oceanic art, clearly evident in works by the Cuban painter Wifredo Lam, such as *The Jungle* (1943) and *Murmur of the Earth* (1959), but also for Native American tribal art and

138
139

137 Max Ernst *Vision Induced by the Nocturnal Aspect of the Porte Sainte-Denis* 1927

pre-Columbian court arts. Lam's demonized, poetic evocation of a jungle derived from African and Oceanic sculpture is particularly interesting in this context because it signals a visual attack on colonialism by the colonized and with it an assertion of the painter's own negritude.

The extent of Surrealist interest in cultures outside the West is clearly demonstrated by a map published in a Belgian review, *Variétés*, in 1929, entitled 'The World in the Time of the Surrealists'. Here the relative sizes of geographical areas were redrawn to reflect their importance in the Surrealist project. Thus, Europe is decentred and its dominant position replaced by the Pacific Islands, flanked by Russia on one side and the 'primitive' America on the other. Russia remains important because it is the site of the first Marxist state, but

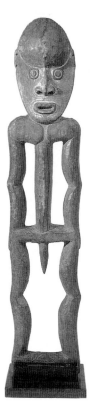

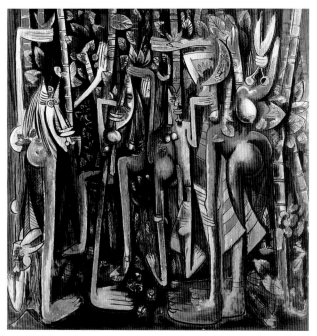

138 *(left)* Iatmul figure from East Sepik Province, Papua New Guinea

139 *(above)* Wifredo Lam *The Jungle* 1943

the others are given prominence by virtue of the parallels between their perceived primitive states and Surrealist thought. Africa, though, is relatively small, which is partly a reflection of the fact that Breton and others preferred what they saw as the more 'fantastic' nature of art from the South Seas and the American north-west coast. However, it is surely also a result of the institutional blessing that conventional French ethnography had given to 'African Studies' by the end of the 1920s. Similarly, although there was a fashion for *l'art nègre*, black music and artistes such as Josephine Baker in the 1920s, which had arisen directly out of pre-war Parisian avant-garde interests in tribal art, it was treated on the whole with circumspection by Surrealism, precisely because of the seeming ease with which Africa had been absorbed by conventional European culture – the Surrealist photographer Man Ray's stylish juxtaposition of white female and dark African mask in *Black and White* (1926) is, ironically, an indication of the extent of this cultural appropriation.

140

Given their interest in primitive culture as a whole it is not surprising that the formal influence of tribal art was real and demonstrable in Surrealist art. Often we can detect an artist's use of a certain type of object and sometimes even of a particular piece. For example, Brauner's *Prelude to a Civilization* (1954), which is reminiscent of ceremonial pictographic robes worn by American Plains Indians, the Swiss sculptor Alberto Giacometti's *No More Play* (1933), which is related to gameboards used in parts of West Africa, or Moore's *Girl* (1932), whose starting-point was a small Eskimo carving he had studied in the British Museum, London.

Miro's paintings often have a whimsical, childlike quality that seems to be derived, in part, from his interest in Eskimo masks such as the one from Alaska formerly in the collection of Breton. In these masks feathers and carved objects protrude from a central face, and variations on the device are reproduced in pictures by Miro, such as *The Hunter (Catalan Landscape)* (1923–24) and *Carnival of Harlequin* (1924–25). Ernst and other similar artists attempted to identify much more profoundly than Miro with tribal culture, for instance, in his construction of a personal totemic myth, based around an alter ego in the form of a bird, called Loplop. Ernst's Surrealist work is pervaded by a sensibility that is seemingly given over entirely to tribal perception, as comprehended through his wide-ranging reading of such men as Frazer, Lévy-Bruhl and Freud.

141 142 148 149 144, 143 145, 146 147 150 151

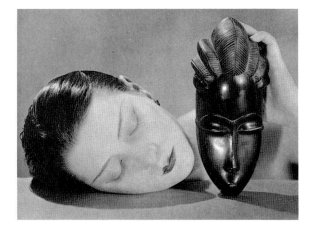

140 Man Ray *Black and White* 1926

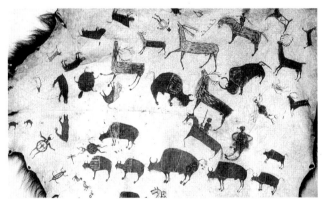

141 *(top)* Victor Brauner *Prelude to a Civilization* 1954

142 *(above)* American Indian Sioux buffalo-skin robe. Collected 1833

144 *(far right)* Henry Moore *Girl* 1932

143 *(right)* Eskimo figure from Alaska. Nineteenth century

145 *(above, left)* Eskimo shaman's mask from South Alaska. Early twentieth century

146 *(above, right)* Eskimo mask from Hooper Bay, Alaska

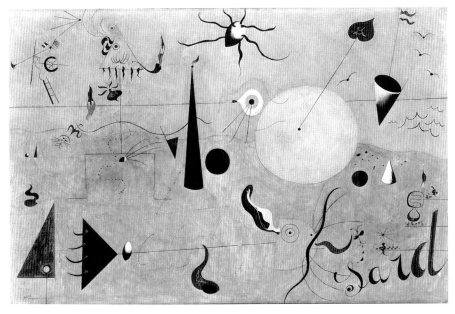

147 Joan Miro *The Hunter (Catalan Landscape)* 1923–24

148 *(above)* Alberto Giacometti
No More Play 1933

149 *(right)* Gio gameboard from
Liberia

Totemism relies on the operation of an animistic sensibility that
involves, according to Lévy-Bruhl, the belief that all things are related
to other groups: 'to the primitive who belongs to a totemistic
community, every animal, every plant, every object indeed, such as
sun, moon, stars, forms part of a totem', thus allowing a kinship to be
set up between all things in the cosmos. Ernst's own fictional account
of his becoming an artist is important in respect of these connections:
'Max Ernst died', he tells us, 'the 1st of August 1914. He resuscitated
the 11th of November 1918 as a young man aspiring to become a
magician and to find the myth of his time. Now and then he consulted
the eagle who had hatched the egg of his pre-natal life. You may find
the bird's advices in his work' (*Beyond Painting*, 1948). Ernst's
symbolic transformation when he was initiated into shaman-artist
relates directly to such primitive myths described by Frazer and
others, especially in so far as the First World War, in which Ernst

174

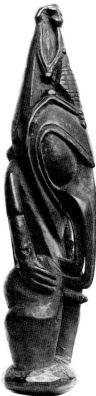

150 *(above)* Max Ernst *Loplop présente Loplop (Chimère)* 1930

151 *(right)* Bosman standing figure of a man from Ramu River, Northern New Guinea 1936

The Surrealists often used primitive art in a more informed way than their predecessors. Ernst explored the magical purpose of hybrid figures in his search for a shamanic persona, while absurd non-functional 'games' by Giacometti can be compared with decontextualized African gameboards.

fought, is emblematic of the period of trial and physical danger through which the aspiring shaman must pass.

The use of primitive forms by certain Surrealists (as in the case of Ernst, Brauner and Lam) reflects an informed ethnographic knowledge that was absent in the earlier Primitivist works of, for instance, Picasso and Brancusi. This is important if, as is probably the case, they subscribed to the idea propounded by Mauss and his followers, including ethnographers within the Surrealist group such as Leiris, that the primitive artefact, when removed from its original context, nevertheless functions as a 'witness' for the culture that produced it. It follows that it should be possible to re-create something of a living culture through its objects. For example, Ernst incorporated references to African art and the supernatural Native American *kachina* 152 dolls that were thought to be the ancestors of humans in *Moon Mad* 154 (1944) and references to Easter Island petroglyphs carry symbolic

152 *Kachina* doll from Zuni, Arizona. Early twentieth century

force in *The Interior of Sight: The Egg* (1929). In these works primitive forms are made to ape their original functions, or rather, they undergo a Surrealist transformation. In 'restoring' them to life, Ernst re-sites them in the context of Western usage even as he strives to undermine the dominant Western position.

References to totemic myths and the notion of the artist as a medium or seer can be discerned throughout Surrealism, including the work of later adherents to the movement, such as the Chilean painter Matta Echaurren and Lam, as well as among artists whose association was more distant. The content of Kandinsky's Parisian works of the 1930s, for example, appears to relate partly to European shamanic imagery, while Lipchitz's *Figure* (1926–30) provides a more 155 vaguely defined image of totemic structures. Similarly, Read drew upon a shared interest in Jungian psychology to call attention to Moore's chthonian concerns. He argued, for example, that in *Upright* 153 *Motive No.1: Glenkiln Cross* (1955–56) Moore had characteristically attempted to mediate between the 'chaos of the unconscious' and the 'order which art imposes on this chaos'. The fact that the form is irregular ('even the "cross" is blunted and humanized, and the pedestal or shaft deformed') is of no concern to Read, for: 'We must not confuse order with regularity or symmetry'.

ART AND ANTHROPOLOGY

The use to which the Surrealists put information they had gained about non-European cultures from their reading of early anthropological texts often undermined the intentions of their authors – where the latter saw evidence of social evolution or the existence of a 'Great Chain of Being', which supported the idea of the West's dominant position in the world, Surrealism imposed a vision of cultural rupture. Consequently, the writer James Clifford has argued that the Surrealists' interest in primitive art was motivated by a more profound sense of its difference: 'Unlike the exoticism of the nineteenth century, which departed from a more or less confident cultural order in search of a temporary *frisson*, a circumscribed experience of the bizarre, modern Surrealism and ethnography began with a reality deeply in question. Others appeared now as serious human alternatives: modern cultural relativism became possible.' However, where ethnography 'strives to render the unfamiliar comprehensible', Surrealism makes 'the familiar strange'.

 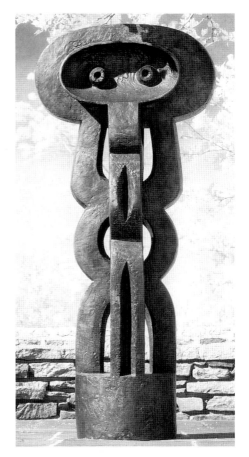

154 Max Ernst *Moon Mad* 1944 155 Jacques Lipchitz *Figure* 1926–30

The formal simplifications wrought on the human figure in the sculpture of Ernst, Lipchitz and Moore represent part of their attempt to strip objects of the layers of complexity that civilization had given to the perceptions of modern Europeans and to reveal more profound, primitive depths. These works have in common a desire to present what Jung called archetypal images, commonly comprehensible irrespective of race or history.

153 *(opposite)* Henry Moore *Upright Motive No.1: Glenkiln Cross* 1955–56

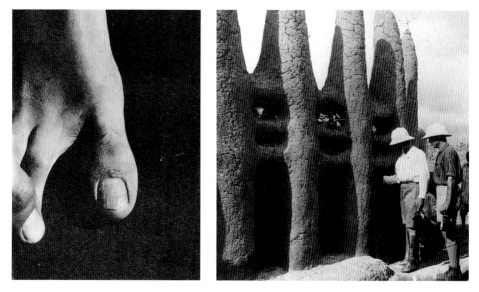

156 *(left)* Jacques-André Boiffard *Untitled* 1929

157 *(right)* Marcel Griaule and Michel Leiris prepare to sacrifice chickens before the Kono altar at Kemeni, 6 September 1931, as a condition of entering the sanctuary

Ironically, Surrealism and ethnography seem to meet most emphatically not in Breton's mainstream group, but among the 'dissident' Surrealists, including Leiris and Georges Bataille, who gathered around the journal *Documents* in 1929. The magazine's basic method was the juxtaposition and collage of apparently unrelated fragments in order to present, as Clifford writes: 'evidence or data', but only of 'surprising, declassified cultural orders and of an expanded range of human artistic invention.... The Surrealist moment in ethnography is that moment in which the possibility of comparison exists in unmediated tension with sheer incongruity.' Examples of this can be found in Bataille's idea of *bassesse* (baseness) developed in an essay, 'The Big Toe', which was accompanied by photographs of toes by Jacques-André Boiffard. Bataille argued that this was 'the most human part of the body ... no other element of this body is as differentiated from the corresponding element of the anthropoid ape', but that mankind has a 'secret horror' of it because it is firmly fixed 'in the mud'. Perhaps unsurprisingly, the excesses of pre-Columbian culture were an important symbol of Bataille's idea of *bassesse*. In 'Lost America' (1930) he speaks of the 'astonishing joyous character' of the

156

'horrors' of human sacrifice – for the Aztecs 'death was nothing'. Their culture is simultaneously beautiful and ugly, seductive and repugnant: 'Mexico was not only the most streaming of the human slaughterhouses, it was also a rich city, a veritable Venice of canals and bridges, of decorated temples and beautiful flower gardens' – as beautiful as the flies that swarmed on the running blood.

Pre-Columbian art was an important source in much modern work related to Surrealism, from Moore's translation of the 'stoniness' of Mayan rain gods in *Reclining Figure* (1929) to Diego Rivera's design for the cover of the periodical *Minotaure* (1939). But the artist who perhaps comes closest to the concerns of Bataille is Giacometti. Throughout the 1920s he had made drawings of African and Oceanic sculpture (apparently from photographs, rather than the real objects) and his early works, such as *The Couple* (1926), employ formal elements of primitive art, though they are wrenched from their tribal context and used either to produce visual puns, or as a kind of representational shorthand. Unlike mainstream Surrealists such as Ernst, Giacometti was not an amateur of ethnology and his Primitivism must be considered against a complex relationship between indirect primitive sources, through the work of such artists as Brancusi, as well as a wide range of primitive art itself. The artist's *Invisible Object* (1934), for example, is related to certain

160, 159, 158

161

162

158 Diego Rivera *Minotaure* 1939. Design for the inner cover of *Minotaure* No. 12–13

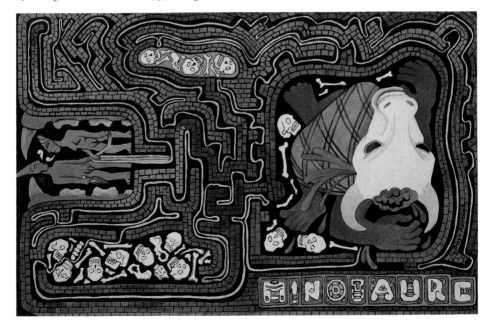

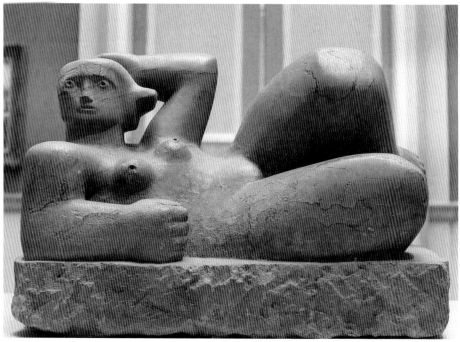

159 Henry Moore *Reclining Figure* 1929

160 Mayan rain god from Chichén Itzá, Mexico AD 948–1697

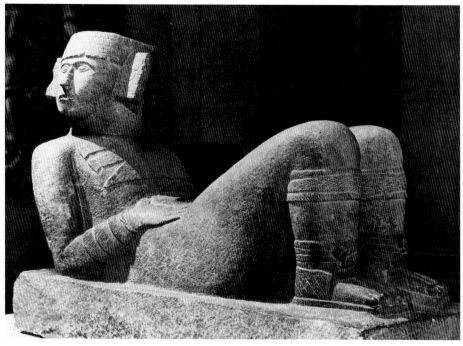

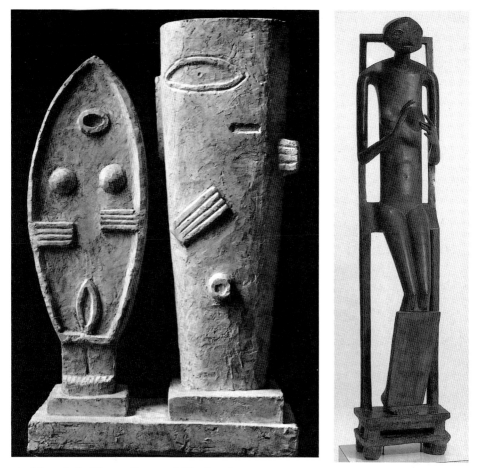

161 *(above, left)* Alberto Giacometti *The Couple* 1926

162 *(above, right)* Alberto Giacometti *Invisible Object* 1934

characteristic figure sculptures from the Solomon Islands – notably in the bent-legged pose and architectural frame – yet, one of the most striking features, the mask-like face, derives from a French military protection mask produced during the First World War. In sculptures, for instance, *Suspended Ball* (1930–31) and *Cage* (1931), Giacometti utilizes forms from cultures as distant as Melanesia and Mexico as structural, symbolic elements and presents us with objects that can be understood as erotic machines for desire. *Suspended Ball* is 'explicitly sadistic ... For the sliding action that visibly relates the sculpture's

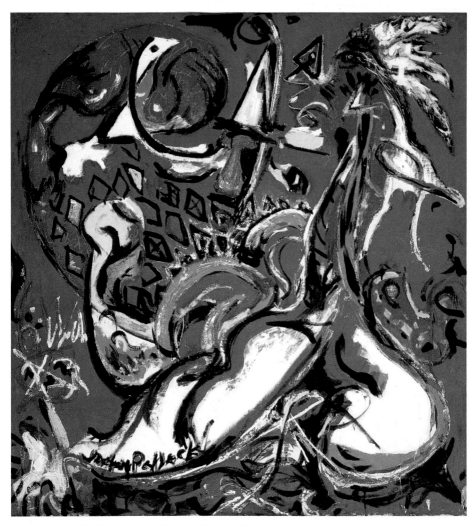

163 Jackson Pollock *The Moon-Woman Cuts the Circle* 1943

grooved sphere to its wedge-shaped partner not only suggests the act
of caressing but that of cutting' (Rosalind Krauss, 'Giacometti', 1984).
Aside from the crudity of its construction – its stylistic Primitivism –
Suspended Ball reflects the deeper, more pervasive intellectual
Primitivism of the *Documents* group. It represents a collapse of the
distinction between genders and the lure of the combined slaughter-
house and altar.

184

Surrealism was born, in the wake of the First World War, out of the belief that the West's abandonment of the mythic or symbolic aspect of its everyday life was detrimental to its cultural well-being. Most Surrealists concluded that reparative action could not be achieved by attempting to revive existing, though destitute, systems and instead they looked to other, apparently more primitive world-views, as a means of establishing a new Western culture. In Paris, until his death in 1944, Kandinsky explored the possibilities of shamanic imagery as a vehicle for a transcendent abstraction, including elements similar to the pictograms on shaman drums from Siberia, as is the case in *Le Lien* 165, 166 *vert* (1944) and related drawings. But, in the face of the new darkness that befell Europe in the 1930s many artists transported these interests and the general Surrealist project to the United States, where they complemented and enriched the established concerns of New York artists such as John Graham, Adolph Gottlieb, Lee Krasner, Richard 167, 169 Pousette-Dart and Jackson Pollock. 163

164 Theodoros Stamos *Ancestral Myth* 1943

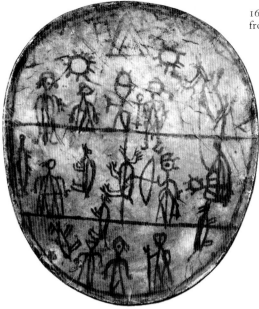

165 Lapp shaman's drum (bowl type) from Northern Scandinavia

Abstract Expressionists such as Gottlieb sought the primitive within the arts of the native 'tribal' peoples of North America, often producing 'ideographic' pictures that seemed to exist at the coming into being of language – a process that, at the end of his life, the Russian painter Kandinsky reversed in images derived in part from the pictograms of the shamanic tribes of Siberia and Scandinavia.

166 Wassily Kandinsky Untitled drawing for *Le Lien vert* 1944

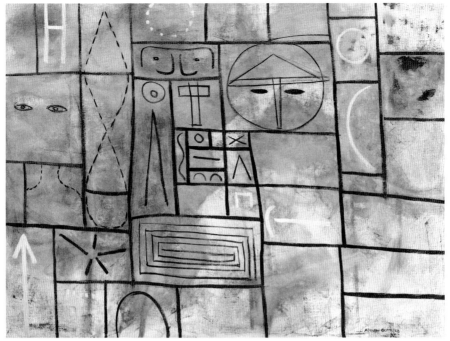

167 Adolph Gottlieb *Labyrinth No.2* 1950

168 Tlingit blanket from Alaska 1850–1900

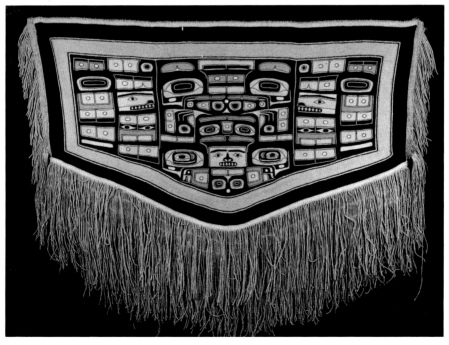

The Surrealist technique of juxtaposing incongruous pictorial elements was used by many of these artists in their painting and Pollock in particular adapted automatic techniques with monumental results in his so-called 'all-over' paintings, such as *Number 1, 1948* (1948). More significant, perhaps, is the New York painters' generally well-informed interest, mediated through a knowledge of Jung's writings, in tribal art and culture, and especially that of the various Native American groups. As with the Surrealists their view was that the artist should act from the position of a medium or seer. Their general belief was summed up well by Graham, who said: 'The purpose of art in particular is to reestablish a lost contact with the unconscious . . . with the primordial racial past.' Typically, Pousette-Dart defined this in specifically American terms: 'I felt close to the spirit of Indian Art. My work came from the spirit or force in America, not Europe.'

The Abstract Expressionist Barnett Newman's importance lay as much in curatorial and critical activity as in painting in the period

169 Richard Pousette-Dart *Hesperides* 1944–45

170 Jackson Pollock *Number 1, 1948* 1948

from 1944 to 1947, when he was involved in several interesting exhibitions in New York: *Pre-Columbian Stone Sculpture* (1944), *Northwest Coast Indian Painting* (1946) and *The Ideographic Picture* (1947). Whereas the first two were concerned with examples of primitive art, the last presented modern American artists (Newman, Mark Rothko and Theodoros Stamos among them) who had turned to Native American and other primitive sources as part of an attempt, echoing the Surrealist Breton's words, to create the 'living myth of our time'. In his introduction to the catalogue of the 1946 exhibition Newman employed the still-pervasive idea that primitive society was communal to argue for the 'democratic' nature of abstract art. He saw in the north-west coast Indian works an answer 'to all those who assume that modern abstract art is the esoteric exercise of a snobbish élite, for among these simple peoples, abstract art was the normal, well-understood, dominant tradition.'

The New York painters' common interest in Jungian psychology led them to believe that their work arose from the unconscious and,

164

therefore, contained within it the possibility of communicating directly with the viewer at this more primitive level, so that they might, in Newman's words, make 'ideographic' pictures that present symbols or figures which suggest the idea of an object 'without expressing its name'. They saw the unconscious as a dark, primordial and subterranean realm populated by mythic and religious symbols, and their interest in Native American art led them to experiment with its visual grammar and ancient motifs as a way of penetrating the unconscious mind, resulting, for instance, in works such as Gottlieb's *The Oracle* (*c.* 1947) and Pollock's *The Moon-Woman Cuts the Circle* (1943). This painterly method of shamanic self-discovery was related to two Jungian principles, namely, that myths are archetypal forms that codify basic human experiences, and that conscious and unconscious are interfused. These ideas are brought together in Pollock's famous statement from 1947: 'My painting does not come

102, 163

171 Nancy Graves *Paleo-Indian Cave Painting, Southwestern Arizona (To Dr. Wolfgang Becker)* 1970–71

172 Joseph Beuys *House of Shaman I* 1959

from the easel. . . . On the floor I am more at ease. I feel nearer, more a
part of the painting, since this way I can walk around it, work from
the four sides and literally be *in* the painting. This is akin to the
method of the Indian sand painters of the West. . . . I have no fears
about making changes, destroying the image, etc., because the
painting has a life of its own. I try to let it come through. It is only
when I lose contact with the painting that the result is a mess.'

The idea of the artist as shaman or seer is a recurring theme in art of
the 1960s and 1970s, including among other works early sculpture by
Nancy Graves, in which materials such as bones and animal hides
were used in conjunction with more accepted sculptural materials to
construct elaborate mythic objects, as is the case in *Paleo-Indian Cave* 171
Painting, Southwestern Arizona (To Dr. Wolfgang Becker) (1970–71). It
is a particularly powerful and pervasive element in the work of Beuys
from early drawings and watercolours, such as *House of Shaman I* 172
(1959), to the later objects and performances ('Actions') on which his

reputation rests. In the latter work the figure of the artist himself looms large. Beginning in the early 1960s, it was through Beuys that metaphysical processes and spiritual energies were channelled in 'Actions' such as *How to Explain Paintings to a Dead Hare* (1965) and *Eurasia* (1966). In the former, Beuys – his head covered in honey and gold leaf – conducted the hare on a tour of the gallery. Where painters of the New York School had explored the 'magical' symbolism of Native American shamanic ritual, Beuys turned to Northern Europe's pagan past for guidance and, for him, these performances were part of a process of cultural healing:

> The hare has a direct relation to birth.... For me the hare is a symbol of incarnation. The hare does in reality what man can only do mentally: he digs himself in, he digs a construction. He incarnates himself in the earth and that itself is important.... Using honey on my head I am naturally doing something that is concerned with thought. The human capacity is not to give honey, but to think – to give ideas. In this way the deathlike character of thought is made living again.

173 The importance of honey as a primitive, organic symbol of the transformations of energies, comparable with alchemical processes, was brought most closely into focus in the installation, *Honey Pump at the Work Place* (1977), in which electric motors circulated honey through a museum via a system of transparent tubes. To note the similarity with the human circularity system is irresistible. It was through the viewer's recognition of this that Beuys hoped to suggest comparisons between the dynamics of the organism and possibility of what he called the 'social sculpture' or society as a work of art.

173 Joseph Beuys *Honey Pump at the Work Place* 1977

174 Bembe sculpture of Europeans in a motor-car from the People's Republic of the Congo. Early twentieth century

Primitivism and the Dilemma of Post-Colonialism

The history of the West's contact with its colonies is usually presented as one of steadily worsening relations between colonizer and colonized, destined to culminate in the extinction of primitive societies – either literally, as in Tasmania, or in the sense of radical change brought about through the 'civilizing process'. In view of this it was possible to formulate the idea of making collections in the West of 'authentic' tribal works and of justifying the removal of objects from the colonies to ethnographic museums as acts of rescue. Yet this can also be seen as another indicator of a deep-rooted Western desire to classify and preserve, even where those other cultures in question place no value on the continued existence of individual objects.

The paternalism and lack of trust that is still to be found in the West's attitude towards the developing world is a sign of its continued involvement with it and the remaining potency of myths of the primitive at work in the relationship. Colonialism made the need for a description of subject peoples necessary – both of their manners and their way of life – in order not so much that they might be understood, but as a means of exercising control over them. Representations of the colonial subject devised by the West for Western consumption were essentially stereotypes based on the specific administrative needs of the 'Mother Country'. As a result some writers have provided definitions of Primitivism that reflect imperialist power gambits operating in the institutions of the West, where the Western gaze is directed towards non-Western peoples. This 'institutional primitivism' reflects the prevailing, dominant ideas of Western society. It is, first and foremost, a means of justifying and reaffirming conventional Western values, rather than a weapon whereby those principles might be challenged. Modern art, though, is marked by its adoption of critical stances against the cultural institutions of the West and its Primitivism is accordingly distinct from the institutional variety.

The great irony of the moderns' search for the primitive is, of course, that although it must be viewed in the context of a reaction

against the cold rationalism and functionalism that had come to characterize the most influential ideas in western science, philosophy and politics, the definitions of the primitive to which artists turned were created and maintained by those same disciplines. Modern artists were, it must be said, the first who were able to draw on a vast body of scientific knowledge in order to justify their Primitivism. Yet, while they made use of conventional definitions of the primitive, they always began by assigning it positive value. Criticism of precisely the ideas that produced this definition was implicit in modern artists' embrace of the primitive in all its various guises.

Attempts to neutralize and retain the word primitive by emptying it of its pejorative meanings continue to find approval in the popular imagination today. This is a legacy of anthropological theories – born out of the milieu of Surrealism – that narrow the word's meaning to tribal peoples and that afford equal status to definitions of the primitive and civilized alike. But by continuing to insist on the fundamental difference between the two world-views such theories reproduce the dilemma at the heart of modern artistic Primitivism; that is, the relevance of the primitive as a point of opposition in postmodern Western cultures is apparently given institutional sanction, while at the same time its difference to those cultures is re-emphasized.

The attraction of this idea of the primitive is described by Susan Hiller in *The Myth of Primitivism* (1991). Hiller tells how, in a lecture on African art, she decided to abandon her studies in anthropology and become an artist, relinquishing 'factuality' for 'fantasy': 'I felt art was, above all, irrational, mysterious, numinous: the images of African sculpture I was looking at stood as a sign for all this.' At the time, Hiller says, art seemed to offer the promise of empathy with tribal peoples, as opposed to scientific 'knowledge' about them. The emphasis on feeling above rationality is, of course, also a characteristic of earlier artistic Primitivism, although we might be wise to heed the words of the Martinican writer Frantz Fanon in his anti-colonialist polemic, *Black Skin, White Masks* (1952): 'I believe it is necessary to become a child again in order to grasp certain psychic realities. This is where Jung was an innovator: he wanted to go back to the childhood of the world, but he made a remarkable mistake: he went back only to the childhood of Europe.'

The question remains as to whether there is a place for primitivist tendencies in the art of the post-colonial West and whether the means exist to negotiate sensitively the complex relationship between the

175 A. R. Penck *Metaphysical Passage Through a Zebra* 1975

diverse material culture of the contemporary world. There is undoubtedly a large body of art made after 1945 that owes much to sources such as children's art, psychotic art and tribal culture, but are artists such as Georg Baselitz, A. R. Penck, Jean-Michel Basquiat and others acting upon the same ideas about primitivity as earlier artists? Moreover, if they *are*, can such beliefs be sustained in the wider cultural context? In one sense the problem becomes partly one of nomenclature, but the idea of reintroducing the word 'primitive' as a

175

EDUARDO PAOLOZZI
Lost Magic Kingdoms

176 Front cover of Eduardo
Paolozzi *Lost Magic Kingdoms* 1985

supposedly neutral term cannot really be substantiated precisely
because the idea of primitive society itself is no more than an
invention of Western anthropology. The category of the primitive is
a historical construction that has a particular range of meanings in
modern art and, therefore, it should come as no surprise that I have
proposed no alternative for this global term.

The supposed Primitivism of some art since about 1940 has usually
been either markedly specific to culture and time, or concerned with
the primitive aspects of the artist's own psychology, apparently
without connections to the generic child or tribal society. This is
especially apparent in the archaic ritualism of performance artists
in the 1960s such as Carolee Schneemann or Hermann Nitsch.
Primitivism has often been defined in terms of the appropriation and
absorption of difference by Western artistic practice. 'Idols' and

198

177 *(above)* Eduardo Paolozzi *Collage over African Sculpture* 1960

178 *(right)* Cameroon horse and rider from Grasslands

179 Installation at the *Magiciens de la terre* exhibition, Paris, May–August 1989, with *Mud Circle* by Richard Long and *Yarla* ground painting by Yuendumu community, Australia

'fetishes' are redefined as art and primitive art becomes another technical and stylistic source in the vocabulary of Western painting and sculpture. Yet, even in this partial view of Primitivism it is possible to point to contemporary artists who seem to utilize extra-European material culture without attempting to conceal its particular identity. For example, in the work of the American artist Robert Rauschenberg and the British sculptor Sir Eduardo Paolozzi, diverse pictorial elements are often related to each other by no more than their physical contiguity.

177 Paolozzi's art testifies to the modern preoccupation with fragmentation and the attempt to revitalize cultural fragments through

imaginative restructuring. He employs techniques from earlier modern art, such as collage and construction from found objects, which are analogous to Lévi-Strauss's idea of *bricolage*, abandoning distinctions between high and low culture, as well as those between the intended and transformed functionalities of the pieces he appropriates. This is clearest in *Lost Magic Kingdoms* (1985), a small 176 exhibition curated by Paolozzi at the Museum of Mankind, London, whose purpose was to explore the influence on Western artists of the British Museum's vast collections of ethnographic art by directly involving a major contemporary artist. Paolozzi was given a free hand in choosing from the museum's collections with the (perhaps predictable) result that besides masterpieces of tribal sculpture, he 178 chose objects as diverse as 'tourist' pieces (usually regarded as inauthentic), utilitarian objects and contemporary Mexican samples made for the Day of the Dead celebrations. Thus, Paolozzi presented an unusual view of the museum's collections. Malcolm McLeod, at that time the museum's director, suggested that: 'In making his selection, [Paolozzi] may happily ignore or reject aspects of a piece which, for an archaeologist or anthropologist, are its most important attributes.' This raises the possibility of focusing the viewer's attention on the rather arbitrary game of appropriation, definition and redefinition that inevitably takes place in this kind of cultural exchange without offering possible solutions to the problem.

If the controlling presence of the Western artist in *Lost Magic Kingdoms* represented a creative closure of modern Primitivism by revealing, though not attempting to solve, the difficulties that arise from using the cultural production of groups outside the West, another exhibition, *Magiciens de la terre* – staged in Paris in 1989 – attempted to introduce the possibility of showing art in a truly international way. The Western term 'art' was missing from the title of the show. The work displayed was by contemporary artists not only from Europe, the United States and the Far East, but also from the Third World, selected by the French organizer on the principle of the 'intensity of communication of meaning' in works by named individuals, rather than the unknown creators of most tribal sculpture in Western collections.

However, despite its careful even-handedness, it came under attack from many quarters. This was, perhaps, part of the inevitable difficulty one encounters when trying to make sense of the rich diversity of world cultures. It was partly because a clear – and unsubstantiated – assumption concerning the 'spiritual' nature of all

art had been made by the organizer and this had dictated his choice of artists and works. Shortly before *Magiciens de la terre* opened, he said: 'I know it is dangerous to extricate cultural objects from other civilizations. But we can also learn from these civilizations, which – just like ours – are engaged in a search for spirituality.'

It must be said that there were positive signs in *Magiciens de la terre* of previously silenced cultures asserting their own sense of identity by manipulating Western ideas about art practice, such as the Australian aborigines, who were prepared to show their work outside its functional context in order to defend their identity through its assertion as art. Despite this, one begins to wonder whether such projects (aimed, as they are, at a European audience) can ever really transcend the appearance of exotic spectacle so familiar to nineteenth-century Europeans in the guise of the colonial exhibition or the ethnographic museum. More significantly, are we here witnessing the demise of Primitivism in modern art, only to see it replaced with a new pluralist invention of a 'difference' that can be consumed, but which cannot be digested?

Bibliography and Sources

General

Forms of Primitivism have operated throughout the West's history. The earliest important study of the subject, A. O. Lovejoy and G. Boas, *Primitivism and Related Ideas in Antiquity* (New York, 1965) was first published in 1935. Although concerned with Classical Greek and Roman literature, it provides a useful general theoretical structure from which to explore Primitivism in the other arts and at other periods. Until recently studies of literary Primitivism have tended to provide a more useful view of the broader cultural implications inherent in ideas associated with Primitivism in general than art historical treatments of the subject. Notable examples are: J. Baird, *Ishmael* (Baltimore, 1956); M. Bell, *Primitivism* (London, 1972) and E. Dudley and M. Novak, eds, *The Wild Man Within: an Image in Western Thought from the Renaissance Romanticism* (London, 1972). The art historian E. H. Gombrich uses Lovejoy and Boas's ideas in his interesting overview of Primitivism in art from the late eighteenth century to the beginning of the twentieth century, 'The Primitive and its Value in Art', *The Listener* (15, 22 February and 1, 8 March 1979).

Any work that concerns itself with Primitivism and modern art cannot overlook R. Goldwater's seminal book *Primitivism in Modern Painting* (1938). The most recent edn of the book, *Primitivism in Modern Art* (enlarged edn, Cambridge, Mass., 1986) covers the period from the end of the nineteenth century to around the beginning of the Second World War, including a chapter on the rise of ethnographic museums in Europe. Also included are two important essays originally published elsewhere: 'Judgements of Primitive Art 1905–1965' (1969) and

'Art History and Anthropology: Some Comparisons of Methodology' (1973).

Only a few general works on artistic Primitivism succeeded Goldwater's pioneering book during the following half-century. These included: J. Laude, *La Peintre française (1905–1914) et l'art nègre* (Paris, 1968); C. Wentinck, *Modern and Primitive Art* (Oxford, 1979); Musée de l'Homme, *Arts primitifs dans les ateliers d'artistes* (exh. cat., Paris, 1967); L. Lippard, 'Heroic Years from Humble Treasures', *Art International* (September 1966).

The subject was brought to the fore again in 1984 via an ambitious exhibition and book created by W. Rubin (with the assistance of K. Varnedoe) for the Museum of Modern Art, New York, *'Primitivism' in 20th-Century Art: Affinity of the Tribal and Modern*. A number of specialists in particular areas of modern art were invited to contribute to the book. Important essays include, among others: Rubin, 'Modernist Primitivism: An Introduction'; Varnedoe, 'Gauguin' and 'Contemporary Explorations'; J. D. Flam, 'Matisse and the Fauves'; D. E. Gordon, 'German Expressionism'; R. Krauss, 'Giacometti' and essays on 'The Arrival of Tribal Objects in the West'. To a large extent Rubin's project was a conscious attempt to supersede Goldwater's work as the definitive text on artistic Primitivism, although in some ways it was less ambitious in its scope – among other things, Rubin's two volume catalogue reduced the 'primitive' to so-called tribal art, whereas Goldwater had also rightly considered other types of production, including children's drawings, Folk art and the art of the insane.

The 'Primitivism' show engendered a barrage of critical responses, most of which were more or less hostile, and in retrospect the sheer volume of criticism and its generally serious tone appears to have had the effect of

mythologizing the exhibition, rather than clarifying and correcting its premises. T. McEvilley's 'Doctor Lawyer Indian Chief', *Artforum* (November 1984), one of the earliest important reviews, prompted an angry exchange of letters between the author and exhibition organizers in the pages of *Artforum* (February and May 1985). Other relevant essays include: R. Araeen, 'From Primitivism to Ethnic Arts', *Third Text* (Autumn 1987); D. Ashton, 'On an Epoch of Paradox: "Primitivism" at the Museum of Modern Art', *Arts Magazine* (November 1984); Y.-A. Bois, 'La Pensée sauvage' and J. Clifford, 'Histories of the Tribal and Modern', *Art in America* (April 1985); A. C. Danto, '"Primitivism" in 20th-Century Art' in Danto, *The State of the Art* (New York, 1987); H. Foster, 'The "Primitive" Unconscious of Modern Art, or White Skin Black Masks' in Foster, *Recodings: Art, Spectacle, Cultural Politics* (Washington, D.C., 1985); J. Knapp, 'Primitivism and the Modern', *Boundary 2* (Fall/Winter 1986–87); H. Kramer, 'The "Primitivism" Conundrum', *New Criterion* (December 1984) and M. Torgovnick, 'William Rubin and the Dynamics of Primitivism' in Torgovnick, *Gone Primitive: Savage Intellects, Modern Lives* (Chicago and London, 1990).

More recent general works on Primitivism include: Varnedoe, *A Fine Disregard: What Makes Modern Art Modern* (London, 1990), especially Chapter 4, 'Primitivism'; S. Hiller, ed., *The Myth of Primitivism: Perspectives on Art* (London, 1991); S. Price, *Primitive Art in Civilized Places* (Chicago and London, 1991); J. Lloyd, *German Expressionism: Primitivism and Modernity* (New Haven and London, 1991); G. Perry, 'Primitivism and the "Modern"' in C. Harrison *et al*, *Primitivism, Cubism, Abstraction* (New Haven and London, 1993); F. S. Connelly, 'The Origins and Development of Primitivism in Eighteenth and Nineteenth-Century European Art and Aesthetics' (PhD thesis, University of Pittsburgh, 1987) and C. Rhodes, 'Primitivism Re-examined: Constructions of the "Primitive" in Modernist Visual Art' (unpublished PhD thesis, University of Essex, 1993).

Introduction

Goldwater, 1986, *op. cit.*; P. Klee, *The Thinking Eye: The Notebooks of Paul Klee* (London, 1961), p. 451.

Chapter 1

M. de Zayas, 'How, When, and Why Modern Art Came to New York', *Arts Magazine* (April 1980), pp. 96–126; C. Darwin, *On the Origin of Species* (London, 1859), p. 427; E. Haeckel, *The Riddle of the Universe*, trans. J. McCabe (London, 1929), pp. 66, 84; Darwin, *The Descent of Man* (London, 1871), pp. 618–19; Haeckel, *India and Ceylon* as quoted in D. Gasman, *The Scientific Origins of National Socialism: Ernst Haeckel and the German Monist League* (London, 1971), p. 19; for L. Lévy-Bruhl's ideas see, for example, his *How Natives Think*, trans. A. Clare (New Jersey, 1985); for C. Lévi-Strauss's ideas see, for example, his *La Pensée sauvage* (1962) – in English: *The Savage Mind* (London, 1989); L. Adam, *Primitive Art* (Harmondsworth, 1949), p. 79; Arthur Lovejoy and George Boas, 1965, *op. cit.* – on Cultural Primitivism see pp. 7–11; W. Kandinsky and F. Marc, eds, *Der Blaue Reiter* (Munich, 1912) – in English: *The Blaue Reiter Almanac* (documentary edn, London, 1974); Marc, 'Two Pictures' (in *ibid.*), p. 23.

Chapter 2

O. Mirbeau, as quoted in L. and E. Hanson, *The Noble Savage: A Life of Paul Gauguin* (London, 1954), p. 200; M. Denis, 'From Gauguin and van Gogh to Neo-Classicism' in C. Harrison and P. Wood, *Art in Theory 1900–1990* (Oxford, 1992), pp. 47–53. The most useful and accessible work in English on artists' colonies is M. Jacobs, *The Good and Simple Life* (Oxford, 1985); see also U. Linse, ed., *Zurücke, o Mensch, zur Mutter Erde: Landkommunen in Deutschland, 1890–1933* (Munich, 1983); a number of texts on Gauguin pertinent to this discussion exist, including: F. Orton and G. Pollock, 'Les Données bretonnantes: La prairie de réprésentation', *Art History* (September 1980), pp. 314–44; A. Solomon-Godeau, 'Going Native', *Art in*

America (July 1989), pp. 118–29; the sources consulted for translations of Gauguin quotations were H. B. Chipp, *Theories of Modern Art* (Berkeley and Los Angeles, 1968), pp. 78–86 and D. Guérin, ed., *The Writings of a Savage: Paul Gauguin* (New York, 1990); see Perry, 1993, *op. cit.*, pp. 8–27; J. Langbehn, *Rembrandt as Educator* (Leipzig, 1890); for more on the 'city versus nature' debate in its German context see W. S. Bradley, *Emil Nolde and German Expressionism: A Prophet in his Own Land* (Ann Arbor, 1986); Lloyd, 1991, *op. cit.*, especially Chapters 6–9; G. Perry, '"The Ascent to Nature" – Some Metaphors of "Nature" in Early Expressionist Art', in S. Behr *et al*, *Expressionism Reassessed* (Manchester, 1993), pp. 53–64 and F. Stern, *The Politics of Cultural Despair* (Berkeley, 1974); on nudism and related activities in Germany see M. Andritzky and T. Rautenberg, eds, '*Wir sind nackt und nennen uns Du': Von Lichtfreunden und Sonnenkämpfern: Ein Geschichte des Freikörperkultur* (Giessen, 1989); A. Macke, 'Masks' in *Der Blaue Reiter*; Kandinsky, 'On the Question of Form' in *Der Blaue Reiter*; A. Shevchenko, 'Neoprimitivism: Its Theory, Its Potentials, Its Achievements' as trans. in J. Bowlt, *Russian Art of the Avant Garde* (London, 1988), pp. 41–54; H. Prinzhorn, *Bildnerei der Geisterkranken* (Berlin, 1922) – in English: *Artistry of the Mentally Ill* (New York, 1972); as trans. in Klee, *The Diaries of Paul Klee 1898–1918* (London and Berkeley, 1968); H. Read, *Art Now* (London, 1933), pp. 45–46; E. Dingwall, ed., H. Ploss and M. Bartels, *Woman: An Historical, Gynaecological and Anthropological Compendium* (London, 1935); H. Ellis, *Studies in the Psychology of Sex* (New York, 1975); on Western ideas about black sexuality see S. Gilman, *Difference and Pathology: Stereotypes of Sexuality, Race and Madness* (Ithaca, 1985), especially Chapter 3, 'The Hottentot and the Prostitute: Toward an Iconography of Female Sexuality'.

Chapter 3

Montaigne, 'On Cannibals', 1580, as trans. in Montaigne, *Essays* (Harmondsworth, 1993);

L. A. de Bougainville as quoted in B. Smith, *European Vision and the South Pacific* (New Haven and London, 1988), p. 42; Gauguin, as quoted in Guérin, pp. 40, 42 and N. Wadley, *Paul Gauguin; Noa Noa* (Oxford, 1985); Wadley, 'Maori Mythology: Tehamana and Moerenhout' (in *ibid.*) – the book to which Gauguin referred was J. A. Moerenhout, *Voyages aux Iles du Grand Océan* (1837); M. Pechstein, *Erinnerungen* (Munich, 1963); Smith, 1988, *op. cit.*, p. 129; E. Said, *Orientalism* (Harmondsworth, 1991); L. Nochlin, 'The Imaginary Orient', *Art in America* (May 1983); useful surveys of Orientalist painting include: L. Thornton, *The Orientalists: Painter-Travellers, 1828–1908* (Paris, 1983) and Royal Academy of Arts, *The Orientalists: Delacroix to Matisse* (exh. cat., London, 1984); the Kokoschka quotations can be found in Tate Gallery, *Oskar Kokoschka 1886–1980* (exh. cat., London, 1986), pp. 114, 309; P. Leighten, 'The White Peril and *L'Art nègre*: Picasso, Primitivism and Anticolonialism', *The Art Bulletin* (vol. 72, no. 4, 1990) – see also F. Frascina, 'Realism and Ideology: An Introduction to Semiotics and Cubism' in Harrison, 1993, *op cit.*; J. Berger, *The Success and Failure of Picasso* (London, 1980); A. Salmon, 'Anecdotal History of Cubism', 1912, as trans. in E. Fry, *Cubism* (London, 1978), p. 82; on World Fairs see P. Greenalgh, *Ephemeral Vistas* (Manchester, 1988); for a different discussion of *The Whites Visiting the Blacks* and its companion image see Lloyd, 1991, *op. cit.*; G. Grosz, *Ein kleines Ja und ein grosses Nein* (Hamburg, 1955), trans. as *A Small Yes and a Big No* (London, 1982) – on his visit to Karl May see pp. 60–63; quotations from pp. 74, 76; the first writer to consider the Ajanta source in Brücke art was Gordon, 'Kirchner in Dresden', *The Art Bulletin* (vol. 48, nos 3–4, 1966), pp. 335–66, see also Lloyd, 1991, *op. cit.*; J. Gage, *Goethe on Art* (London, 1980).

Chapter 4

Rubin, 1984, *op. cit.*; Goldwater, 'Judgements of Primitive Art, 1905–1965' in 1986, *op. cit.*, p. 275 and also pp. 147–54; for Picasso on his

experience at the Trocadéro museum see F. Gilot and C. Lake, *Life with Picasso* (London, 1966); D.-H. Kahnweiler, 'Negro Art and Cubism', *Horizon* (December 1948); W. Worringer, 1963, *op. cit.*, trans. M. Bullock (New York, 1963); Gordon, 1966, *op. cit.*; E. Nolde, as trans. in Chipp, 1968, *op. cit.*, pp. 150–51.

Chapter 5

Kandinsky, 'Reminiscences', as trans. in K. Lindsay and P. Vergo, ed., *Kandinsky: Complete Writings on Art* (Boston, Mass., 1982); F. T. Marinetti, 'The Founding and Manifesto of Futurism' in U. Apollonio, ed., *Futurist Manifestos* (London, 1973); A. von Jawlensky, as trans. in H. Roethel, *The Blue Rider* (New York, 1971), pp. 47, 44; on the Expressionist relationship with nature see A. K. Wiedmann, *Romantic Roots in Modern Art* (Surrey, 1979); Worringer, 1963, *op. cit.*; Kandinsky, *Über das Geistige in der Kunst* (Munich, 1912); Marc, as trans. in Roethel, p. 105; a good source for statements by all the major Dadaists is R. Motherwell, ed., *The Dada Painters and Poets: An Anthology* (Cambridge, Mass. and London, 1989); on Primitivism in Dada see C. Middleton, 'The Rise of Primitivism and Its Relevance to the Poetry of Expressionism and Dada' in *Bolshevism in Art (and Other Expository Writings)* (Manchester, 1978); also useful are H. Richter, *Dada: Art and Anti-Art* (London, 1978) and W. Verkauf, ed., *Dada, Monograph of a Movement* (London, 1975); H. Moore, 'Sculpture' in R. Lambert, *Art in England* (Harmondsworth, 1938), pp. 93–99; S. Freud, *Totem and Taboo* (Harmondsworth, 1940), *Interpretation of Dreams* (1900) and *Psychopathology of Everyday Life* (1901); Lévi-Strauss, 1989, *op. cit.*; A. Breton, 'The First Surrealist Manifesto' in Lippard, ed., *Surrealists on Art* (New York, 1970); Breton, 'Limits Not Frontiers of Surrealism' in F. Rosemont, ed., *André Breton: What is Surrealism?: Selected Writings* (London, 1989); on Surrealism and the body see, for example, B. Fer, 'Surrealism, Myth and Psychoanalysis' in B. Fer, D.

Batchelor, P. Wood, *Realism, Rationalism, Surrealism* (New Haven and London, 1993); on the Surrealists' interest in the 'primitive' see, for example, L. Cowling, 'An Other Culture' in D. Ades, *Dada and Surrealism Reviewed* (London, 1978); M. Ernst, 'Some Data on the Youth of M. E.' in Ernst, *Beyond Painting* (New York, 1948), p. 29; H. Read, *Modern Sculpture* (London, 1964); on Surrealism and anthropology see Clifford, *A Predicament of Culture: 20th-Century Ethnography, Literature and Art* (Cambridge, Mass., 1988); G. Bataille, 'L'Amérique disparue' in J. Babelon, *L'Art précolumbien* (Paris, 1930); Krauss, 'Giacometti' in Rubin, 1984, *op. cit.*; P. Weiss, 'Kandinsky and "Old Russia"' in G. Weisberg and L. Dixon, ed., *The Documented Image* (New York, 1987); on American Expressionism and the 'primitive' see, for example, W. J. Rushing, 'Ritual and Myth: Native American Culture and Abstract Expressionism' in M. Tuchman, *The Spiritual in Art: Abstract Painting 1890–1985* (exh. cat., Los Angeles, 1987); also, E. Langhorne, 'Pollock, Picasso and the Primitive', *Art History* (March 1989); Pollock, 'My Painting', *Possibilities I* (Winter 1947–48); on contemporary Primitivism see, for example, C. Ratcliffe, 'On Contemporary Primitivism', *Artforum* (November 1975); Varnedoe, 'Contemporary Explorations' in Rubin, 1984, *op. cit.* and D. Kuspit, 'Concerning the Spiritual in Contemporary Art' in Tuchman (1987); Beuys as quoted in G. Adriani *et al*, *Joseph Beuys: Life and Work* (New York, 1979), p. 132.

Epilogue

Hiller, ed., 1991, *op. cit.*; F. Fanon, *Black Skin, White Masks*, trans. C. Markmann (London, 1986); E. Paolozzi, *Lost Magic Kingdoms and Six Paper Moons from Nahuatl* (London, 1985); on *Magiciens de la terre* see, for example, B. Buchloh, 'The Whole Earth Show', *Art in America* (May 1989) and E. Heartney, 'The Whole Earth Show: Part II', *Art in America* (July 1989).

List of Illustrations

Measurements are given in centimetres, followed by inches, height before width before depth, unless otherwise stated.

25 Wassily Kandinsky Study for *Picture with a White Border* 1913. Oil on burlap canvas 99.6 × 78.1 (39¼ × 30¾). © The Phillips Collection, Washington, D.C.

26 Wassily Kandinsky in his home at Ainmillerstrasse 36, Munich, 24 June 1911. Photograph by Gabriele Münter. Städtische Galerie im Lenbachhaus, Munich.

27 Wassily Kandinsky *Small Pleasures* 1913. Oil on canvas 110.5 × 120.7 (43½ × 47½). The Solomon R. Guggenheim Museum, New York.

28 Kasimir Malevich *Painterly Realism. Boy with Knapsack – Color Masses in the Fourth Dimension* 1915. Oil on canvas 71.1 × 44.5 (28 × 17½). The Museum of Modern Art, New York.

29 Kasimir Malevich *Taking in the Harvest* 1911. Oil on canvas 72 × 74.4 (28⅜ × 29⅜). Stedelijk Museum, Amsterdam.

30 David Burliuk *My Cossack Ancestor c.* 1908. Oil on canvas. Whereabouts unknown.

31 Mikhail Larionov *Soldiers* 1911 (second version). Oil on canvas 88 × 102 (34⅝ × 40⅛). The Los Angeles County Museum of Art, Los Angeles.

32 Pablo Picasso *Obliging Woman* 1905. India ink 21 × 13.5 (8¼ × 5⅜). Musée Picasso, Paris. © Photo R.M.N.

33 George Grosz *Murder* 1916. Pen and ink drawing. Plate 12 from George Grosz *Ecce Homo* 1923.

34 Jean Dubuffet *'Il tient la flûte et le couteau'* 1947. Oil on canvas 129.5 × 97.1 (51 × 38¼). Private collection.

35 Paul Klee *Portrait of a Mad Person* 1925. Pen and black ink on paper 18.2 × 22.8 (7⅛ × 9). Paul Klee Stiftung, Kunstmuseum, Bern.

36 Paul Klee *Child as Hermit* 1920. Oil on paper laid down on board 19.3 × 26.4 (7⅝ × 10⅜). Kasama Nichido Museum of Art, Tokyo.

37 Child's drawing *House*. Crayon and pencil on paper 23.9 × 19.8 (9⅜ × 7¾). Gabriele Münter and Johannes Eichner Foundation, Munich.

38 Gabriele Münter *House* 1914. Oil on cardboard 40.5 × 32.5 (16 × 12¾). Gabriele Münter and Johannes Eichner Foundation, Munich.

39 Karel Appel *Questioning Children* 1949. Gouache on pinewood relief 87.3 × 59.8 × 15.8 (34⅜ × 23½ × 6¼). Tate Gallery, London.

40 Jean Dubuffet *Mother and Child* 1956. Oil on canvas 100.6 × 81.6 (39⅝ × 32⅛). Ulster Museum, Belfast.

41 Ernst Ludwig Kirchner *Fränzi in Front of a Carved Chair* 1910. Oil on canvas 70.5 × 50 (27¾ × 19⅝). Thyssen-Bornemisza, Collection, Lugano-Castagnola. Copyright (for works by E L Kirchner) by Ingeborg & Dr Wolfgang Henze, Wichtrach/Bern.

42 Paul Gauguin *Merahi Metua No Tehamana (Tehamana has many parents)* 1892. Oil on canvas 76.3 × 54.3 (30 × 21⅜). The Art Institute of Chicago. Photo © 1994, The Art Institute of Chicago, All Rights Reserved.

43 Max Pechstein *Early Morning* 1911. Oil on canvas 75 × 100 (29½ × 39⅜). Peter Selinka Collection, Ravensburg.

44 Franz Marc *Red Woman* 1912. Oil on canvas 100.5 × 70 (39½ × 27⅝). Leicestershire Museums, Arts and Records Service.

45 Hottentot woman with steatopygia and crural obesity. Fig 273 from Volume 1 *Woman, An Historical, Gynaecological and Anthropological Compendium* by Hermann Heinrich Ploss, Max Bartels and Paul Bartels 1935. Photo Sander and Roesehke.

46 Ernst Ludwig Kirchner *Erna in a Short Jacket with Wooden Figure* 1912. Pencil 49.7 × 32.2 (19½ × 12¾). Staatliche Kunstsammlungen, Kassel. Copyright (for works by E L Kirchner) by Ingeborg & Dr Wolfgang Henze, Wichtrach/Bern.

47 Erich Heckel *Standing Child* 1910. Coloured woodcut 37.5 × 26 (14¾ × 10¼).

48 Paul Gauguin *The Man with the Axe* 1891. Oil on canvas 92 × 70 (36¼ × 27½). Private collection. Courtesy Ellen Melas Kyriazi.

49 Paul Gauguin *Nave Nave Moe (Fragrant Water)* 1894. Oil on canvas 73 × 98 (28¾ × 38⅝). Hermitage Museum, St Petersburg.

50 Paul Gauguin. Page 57 from the Louvre manuscript of *Noa Noa*, with a woodcut of

Hina and Tefatou from *Te Atua*, photograph of Tahitian girl and a watercolour 1894. Musée du Louvre, Paris. © Photo R.M.N.

51 John Webber *A Night Dance by Women, in Hapaee* 1784. Plate 17 from Captain James Cook and Captain James King *Voyage to the Pacific Ocean* 1785.

52 Jean-Léon Gérôme *The Whirling Dervishes* c. 1895. Oil on canvas 73 × 95 (29 × 37.5). Private collection.

53 Jean-Léon Gérôme *Slave Market* early 1860s. Oil on canvas 74.9 × 59.7 (29½ × 23½). Cincinnati Art Museum. John J. Emery Fund. 1917.368.

54 Cameroon chief's stool from Western Grasslands. Before 1910. Painted wood H 73 (28¾). Staatliches Museum für Völkerkunde, Dresden.

55 Max Pechstein *Palau Triptych* 1917. Oil on canvas 119 × 353 (47 × 11' 6). Wilhelm-Hack Museum, Ludwigshafen.

56 Bakuba figure of a man squatting from Zaire 1909. Wood H 54 (24¼). The Trustees of the British Museum, London.

57 Max Pechstein *Still Life in Grey* 1913. Oil on canvas. Whereabouts unknown.

58 Marsden Hartley *Indian Composition* 1914. Oil on canvas 120 × 119.3 (47¼ × 47). Vassar College Art Gallery, Poughkeepsie, New York. Gift of Paul Rosenfeld.

59 Karl Schmidt-Rottluff *Three Nudes – Dunes at Nidden* 1913. Oil on canvas 98 × 106 (38⅝ × 41¾). Staatliche Museen Preussischer Kulturbesitz, Nationalgalerie Berlin.

60 Dan mask from the Ivory Coast or from Liberia. Collected 1952. Wood H 24.5 (9⅝). Collection Musée de l'Homme, Paris. Gift of Baron von der Heydt.

61 Pablo Picasso *Les Demoiselles d'Avignon* Paris (June–July, 1907). Oil on canvas 243.9 × 233.7 (8' × 7'8). The Museum of Modern Art, New York. Acquired through the Lillie P. Bliss Bequest.

62 Carte de visite depicting American Indians scalping a white man c. 1880. The Trustees of the British Museum, London.

63 Kanaka village, New Caledonia, shown at the *Exposition Universelle*, Paris 1889. Engraving after a drawing by Louis Tinayre,

published in *Le Monde illustré*, 27 June 1889.

64 *The Blacks Visiting the Whites* from *Fliegender Blätter* 1905.

65 *The Whites Visiting the Blacks* from *Fliegender Blätter* 1905.

66 George Grosz *Old Jimmy* 1916. Pen and ink drawing. From *Neue Jugend* July, 1916.

67 Senufo door from the Ivory Coast. Wood H 130 (51⅛). Collection Musée de l'Homme, Paris.

68 Ernst Ludwig Kirchner's studio, Dresden 1910. Photograph. Fotoarchiv Bolliger/Ketterer. Copyright (for works by E L Kirchner) by Ingeborg & Dr Wolfgang Henze, Wichtrach/Bern.

69 Ernst Ludwig Kirchner *Negro Couple* 1911. Whereabouts unknown. Photo Kirchner Museum, Davos. Copyright (for works by E L Kirchner) by Ingeborg & Dr Wolfgang Henze, Wichtrach/Bern.

70 Karl Schmidt-Rottluff *Women at a Table* 1914. Woodcut 6 × 7.7 (2⅜ × 3).

71 Ernst Ludwig Kirchner and Erna Schilling in the MUIM-Institute, Berlin-Wilmersdorf c. 1912. Photograph. Fotoarchiv Bolliger/Ketterer. Copyright (for works by E L Kirchner) by Ingeborg & Dr Wolfgang Henze, Wichtrach/Bern.

72 The dancer Nina Hard in the 'Haus in den Lärchen' at Davos 1921. Photograph. Fotoarchiv Bolliger/Ketterer. Copyright (for works by E L Kirchner) by Ingeborg & Dr Wolfgang Henze, Wichtrach/Bern.

73 Paul Gauguin *Te Rerioa (The Dream)* 1897. Oil on canvas 95 × 132 (37⅜ × 52). Courtauld Institute Galleries, London.

74 Baluba headrest from Zaire 1949. Wood H 19 (7½). The Trustees of the British Museum, London.

75 Ernst Ludwig Kirchner *Nude behind a Curtain, Fränzi* 1910–26. Oil on canvas 120 × 90 (47¼ × 35⅜). Stedelijk Museum, Amsterdam. Copyright by Ingeborg & Dr Wolfgang Henze, Wichtrach/Bern.

76 Loin cloth from Irian Jaya, Indonesia. Painted bark cloth H 56.2 (22⅛). Tropenmuseum, Amsterdam.

77 Paul Klee *Picture Album* 1937. Gouache on unprimed canvas 59.3 × 56.3 (23⅜ × 22¼). ©

The Phillips Collection, Washington, D.C.
78 Max Pechstein *Moon* 1919. Painted wood. Whereabouts unknown.
79 Maori female figure from New Zealand. Wood H 54.5 (21½). The Trustees of the British Museum, London.
80 Pablo Picasso *Three Figures Under a Tree* 1907. Oil on canvas 99 × 99 (39 × 39). Musée Picasso, Paris. © Photo R.M.N.
81 Pablo Picasso in his studio in the Bateau-Lavoir, Paris 1908. Photographed for Gelett Burgess.
82 Pablo Picasso *The Dryad (Nude in the Forest)* 1908. Oil on canvas 185 × 108 (72⅞ × 42½). Hermitage Museum, St Petersburg.
83 Pablo Picasso *Nude with Raised Arms (The Dancer of Avignon)* 1907. Oil on canvas 150.3 × 100.3 (59⅓ × 39½). Private collection.
84 Kota reliquary figure from the People's Republic of the Congo. Brass sheeting over wood H 70.5 (27¾). Herbert Ward Collection, Smithsonian Institution, Washington, D.C.
85 Paul Cézanne *The Large Bathers* 1900–6. Oil on canvas 172.2 × 196.1 (67⅞ × 77¼). Reproduced by courtesy of the Trustees, National Gallery, London.
86 Kulango figure from the Ivory Coast. Wood H 65.4 (25¾). Collection Thomas G.B. Wheelock. Photo Robin Grace.
87 Constantin Brancusi *Adam and Eve* 1916–21. Chestnut and old oak H 224.8 (88½) limestone base H 130.2 (51¼). The Solomon R. Guggenheim Museum, New York.
88 Fang figure of a man standing from Gabon. Presented in 1956. H 60 (23¾). The Trustees of the British Museum, London.
89 Amedeo Modigliani *Standing Nude* c. 1911–12. Stone H 160 (63). Australian National Gallery, Canberra.
90 Henri Gaudier-Brzeska *Caritas* 1914. Pencil 45.7 × 30.8 (18 × 12⅛). Kettle's Yard, University of Cambridge.
91 Jacques Lipchitz *Guitar Player* 1918. Bronze H 72 (28⅜). Stadt Kunstmuseum, Duisburg.
92 Pablo Picasso *Guitar* Paris (Winter, 1912–13). Construction of sheet metal and wire 77.5 × 35 × 19.3 (30½ × 13⅜ × 7⅝). The

Museum of Modern Art, New York. Gift of the artist.
93 Grebo mask from the Ivory Coast or from Liberia. Painted wood and fibre H 64 (25⅛). Musée Picasso, Paris. © Photo R.M.N.
94 Pablo Picasso *Nude* 1910. Pencil and ink 51.5 × 41 (20¼ × 16⅛). Národní Galerie, Prague.
95 *Five Figures*, Ajanta wall painting, Cave II. 2nd century BC–AD 7th century. 243.8 × 274.3 (8' × 9'). From John Griffiths *The Paintings in the Buddhist Cave – Temples of Ajanta* 1896, Vol 1.
96 Ernst Ludwig Kirchner *Five Bathers by a Lake* 1911. Oil on canvas 150.5 × 200 (59¼ × 77¾). Brücke-Museum, Berlin. Copyright (for works by E L Kirchner) by Ingeborg & Dr Wolfgang Henze, Wichtrach/Bern.
97 Ernst Ludwig Kirchner *Half-Length Nude with Hat* 1911. Oil on canvas 76 × 70 (30 × 27⅝). Wallraf-Richartz Museum, Cologne. Copyright (for works by E L Kirchner) by Ingeborg & Dr Wolfgang Henze, Wichtrach/Bern.
98 Emil Nolde *Family* 1914. Oil on canvas 71 × 104.5 (28 × 41⅛). Nolde-Stiftung, Seebüll.
99 Emil Nolde *Man, Fish and Woman* 1912. Oil on canvas 71.5 × 57.5 (28⅛ × 22⅝). Nolde-Stiftung, Seebüll.
100 Ernst Ludwig Kirchner *Portrait of David Mueller* 1919. Woodcut 34.1 × 29.2 (13¾ × 11½). Copyright (for works by E L Kirchner) by Ingeborg & Dr Wolfgang Henze, Wichtrach/Bern.
101 Barbara Hepworth *Nesting Stones* 1937. Serravezza marble L 30.5 (12). Private collection.
102 Adolph Gottlieb *The Oracle* c. 1947. Oil on canvas 152.4 × 111.8 (60 × 44). Private collection.
103 Maori *Madonna and Child* from New Zealand 1840. Wood and shell H 82.5 (32½). Auckland Institute and Museum, New Zealand.
104 Emil Nolde *The Twelve-Year-Old Christ* 1911. Oil on canvas 100 × 86 (39⅜ × 33⅞). Nolde-Stiftung, Seebüll.
105 Paula Modersohn-Becker *Reclining*

Mother and Child 1906. Oil on canvas 82 × 124.7 (32¼ × 49). Freie Hansestadt, Bremen. Photo Lars Lohrisch.

106 Alexei Jawlensky *Love* 1925. Oil on cardboard 59 × 49.5 (23¼ × 19¼). Städtische Galerie im Lenbachhaus, Munich.

107 Franz Marc *Birth of the Wolf* 1913. Woodcut 25.3 × 18.5 (10 × 7¼).

108 Emil Nolde *Autumn Evening* 1924. Oil on canvas 73 × 100.5 (28¾ × 39½). Thyssen-Bornemisza, Lugano-Castagnola. Copyright Nolde-Stiftung, Seebüll.

109 Mikhail Larionov *Spring* 1912. Oil on canvas 85 × 67 (33½ × 26¾). Formerly collection of the artist.

110 Gela Forster *Conception* c. 1919. Stone. Whereabouts unknown.

111 Otto Dix *Pregnant Woman* 1919. Oil on canvas 135 × 72 (53⅛ × 28¾). Galerie Valentien, Stuttgart on loan to the Galerie der Stadt Stuttgart.

112 Oskar Kokoschka *Murderer Hope of Woman* 1909. Lithograph 118.1 × 76.2 (46½ × 30).

113 Franz Marc *Blue Horse I* 1911. Oil on canvas 112 × 84.5 (44⅛ × 33¼). Städtische Galerie im Lenbachhaus, Munich. Bernhard Koehler Donation, 1965.

114 Franz Marc *Cows, Yellow-Red-Green* 1912. Oil on canvas 62 × 87.5 (24⅜ × 34½) Städtische Galerie im Lenbachhaus, Munich. Donated by Gabriele Münter, 1961.

115 Hannah Höch *The Sweet One* from the series 'From an Ethnographical Museum' 1926. Collage 30 × 15.5 (11⅞ × 6⅛). Collection Eva-Maria and Heinrich Rösner, Backnang.

116 Marcel Janco *Mask* 1919. Paper, cardboard, twine, gouache and pastel 45 × 22 × 5 (17¾ × 8⅝ × 2). Documentation du Musée National d'Art Moderne – Centre Georges Pompidou, Paris.

117 Hans Arp *Portrait of Tristan Tzara's Shadows* 1916, repainted c. 1950. Relief of painted wood 51 × 50 × 10 (20⅛ × 19⅝ × 3⅞). Musée d'Art et d'Histoire, Geneva.

118 Hans Arp *Human Concretion* 1933. Bronze H 75 × 55.9 × 34.3 (29½ × 22 × 13½). Photo Étienne Bertrand Weill, Paris.

119 Hans Arp *Amphora of the Muse* 1959.

Bronze 113.3 × 44.1 × 44.1 (44⅝ × 17¾ × 17¾). The Nelson A. Rockefeller Collection, New York.

120 Jacob Epstein *Female Figure* 1913. Flenite H 60.9 (24). The Minneapolis Institute of Arts. Gift of Messrs. Samuel H. Maslon, Charles H. Bell, Francis D. Butler, John Cowles, Bruce B. Dayton and anonymous donor.

121 Tahitian standing figure in the form of a man from the Society Islands, Central Polynesia. Collected 1821–24. H 53 (20⅞). Trustees of the British Museum, London.

122 Barbara Hepworth *Pierced Form (Amulet)* 1962. Bronze H 26.7 (10½). Private collection.

123 Henry Moore *Knife Edge Two Piece* 1962. Bronze 274.3 × 365.8 (9′ × 12′). Photo Marlborough Fine Art (London) Ltd.

124 Paul Klee *Botanical Theatre* 1924, reworked 1934. Oil, watercolour and ink on cardboard mounted on plywood 50.2 × 67.5 (19¾ × 26⅝). Gabriele Münter and Johannes Eichner Foundation/Städtische Galerie im Lenbachhaus, Munich.

125 Paul Klee *Cacodaemonic* 1916. Watercolour 18.5 × 25.5 (7¼ × 10). Paul Klee Stiftung, Kunstmuseum, Bern.

126 Willi Baumeister *Rock Garden* 1939. Mixed media and sand on canvas 116 × 81 (45⅝ × 31⅞). Museum Folkwang, Essen.

127 Hans Hofmann *Equinox* 1958. Oil on canvas 91 × 71 (72⅛ × 60¼). University Art Museum, University of California, Berkeley. Gift of the artist.

128 Giuseppe Penone *Breath I* 1978. Terracotta H 160 Diameter 100 (63 × 39⅜). Courtesy Galerie Rudolf Zwirner, Cologne.

129 Rebecca Horn *Metamorphosis of Beatrice* 1984. 3 boxes of glass and iron filled with ash, soot and cuput mortuum with ostrich egg 100 × 70 × 15 each (39⅜ × 27⅝ × 5⅞). Collection of the artist.

130 Child's drawing *Dollies*. Plate 1a from Herbert Read *Education Through Art* 1958.

131 André Breton *Decalcomania* 1936. Gouache 25.4 × 33 (10 × 13). Private collection.

132 Max Ernst *Two Children are Threatened*

by a Nightingale 1924. Oil on wood with wood construction 69.8 × 57.1 × 11.4 (27½ × 22½ × 4½). The Museum of Modern Art, New York. Purchase.

133 Joan Miro *Dutch Interior II* 1928. Oil on canvas 92.1 × 73 (36¼ × 28¾). Peggy Guggenheim Collection, Venice.

134 Victor Brauner *The Birth of Matter* 1940. Oil on canvas 195 × 130 (76¾ × 51⅛). Collection Renos Xippas, Athens.

135 Max Ernst *The Elephant Celebes* 1921. Oil on canvas 125.4 × 107.9 (49⅜ × 42½). Tate Gallery, London.

136 Max Ernst *The Sea and the Rain* 1925. Frottage 42.9 × 26.7 (16⅞ × 10½). Plate 1 from *Historie Naturelle* 1925.

137 Max Ernst *Vision Induced by the Nocturnal Aspect of the Porte Sainte-Denis* 1927. Oil on canvas 65 × 81 (25⅝ × 31⅞). Private collection.

138 Iatmul figure from East Sepik Province, Papua New Guinea. Wood and paint H 138 (54⅜). Private collection.

139 Wifredo Lam *The Jungle* 1943. Gouache on paper mounted on canvas 239.4 × 229.9 (7′ 10¾ × 7′ 6½). The Museum of Modern Art, New York. Inter-American Fund.

140 Man Ray *Black and White* 1926. Silver print on tissue 21.9 × 27.7 (8⅝ × 10⅞).

141 Victor Brauner *Prelude to a Civilization* 1954. Encaustic, pen and ink on masonite 129.5 × 202.5 (51 × 79¾). The Jacques and Natasha Gelman Collection. Copyright © 1988/93 By the Metropolitan Museum of Art. Photo Malcolm Varon.

142 American Indian Sioux buffalo-skin robe. Collected 1833. Museum für Völkerkunde, Staatliche Museen Preussischer Kulturbesitz, Berlin.

143 Eskimo figure from Alaska. Nineteenth century. Walrus ivory H 9.8 (3⅞). The Trustees of the British Museum, London.

144 Henry Moore *Girl* 1932. Boxwood H 31.8 (12½). Private collection. © Photo Malcolm Varon 1983.

145 Eskimo shaman's mask from South Alaska. Early twentieth century. Wood and feathers 20 × 42 (7⅞ × 16½). Thomas Burke Memorial Washington State Museum, University of Washington, D.C.

146 Eskimo mask from Hooper Bay, Alaska. Painted wood and feathers H 48 (18⅞). Private collection. Formerly collection André Breton.

147 Joan Miro *The Hunter (Catalan Landscape)* 1923–24. Oil on canvas 64.8 × 100.3 (25½ × 39½). The Museum of Modern Art, New York. Purchase.

148 Alberto Giacometti *No More Play* 1933. White marble with wood and bronze pieces 45.2 × 58 × 4.1 (17¾ × 22⅞ × 1⅝). Collection Patsy R. and Raymond D. Nasher, Dallas.

149 Gio gameboard from Liberia. Wood L 55.8 (22). Peabody Museum of Archaeology and Ethnology, Harvard University, Cambridge, Mass.

150 Max Ernst *Loplop présente Loplop (Chimère)* 1930. Oil and plaster on wood 89 × 175 (35 × 68⅞). Menil Collection, Houston, Texas.

151 Bosman standing figure of a man from Ramu River, Northern New Guinea 1936. Wood H 29 (11⅜). The Trustees of the British Museum, London.

152 *Kachina* doll from Zuni, Arizona. Early twentieth century. Wood, feathers, cotton, leather and shells H 39 (15⅜). Museum für Völkerkunde, Vienna.

153 Henry Moore *Upright Motive No.1: Glenkiln Cross* 1955–56. Bronze H 335.3 (11′). Collection Miss Mary Moore. Photo Conway Library, Courtauld Institute of Art, London.

154 Max Ernst *Moon Mad* 1944. Bronze H 96.5 (38). The Solomon R. Guggenheim Museum, New York. The Joseph H. Hirshhorn Collection.

155 Jacques Lipchitz *Figure* 1926–30. Bronze H 216.5 (7′ 1¼). The Solomon R. Guggenheim Museum, New York. The Joseph H. Hirshhorn Collection.

156 Jacques-André Boiffard *Untitled* 1929. Photograph. Private collection.

157 Marcel Griaule and Michel Leiris prepare to sacrifice chickens before the Kono altar at Kemeni, 6 September 1931, as a condition of entering the sanctuary. Photograph. Collection Musée de l'Homme, Paris.

158 Diego Rivera *Minotaure* 1939. Design

for the inner cover of *Minotaure* No. 12–13. Gouache 36.5 × 54.5 (14¾ × 21½). Private collection, Geneva. Photo Musée d'Art et d'Histoire, Geneva.

159 Henry Moore *Reclining Figure* 1929. Hornton stone L 83.8 (33). Leeds City Art Gallery and Temple Newsam House.

160 Mayan rain god AD 948–1697. Limestone L 148.6 (58½). From Chichén Itzá, Mexico.

161 Alberto Giacometti *The Couple* 1926. Plaster H 65 (25⅝). Private collection.

162 Alberto Giacometti *Invisible Object* 1934. Bronze 154 × 32.4 × 28 (60⅝ × 12¾ × 11). Albright-Knox Gallery, Buffalo, New York. Edmund Hayes Fund.

163 Jackson Pollock *The Moon-Woman Cuts the Circle* 1943. Oil on canvas 109.5 × 104 (43⅛ × 41). Documentation du Musée National d'Art Moderne – Centre Georges Pompidou, Paris. Gift of Frank Lloyd.

164 Theodoros Stamos *Ancestral Myth* 1943. Oil on masonite 61 × 76.2 (24 × 30). Courtesy Louis K. Meisel Gallery, New York. Photo Steve Lopez.

165 Lapp shaman's drum (bowl type) from Northern Scandinavia. Pine with reindeer skin membrane 37.5 × 32.9 × 9.4 (14¾ × 13 × 3¾). Staatliches Museum für Völkerkunde, Munich.

166 Wassily Kandinsky Untitled drawing for *Le Lien vert* 1944. India ink and black lead 19.6 × 21.1 (7¾ × 8⅜). Documentation du Musée National d'Art Moderne – Centre Georges Pompidou, Paris.

167 Adolph Gottlieb *Labyrinth No.2* 1950. Oil on linen 91.4 × 121.9 (36 × 48). Tate Gallery, London. © 1979 Adolph & Esther Gottlieb Foundation, Inc., New York. Photo Robert E. Mates.

168 Tlingit blanket from Alaska 1850–1900. Linden Museum, Stuttgart. Photo Ursula Didoni.

169 Richard Pousette-Dart *Hesperides* 1944–45. Mixed media on gesso board 50.8 × 61 (20 × 24). Courtesy: The Marisa del Re Gallery, New York.

170 Jackson Pollock *Number 1, 1948* 1948. Oil and enamel on unprimed canvas 172.7 × 264.2 (68 × 8′ 8). The Museum of Modern Art, New York. Purchase.

171 Nancy Graves *Paleo-Indian Cave Painting, Southwestern Arizona (To Dr. Wolfgang Becker)* 1970–71. Steel, fibre glass, oil paint, acrylic and three wood boards 396.2 × 274.3 × 228.6 (13′ × 9′ × 7′ 6). Neue Galerie der Stadt, Aachen. Sammlung Ludwig. Gift of the artist. Photo Ann Münchow.

172 Joseph Beuys *House of Shaman I* 1959. Oil on watercolour on wrinkled tracing paper, pasted on cardboard 49.5 × 54 (19½ × 21¼). Van der Grinten Collection, Kranenburg, Niederhein.

173 Joseph Beuys *Honey Pump at the Work Place* 1977. 2 tons of honey, 100 kg (200 lb) of margarine, 2 ship's engines, steel container, plastic tube, 3 bronze pots. Dimensions according to arrangement. Louisiana Museum of Modern Art, Humlebaek, Denmark. Photo Ute Klophaus, Wuppertal.

174 Bembe sculpture of Europeans in a motor-car from the People's Republic of the Congo. Early twentieth century. Wood. Musée Royale de l'Afrique Centrale, Tervuren. Photo Louis Loose.

175 A. R. Penck *Metaphysical Passage Through a Zebra* 1975. 285 × 285 (9′ 4¼ × 9′ 4¼). Neue Galerie der Stadt, Aachen. Sammlung Ludwig. Courtesy Galerie Michael Werner, Cologne and New York.

176 Front cover of Eduardo Paolozzi *Lost Magic Kingdoms* 1985. The Trustees of the British Museum, London.

177 Eduardo Paolozzi *Collage over African Sculpture* 1960. Photomontage 25.5 × 14.9 (10 × 5⅞). Courtesy of the Anthony d'Offay Gallery.

178 Cameroon horse and rider from Grasslands. Collected 1978. Wood H 29.5 (11⅝). The Trustees of the British Museum, London.

179 Installation at the *Magiciens de la terre* exhibition, Paris, May–August 1989, with *Mud Circle* by Richard Long and *Yarla* ground painting by Yuendumu community, Australia. Earth pigments, mixed media 400 × 1,000 (13′ × 33′). Documentation du Musée National d'Art Moderne – Centre Georges Pompidou, Paris.

Index

214